The Tempting Prospect

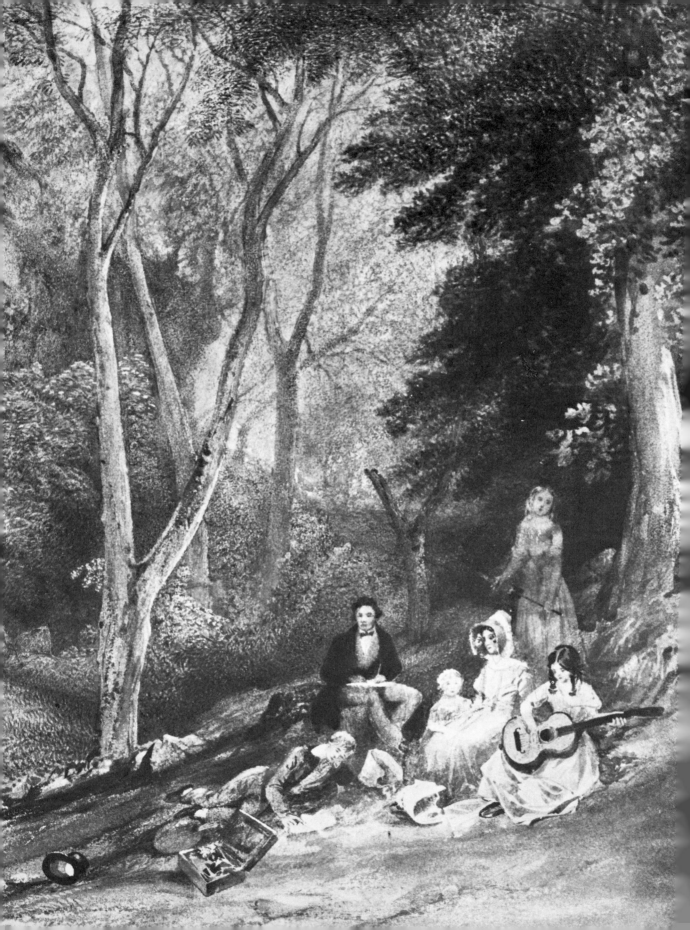

The Tempting Prospect

A SOCIAL HISTORY OF ENGLISH WATERCOLOURS

Michael Clarke

A Colonnade book
Published by British Museum Publications

Colonnade Books
are published by British Museum Publications Ltd and are
offered as contributions to the enjoyment, study and
understanding of art, archaeology and history.

The same publishers also produce the official
publications of the British Museum.

Published by British Museum Publications Ltd
46 Bloomsbury Street, London WC1B 3QQ

Front cover: William Havell (1782–1857) *A view over Windermere* (detail)
Back cover: Thomas Rowlandson (1756–1827) *An artist travelling in Wales*
Frontispiece: Samuel Jackson (1794–1869) *A Sketching party in Leigh Woods* (detail of 53)

British Library Cataloguing in Publication Data
Clarke, Michael, *1952–*
 The tempting prospect.
 1. Water-color painting, English
 I. Title II. British Museum
 759.2 ND1928

 ISBN 0-7141-8016-5

Jacket designed by Patrick Yapp
layouts by Geoff Green

Set in Monophoto Bembo
and printed in Great Britain by
Jolly & Barber Ltd, Rugby

Contents

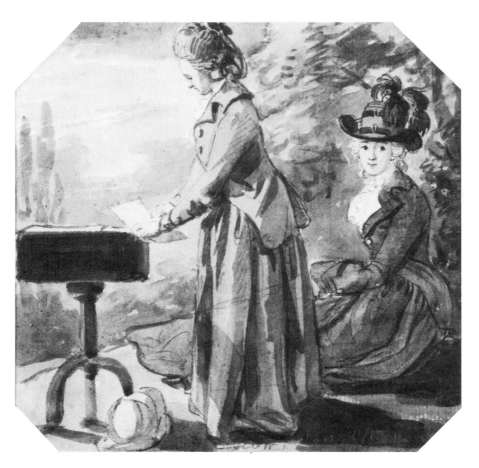

Paul Sandby (1730–1809) *Lady Frances Scott, drawing from a
camera obscura, with Lady Elliott, c.* 1770. Pencil and watercolour.

Preface

In this book I have endeavoured to sketch out, in a series of related and thematic chapters, the background to the growth of watercolours in this country. I have benefited greatly from the many recent publications on the subject but a special debt of gratitude is owed to Dr Michael Pidgley for his permission to quote from his very informative doctoral thesis on Cotman and his patrons. Dr Nicholas Penny and Lindsay Stainton have kindly read the typescript and corrected a number of errors; those that remain are entirely the author's responsibility. A number of individuals have given help in various ways and I would like to thank Judy Egerton, Dr Terry Friedman, John Ingamells, William Joll, Prue Seward, Tessa Sidey and the staff of the British Museum Print Room who have kindly allowed me unlimited access to the drawings in their care. At British Museum Publications Celia Clear enthusiastically set me on my way and my editor Jenny Chattington patiently tolerated the tardy arrival of my final draft and has been enormously helpful throughout. My thanks are also due to the public museums and galleries and private owners who have allowed me to reproduce works in their collections. I am indebted to Her Majesty The Queen for Her gracious permission to quote from the original of the *Farington Diary* at Windsor. Finally, to my wife Deborah I offer my admiration for her stamina in bearing with me during the writing of this book which I gratefully dedicate to her.

MICHAEL CLARKE
Todmorden, 1980

Introduction

'So', said he, 'because master Tom chuses to wash in dirty
water, ergo, this puppy, this ass, this driveller, and the rest
of the herd forsooth, must wash in dirty water too – yes,
by the Lord! and with the very puddle water, which he
has made more dirty!'
W. H. PYNE, *Somerset House Gazette . . .*, 1824

Taken out of context, Pyne's anecdote might be thought to touch on matters
of personal cleanliness; in fact, it refers to the technique used by the water-
colour artist Thomas Girtin (1775–1802) as described by Edward Dayes
(1763–1804), Girtin's former teacher. Dayes had apparently been shown a
portfolio of watercolour drawings by a pupil of Girtin's. In this case, washing
in dirty water had purely visual consequences; the watercolour washes used
by the pupil in question lacked clarity in Dayes's opinion. Pyne was writing
at a time when watercolours were extremely popular in England and un-
doubtedly assumed in the reader of his amusing story a familiarity with the
technique of watercolour painting and with something of the folklore associ-
ated with it.

William Henry Pyne (1769-1845) was a watercolour artist himself, and a
contemporary of Turner, Cotman, Cox, Varley, and of many other artists who
now, with the benefit of historical hindsight, are regarded as the finest of the
English watercolourists. In the same journal, the *Somerset House Gazette . . .*,
Pyne attempted his own explanation of the development of the English
watercolour school. He began a series of articles entitled 'The Rise and
Progress of watercolour painting in England' with a discussion of two of its
major exponents – Turner and Girtin:

Thus these two distinguished artists, improving rapidly, as by inspiration, whilst
young men, achieved the honour of founding that English school, as it now stands
recorded, the admiration of all nations.

Few would deny Turner and Girtin the greatness accorded to them by Pyne
but his judgement of their predecessors shows a decided lack of sympathy:

The efforts which have been made in the water-colour department of landscape and
watercolour painting, before the appearance of William Mallard [*sic*] Turner and
Thomas Girtin, amounted to little more than to produce correct views of abbeys,
castles, ancient towns and noblemen's seats.

Pyne, in his desire to promote his contemporaries, ignored the fact that
landscape watercolours had been executed in England for more than two
hundred years before he published his articles and, although these drawings
cannot rank with even mediocre Turners or Girtins in terms of artistic merit,
they do play a very important rôle in the history of English watercolour.

The tradition of painting landscapes in watercolour in England dates back
to the early years of the seventeenth century. One of the first authors to
instruct the early gentlemen amateurs on watercolour techniques and the

1 William Henry Pyne
(1769–1843) *Gossip at the
Cottage Door*, 1794. Pen,
ink and watercolour.

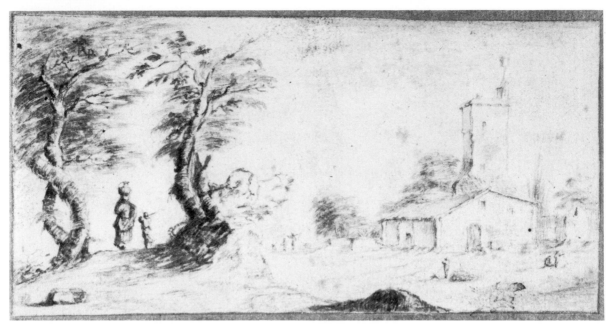

means of producing 'the prospecte of a well-wrought landscape' was Edward Norgate (1581–1650) in his treatise *Miniatura or the Art of Limning* (1649). The advantages of watercolour had already been stated by a teacher and author, Henry Peacham, in his book on education, *The Compleat Gentleman* in 1634: 'Beside, oyle nor oyle-colours, if they drop upon apparrell, wil not out; when watercolours will with the least washing'. The medium was further ennobled, 'since in other countries it is the practice of Princes, as I have shewed heretofore; also many of our young Nobilitie in England exercise the same with great felicitie'.

Painting in watercolour advanced from being merely an occasional pastime in the seventeenth century to become widely popular two hundred years later. It was improvements in the technology of the medium that, above all else, led to it being more generally practised. The colour in any type of paint derives from small, finely ground particles of pigment (e.g. ultramarine, ochre etc.) which are bound by the medium of the paint to the painting surface. These pigments, which can be organic or inorganic, give off their particular colour when struck by rays of light. With oil colours it is, of course, oil (usually linseed oil) which is used as the medium to bind the pigment particles to the surface. By contrast, 'watercolour' is a misleading term because it is not the water (which evaporates) which binds the pigments to the surface but a vegetable gum, usually gum arabic, which is derived from the acacia tree. Water, in fact, is used to spread and dilute the colour and, after evaporation, it is the gum arabic which binds the pigments to the surface. In what is rather mistakenly termed traditional watercolour painting the colour washes are transparent and the more the colour is diluted with water the more transparent is the resulting wash and the more the (usually) white surface of the paper shines through. There is another type of watercolour which is opaque and can more justifiably be nominated as the traditional watercolour. The opacity of this type of watercolour (sometimes called bodycolour or *gouache*) derives from the addition of opaque white (at first made from lead, later from

2 Prince Rupert (1619–92) *Landscape*. Black lead and wash. This drawing illustrates one of the many talents of Prince Rupert, who is best remembered today for his military exploits in the Royalist cause during the English Civil War.

3 Anthony Van Dyck (1599–1641) *Landscape with trees*. Pen and watercolour. Van Dyck settled permanently in England in 1632 and, although the question of his few landscape drawings is somewhat problematical, he was certainly one of the first artists to paint landscapes in watercolour in this country.

zinc oxide) which prevents light from passing through the gum arabic to the painting surface as it does in the transparent type of watercolour.

Prior to the seventeenth century both types of watercolour had been in use for activities as diverse as manuscript illumination, portrait miniatures and the colouring of maps and prints. Richard Haydocke, a physician who was interested in the arts, noted in his *Tracte Containing the Artes of Curious Painting* (1598) the differences between transparent and opaque watercolour: 'In washing with gummed colours, but tempered very thin and bodilesse, used in mappes, printed stories &c. And in Limning, where the colours are likewise mixed with gummes, but laied with a thick body and substance.' Washing and colouring prints and maps was not always to be encouraged, though, as one writer stated in 1666: 'For as much as Colouring Prints, and Maps, is of common use, and much Practised by the Gentry and Youths, who for want of knowledge therein, instead of making them better, quite spoyl them.'

In the seventeenth century, especially in the first half, watercolour was most frequently used for making miniature copies of larger works in oil, for miniature portraiture and for heraldic painting. At this time, and to some extent in the eighteenth century, the painter in miniature was known as a

'limner' (from the medieval Latin *illuminare* = to paint.) 'Washing' and 'limning' were the terms used up to the end of the seventeenth century to distinguish the two types of watercolour. The traditional 'limner' used the opaque colours.

When Peacham wrote his book on education in 1634 he talked of the medium of watercolour, but he did not imply it should be used, as later, for depicting landscape which was at this time a relatively rare art form in England. In fact, it was professional artists from abroad, such as the Flemish portrait painter Van Dyck (3) and the Czech topographer Wenceslaus Hollar, who by their example spread the practice of painting landscape watercolours in this country. Hollar and his English followers, like the north-countryman Francis Place, used pen, often in conjunction with simple washes of transparent watercolour, to depict the scenery they chose, or were commissioned, to illustrate.

The equipment of the early watercolour artists was relatively unsophisticated and it can be seen from the writings of authors such as Norgate that the small portable watercolour paintbox of today was unknown in the seventeenth century:

Your colour being dry, reserve it in cleane papers and boxes for your use, and when you will fall to worke take as much as will lie in a muscle shell (which of all others are fittest for limning or otherwise those of Mother Pearle).

Even earlier Nicholas Hilliard (1547–1617), the portrait miniaturist, had advised in his *The Arte of Limning*, written around the turn of the seventeenth century:

. . . the watter wel chossen or distilled most pure, as the water distilled from the watter of some clear spring . . . the goume to be goume arabeeke of the whitest and briclest, broken into whit pouder one a faire and cleare grinding stone, and whit sugar candy in like sort to be keept dry in boxes of iuory, the grinding stone of fine cristall serpentine, jasper or hard porfory . . . take heed of the dandrawe of the head sheading from the haire . . .

The materials for washing and limning were at first difficult to obtain, and this would seem to indicate that demand had outstripped supply. Alexander Browne, who taught drawing to Pepys's wife, advertised at the front of his *Ars Pictoria* (1669), 'Because it is very difficult to procure the Colours for Limning rightly prepared', that he had collected and manufactured suitable colours 'which are to be had at my Lodging in Long-Acre, at the Sign of the Pestel and Mortar, an Apothecary's Shop'.

The apothecary's shop, as opposed to the modern-day art supplier, was where all the early watercolourists had to go to obtain their raw materials. It is worth remembering that the Latin for both pigment and drug is the same, *pigmentum*, and this may partly explain why a physician, such as Richard Haydocke, should have been interested in painting. Sir Theodore Turquet de Mayerne, for whom Norgate wrote his *Miniatura*, was successively physician to Henry IV of France, and James I and Charles I of England.

Until the middle of the eighteenth century it was quite usual for the artist to prepare his own colours; grinding and washing them and then mixing his pigments with the requisite proportion of gum arabic. Whereas colourmen, that is sellers of prepared colour, had existed for the painter in oils in England since the middle of the seventeenth century, the 'watercolourman' did not

4 Peter Paul Rubens (1577–1640) *Sir Theodore Turquet de Mayerne (1573–1655)*. Black chalk, oils and wash.

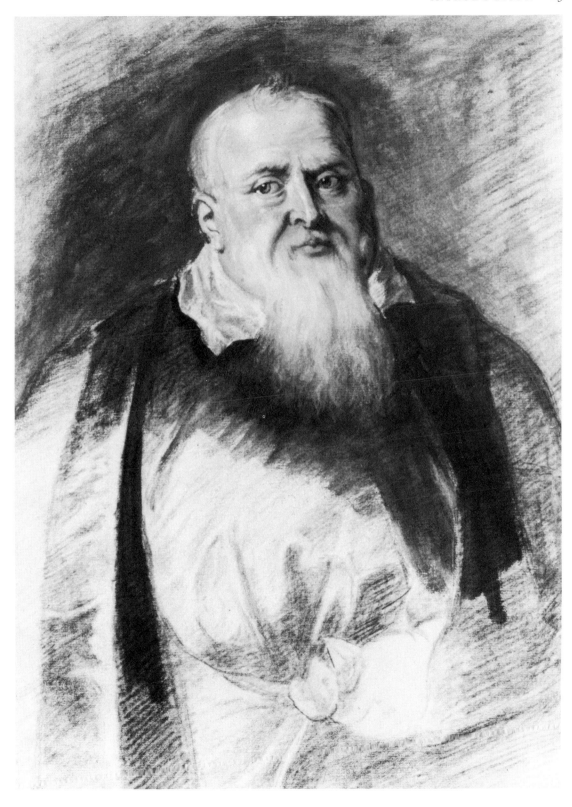

really come into existence until a hundred years later. Alexander Browne was the exception to the rule.

In 1811 the son of Paul Sandby (plate 3), who was one of the most important eighteenth-century watercolour artists, published a posthumous *Memoir* of his father in which he claimed 'that for many years after Mr Sandby commenced landscape drawing no colours were in general use except such as were peculiarly adapted for the staining of maps and plans, & indeed it was himself who first set Middleton the colour maker to prepare them in somewhat like their present state, & which are now brought to so great perfection by Reeves, Norman and others'. It is difficult to prove the accuracy or otherwise of this statement but is certainly true that advertisements for watercolour artists' materials appeared with increasing frequency in journals and newspapers in the later decades of the eighteenth century.

One such advertiser was John Middleton, who is mentioned in Sandby's *Memoir* and is known to have supplied materials to the portrait painter Sir Joshua Reynolds. The variety of his activities, and indeed of many suppliers of artists' materials, can be indicated by the fact that he was, at various times, recorded as also selling oiled umbrellas, wall-paper, riding-hoods, aprons and bathing-caps! Middleton was one of the first colourmen to market watercolours in cakes. The great advantages of these cakes, in which the pigment was mixed with gum arabic and honey or glycerine to prevent the cake drying out, were ease of use and improved quality of colour. No longer did the watercolour artist have to make his colours from raw materials; he could now buy them ready-made. They were also more portable and could easily be fitted into a box. Middleton published a price list for artists' materials in 1775 and, with camel-hair brushes at a penny and blacklead pencils at sixpence each, it can be seen that the equipment was not very expensive. This would undoubtedly have been a contributory factor towards the rise in popularity of the watercolour; it was relatively simple to use and it was inexpensive.

A more famous name in what amounted to a technical revolution in the development of watercolour towards the end of the eighteenth century was that of Reeves. Describing the achievements of the firm and reinforcing the statement made in Sandby's *Memoir*, a writer in *The Repository of Arts . . .* in 1813 observed: 'Until this period [1780], every artist was obliged to prepare his own colours.' The two brothers William and Thomas Reeves set up their business at the sign of the Blue Coat Boy and King's Arms, Holborn Bridge. In 1784 they quarrelled and divided the business, Thomas staying on at Holborn Bridge. Six years later disaster struck his shop, as the *Morning Herald* reported on 12 October:

. . . an overdrove ox ran into the shop of Mr Reeves, Colourman to Her Majesty, Holborn Bridge; broke the windows of the shop and knocked down the whole of the colours and stock; he was at last secured and taken to the slaughter house. He tossed two women in Holborn and bruised them in so dreadful a manner that they were conveyed to a hospital without hopes of recovery.

The technical advances made by Reeves and other colour manufacturers undoubtedly increased the popularity of watercolour painting, which reached its zenith in the early decades of the nineteenth century. The new materials were available in the provinces as well as in London. John Scott of 417 The Strand advertised in the *St James Chronicle*, 12–14 August 1788, as a 'Superfine Water-Colour Cake Preparer to her Majesty and the Royal Family'. His products were 'sold by the first Booksellers and Druggists in every provincial

5 ABOVE RIGHT The trade card of William Reeves.

6 BELOW RIGHT Advertisement for S. & I. Fuller, from the *Lady's Magazine*, August 1823. The interior of Fuller's premises, delightfully termed a 'Temple of Fancy', resembled those of a number of shops where drawing and watercolour materials, prints, books of instruction, watercolours and oil-paintings could be purchased.

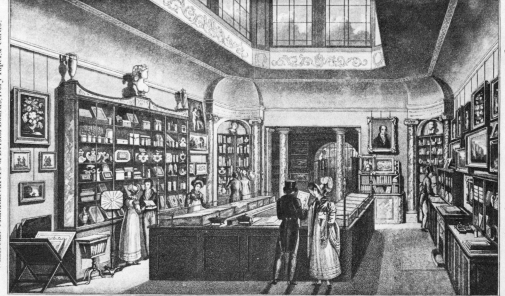

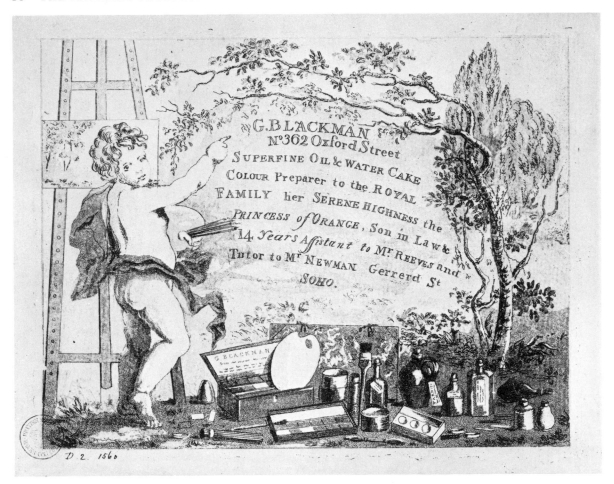

Town in the Kingdom . . .' One such bookseller was J. Todd of Stonegate, York, who advertised in the *York Courant*, 6 May 1783, 'Scott's Superfine Water Colours . . . prepared as in China, in Pots and Cakes'. The wide distribution of Scott's products can be gauged by the mention in Todd's advertisement 'of the following Book and Printsellers in the Country; Mr Crome, Liverpool; Mess Carrington and Co. and Mrs Walter, Deansgate, Manchester'. Scott's watercolours could be used for a wide variety of purposes as they were 'adapted for painting in Miniature, on Silk, for Signals, Fortifications or Landscape'. A considerable degree of competition amongst the various watercolour manufacturers is indicated by George Blackman's claim in the *Morning Herald*, 28 July 1790, that his watercolours were 'equal if not superior to those of Mr Reeves'. Blackman was a former assistant to William Reeves.

The next step in the technical development of watercolours was taken by William Winsor and H. C. Newton who, in the 1830s, devised moister colours in small pans which were easily fitted into sketching boxes. A sheet of foil was laid over the top of each pan to preserve the moisture more effectively than the traditional addition of honey or glycerine, though these were still used.

7 The trade card of George Blackman, 1802. A number of former apprentices to the firm of Reeves later provided competition for their previous masters. At the bottom of Blackman's trade card can be seen a box containing the cakes of watercolour that had first been developed in the late eighteenth century.

8 Wedgwood
jasperware paint chest
with small interior
containers for pigments
and a palette, *c.* 1785.
(The fittings are modern.)

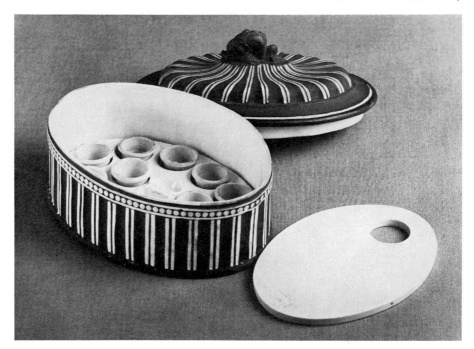

Finally, in about 1846, metal tubes containing moist watercolours were introduced by the firm of Winsor and Newton. These tubes of watercolour permitted the application of large patches of relatively dry colour at full saturation, thus giving watercolours much of the opacity and brilliancy of oil paints. Indeed, Sir Edward Burne-Jones (1833–98) frequently had to advise purchasers of his small-scale works whether they were executed in oils or watercolours, so difficult was it to tell the difference. One disadvantage of the new watercolour tubes was that, because they were made from lead, they were heavy and cumbersome and therefore not very suitable for outdoor sketching, for which purpose 'the old-fashioned *hard* cake colours' (David Cox's description) were still much used.

This was a far cry from the advice given by Nicholas Hilliard at the beginning of the seventeenth century, and the equipment provided for watercolour painters had immeasurably improved since his day. As early as 1732 J. Peele in the *The Art of Drawing, and Painting in Water-Colours* described and illustrated a portable paintbox 'about the Bigness of a Snuff-box, made of Ivory, about half an Inch thick', though it is worth pointing out that this box was produced for colouring in prints and not for the production of watercolour drawings. A paintbox advertised by Wedgwood in his catalogue of 1779 must have constituted a luxury item as it was manufactured in finely ornamented jasperware and was equipped with palettes and dishes for colours made in white stoneware. By 1800 mahogany boxes were in general use and in 1853 the Royal Society awarded a medal for a shilling colour box made out of japanned tin to J. Rogers of Bunhill Row. Eleven million of these boxes had been sold by 1870.

Not all aspects of the watercolourist's equipment required much development though. The finest brushes, which from the middle of the fifteenth century until about 1850 were called 'pencils', were always made from the

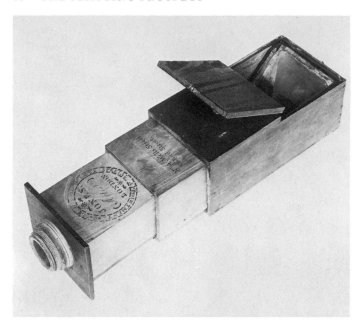

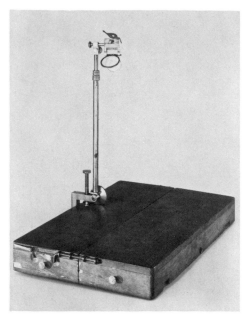

hair of the red sable and the best examples were manufactured in France. Cheaper brushes were made from camel's or, more frequently, squirrel's hair. The broader the brush the better the wash it could apply, though a broad brush could be brought to a fine point by placing it in the mouth, licking it and giving it a slight twist.

Optical drawing instruments, designed to aid the artist recording landscape and the intricacies of architecture, were in relatively widespread use by the end of the eighteenth century. Their ancestor, the *camera obscura* (from the Latin meaning 'a dark room') was developed in the sixteenth century as a drawing device for artists whereby an image was transmitted through a series of lenses onto the sheet of paper on which the artist was to draw. Smaller and more portable versions of the camera obscura were produced in the eighteenth century and a variety of artists are known to have had recourse to one. The great Italian view-painter Canaletto, the Daniells, active in India, Thomas Sandby and Thomas Gainsborough are but a few of the artists who can be cited in this respect. The potential of such an instrument was realised in more efficient versions of the camera obscura which were produced by two men in the early nineteenth century. Dr W. Hyde Wollaston's (1766–1828) *camera lucida* was patented in 1807. It was cheap, small and portable and had a wider field of vision than its predecessor. Four years later the watercolour artist Cornelius Varley (1781–1873) patented his 'Graphic Telescope' which, apart from its compactness of shape, allowed greater facility for adjustment. Several drawings executed with it bear inscriptions such as *Power 2* or *Power 5*.

The inventions of the late eighteenth and first half of the nineteenth centuries sometimes bordered on the ridiculous. In the *Art Union*, January 1842, 'Spilsbury's Water-Colour Preservative' was advertised. This remarkable substance, it was claimed, 'will render Water-Colour Drawings capable of being washed with Soap and Water, and so impervious to dirt, that ink may be spilled upon them and washed again without leaving stain'. The sole agents were Reeves and Sons of 150 Cheapside. One can only hope that the

9 ABOVE LEFT Camera obscura made by Jones (Artist) London. The earliest (*c.* 1700) of the portable drawing instruments that were available in England, the camera obscura projected an image via the lens at the front onto a glass screen at the back over which a sheet of thin drawing paper was placed.

10 ABOVE Portable drawing outfit (camera lucida) with a drawing-board. William Hyde Wollaston patented his camera lucida in 1807. The image is transferred via a prism onto a drawing surface below. An adjustable eye hole over the prism allows both the object to be drawn and the artist's hand to be seen at the same time.

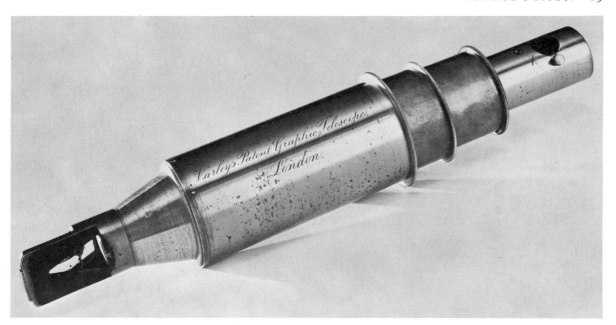

11 Cornelius Varley's Patent Graphic Telescope. Varley (1781–1873) patented his telescope on 5 April 1811. Its main advantage over the camera lucida was its power of magnification (up to × 19 according to the specification).

effectiveness of Spilsbury's miraculous varnish was not put to the test too frequently!

At the time when Spilsbury advertised his preservative it was widely accepted that watercolour was generally used for landscape painting. In direct contrast, a charming seventeenth-century drawing of a pollard oak near West Hampnett Place, Chichester (12) by John Dunstall is an early and rare example of a landscape executed in watercolour. Dunstall probably came from Sussex; he was established in the Strand in London in the 1660s as 'a small professor & teacher of drawings', and died in 1693. His drawing is executed in relatively old-fashioned materials: opaque watercolours on vellum. Vellum, that is fine parchment, was the traditional painting surface for the manuscript illuminators of the Middle Ages. Paper was not widely available in Europe until the fourteenth century and, while it was adopted fairly quickly on the Continent, it was slower to come into general use in England as a drawing surface. (The first known paper mill in England was that established by John Tate about 1490 near Stevenage in Hertfordshire.) Until the invention of machine-made paper in the early nineteenth century all paper was hand-made from boiled rags and linen which, after being reduced to a white pulp by boiling and starching, were carefully laid onto flat moulds and then, usually after being pressed, were allowed to dry. The resulting sheets of paper, at first of relatively small dimensions, were then usually covered with a thin layer of vegetable glue or size which, when it had dried, would prevent ink, washes or watercolours from sinking into the paper with the effect of ink on blotting paper. The major drawback of traditional hand-made fine quality paper as far as watercolour was concerned was that, watercolour being an essentially transparent medium, the lines of the wires of the mould in which the paper was made tended to show through. In the 1780s James Whatman devised a 'wove' watercolour paper which dispensed with the 'chain lines' of the traditional paper and gave a much more even and smooth surface to draw and colour on.

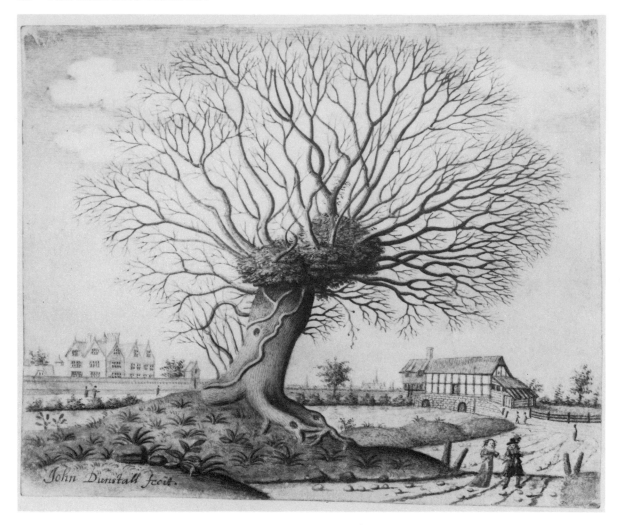

Returning to the seventeenth century, John Dunstall was using materials that were soon to be outmoded, although his method follows exactly that described in many treatises of his day. Little is known of his early life, although, interestingly, he did write a number of manuals on drawing, but even his relative obscurity seems to be typical of the few, largely anonymous professional watercolourists in England in the middle of the seventeenth century. This conservative, yet possibly very representative, drawing by Dunstall stands at the beginning of the development in England of a new branch of art – that of the landscape watercolour.

12 John Dunstall (d. 1693) *A pollard oak near West Hampnett Place, Chichester*. Watercolour over black lead, touched with white on the figures, on vellum. The costumes of the figures can be dated to about 1660.

1 The Prospect

The prospect was so tempting, that I could not forbeare to
designe it with my Crayon.
JOHN EVELYN, *Diary*, 30 September 1644

The diarist John Evelyn (1620–1706) was one of the first amateurs to draw
landscape, and the view that so entranced him was of the Jesuits' College and
the castle at Tournon in the south of France. Although few amateurs' efforts
survive from that period, the mere fact that Evelyn chose to record his
sketching activity is indicative of an awakening interest in landscape.

The appearance of landscape art in seventeenth-century England can be
likened to the grafting of a new branch onto the rather sickly tree that
constituted English art of the period. That branch did not properly bear fruit
until the eighteenth century, in the form of paintings and watercolours by
artists such as Richard Wilson, Paul Sandby and John Robert Cozens. By that
date, however, the branch had forked in two directions – the 'ideal' landscape
on the one hand, the 'topographical' on the other. As far as the early
development of the landscape watercolour is concerned, it is the topographical
branch, that is the recording of an actual view, which is best followed. For
travellers and for the curious, visual records of faraway places could only be
made in the form of drawings, which could later be either washed in with
colours or be used as the basis for engraved or etched views, as indeed was
Evelyn's view of *Naples from Mt Vesuvius* (13).

The novelty of landscape in seventeenth-century England can be gauged
from Norgate's reaction to it. For him it was 'an art so new in England, and so
lately come a shore, as all the Language within our four seas cannot find it a
Name, but a borrowed one ["landscape" from the Dutch *Landschap*] and that
from a people that are noe great Lenders but upon good Securitie, the Duch.
Perhaps they will name their own Child. For to say the truth the Art is theirs.'

An increasing number of Dutch artists visited England in the seventeenth
century. They came to record, in their landscape drawings, views of a country
which lay along one of the growing number of Dutch trade routes. Their
drawings formed the basis for printed views of the countries they visited,
views which were incorporated in books of travel which were bought by
readers on the Continent. In one sense the predecessor of these drawings was
the map. While the accuracy and visual embellishments of these maps varied,
they shared one basic concern with early landscape drawings – they were
utilitarian and intended to show the lie of the land, the size and layouts of
cities. The enjoyment their perusal afforded was aptly described by Robert
Burton in his *Anatomy of Melancholy*, published in 1621: 'What greater
pleasure can there be than to view those elaborate Maps of *Ortelius, Mercator,
Hondius &c.* To peruse those bookes of Citties, put out by *Braunus*, and
Hogenbergius.'

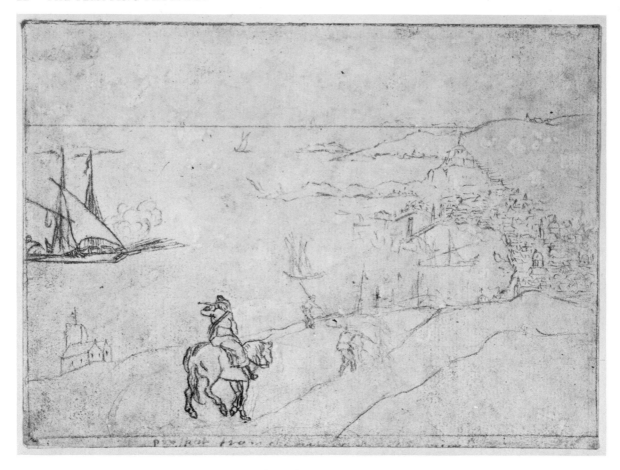

Englishmen like Norgate who observed landscape coming 'a shore' were probably thinking of the paintings purchased by Charles I and collectors in the court circle, such as Lord Arundel. There is little mention in English sources of three Dutch artists who travelled in England shortly after the middle of the seventeenth century making drawings of towns such as Bath, Exeter and Winchester. These three artists, Willem Schellinks (1627–78), Lambert Doomer (1622/3–1700) and Jacob Esselens (1626–82) had been specifically commissioned by the Amsterdam bibliophile Laurens van der Hem (1621–78) to visit England to make landscape drawings or 'prospects' of towns in England which, on their return to the Low Countries, they were to make up into fully finished drawings, coloured in monochrome wash and sometimes watercolour. These English drawings formed one of the forty-six volumes of drawings and maps of other countries which Van Der Hem collected. The resulting Van Der Hem Atlas is now in the National Library in Vienna but some of the preparatory drawings are in the British Museum (plate 1). Comparing early English prospects by artists such as Francis Place (plate 2) and William Lodge with these Dutch drawings clearly demonstrates the debt which early English landscape owes to them. The drawings were taken at some distance from the towns and cities they were intended to depict, and they encompass, if not all-embracing, at least very comprehensive views of their subjects. The prospect, once it became established, was

13 John Evelyn (1620–1706) *Naples from Mount Vesuvius.* Pencil and red chalk. The subject of this drawing by the celebrated diarist is described in an entry for 7 February 1645: 'Turning our faces towards Naples, it presents one of the goodliest prospects in the world'.

a tradition which continued in English art right into the nineteenth century.

Foreign topographers had visited England before the trio of artists working on commission for Van Der Hem. A number of the royal palaces such as those of Whitehall, Hampton Court, Greenwich and Windsor had been drawn between 1558 and 1562 by the Brussels artist Anthonis van den Wyngaerde, possibly in connection with the visit of Philip II of Spain to England in 1557. Approximately one decade later Joris von Hoefnagel of Antwerp had produced views of Windsor, Oxford and Nonesuch for Braun and Hogenberg's monumental series of printed views *Civitatis orbis terrarum* (1572–1618). Even earlier in date were the drawings, executed by unknown draughtsmen about 1520–30, of Dover and Calais which were possibly connected with Henry VIII's new coastal defence system and the work of his military engineers. These early works were, however, primarily concerned with London and the royal palaces. Van Der Hem's employees broadened the scope of foreign enquiry, travelling as far afield as Exeter and Falmouth. Indeed, the extent of their travels must have made considerable demands on their stamina. For Schellinks England was only one country in an itinerary which included France, Italy, Sicily, Malta, Germany and Switzerland. He visited all these countries between July 1661 and August 1665.

The gathering of information was, in essence, the prime function of these early topographers. It was only later, in the relatively sophisticated climate of the eighteenth century, that a more aesthetic response to nature was developed. By the same token it was not until the later years of that century that watercolours or, one might say, the adornment of what had previously been mere 'tinted drawings' were executed by a large number of artists both professional and amateur. One has to return to the seventeenth century, however, to find the man who, in terms of landscape, can generally be regarded as the founder of the English school, and that man was a foreigner.

Wenceslaus Hollar (1607–77), born in Prague, was primarily a printmaker. Etching was his favourite technique and landscape his favourite subject. Preparatory to these prints he executed landscape drawings, and a number of these he later coloured with watercolour washes. He spent most of his working life in England, having been brought there by a curious chain of events.

In 1636 Thomas Howard, Lord Arundel, travelled by coach and barge through Germany on his way to meet Ferdinand II, Emperor of the Germans. Arundel's mission, to negotiate a treaty to end the Thirty Years War, proved unsuccessful. Amongst Arundel's entourage were William Crowne, a youth employed by Arundel to keep a diary of the Embassy, and Dr William Harvey, the noted physician who first correctly charted the circulation of the blood in the human body, and whose presence in the party was due to his desire (which was granted him) to meet the Nuremberg physician Hoffmann. The desolation of the countryside was recorded by Crowne in a number of entries in his *Diary* (printed in 1637): 'From Cologne to Frankfurt all the towns, villages and castles are battered, pillaged and burnt and every one of our halts we remained on board, every man taking his turn on guard duty.'

It was in Cologne that Arundel met Hollar and engaged him to join his ambassadorial party in the capacity of topographical draughtsman. The appointment was noted, somewhat laconically, by Arundel in a letter written from Nuremberg to the Rev. William Petty, his well-tried agent for the purchase of works of art abroad: 'I hope I shall see yu shortly at Lintz. I have

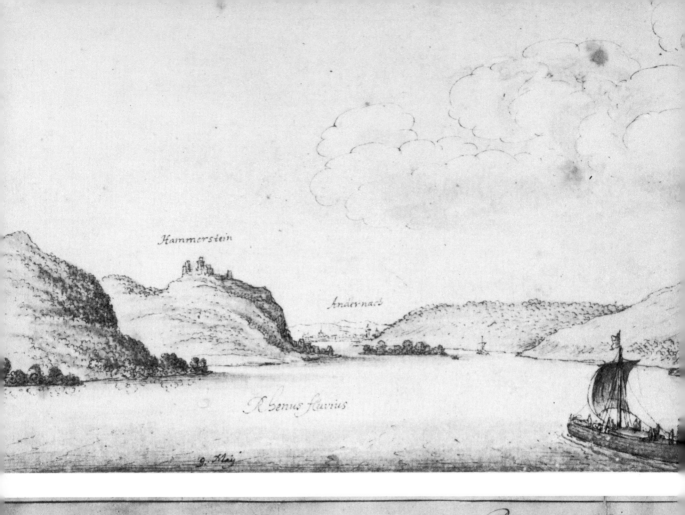

Hammerstein

Andernacs

Rhenus fluvius

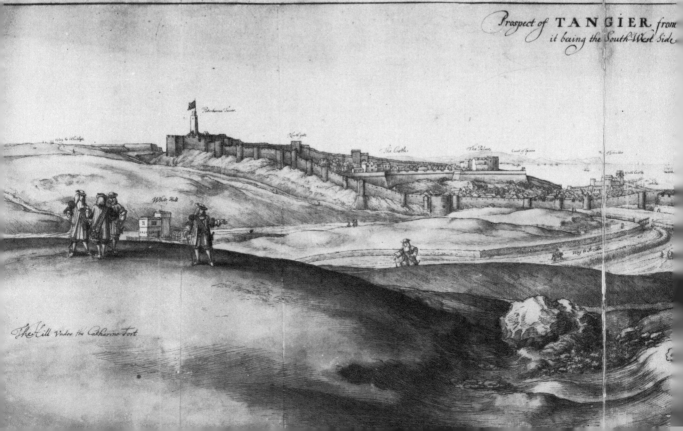

Prospect of TANGIER *from it being the South West Side*

Peterborow Tower

The Castle

The Palace

White Hall

The Hill Under the Catharine Fort

Reineck

14 Wenceslaus Hollar (1607–77) *Rheineck from the North-West*. Pen and ink with blue-grey wash. In the foreground is Lord Arundel's barge flying a flag with the cross of St George; on the right is the castle of Rheineck and to the left the ruins of Hammerstein with Andernach in the distance.

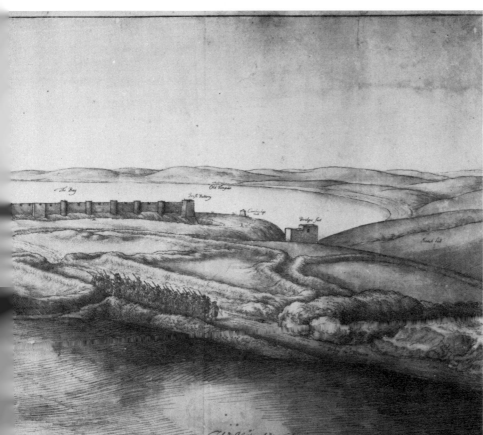

15 Wenceslaus Hollar (1607–77) *Tangier from the South-West*, 1669. Pen and ink with grey wash and watercolour.

one Hollarse w^th me, whoe drawes and eches printes in strong water quickely, and w^th a pretty spiritte.'

To a man like Arundel, who had patronised both Van Dyck and Rubens and whose art collection included works by Holbein and antique sculpture from Greece, the employment of Hollar must have seemed a matter of relatively small consequence. For Hollar, of course, the reverse would have been the case. He was guaranteed employment in what was a relatively low-paid profession and, until the outbreak of the English Civil War, he was free from financial worries. The entries in Crowne's *Diary* form a literary parallel to the images recorded by Hollar: 'Weighing anchor early next morning, we sailed past an island where there is a nunnery called NONNEWERTHER (NONNENWERTH) and so on by HAMMERSTEIN castle.' When the party arrived at Hammerstein Castle skirmishing was still taking place, but seventeenth-century diplomacy triumphed:

Passage was willingly granted, both sides interrupting the fight. The general in the town, making preparation to entertain His Excellency, caused the gate to be opened in readiness for His Excellency's entrance, but the forces in the castle immediately fired a cannon to the great danger of the town defenders, who now took cover until His Excellency actually appeared at the gate.

The drawings which Hollar executed for Arundel fulfilled very much the same function as those executed for Van Der Hem – they recorded a foreign country. In that sense they anticipated the countless drawings executed by English artists in subsequent centuries (see Chapter Three).

When Arundel returned home Hollar accompanied him, and in England he was employed by his patron to make etchings of the treasures in Arundel's collection and to 'finish' his drawings made on the Embassy. He was lodged, at first, in Arundel's house on the Strand. He married a 'waiting woman' of Lady Alathea, Countess of Arundel and, presumably through Arundel, became known at the Court of Charles I, where he was appointed drawing-master to the Prince of Wales, the future Charles II.

With the onset of the Civil War Hollar's fortunes took a downward turn and in 1644 he left England for Antwerp, a sanctuary for self-exiled members of the Royalist nobility, and did not return to England until 1652. His patron Arundel had died in Padua six years before and, once back in England, Hollar was detained for a short while on account of suspected Royalist sympathies. From now until his death twenty-five years later Hollar was in constant financial difficulties. With no assured source of income he was at the mercy of London print publishers such as Peter Stent and John Ogilby who paid him by the hour for engraving book illustrations. In 1666 he was appointed 'King's scenographer or designer of Prospects' and the following year received a grant of fifty pounds. This must have seemed a welcome windfall, for the Plague and the Fire of London had decreased his sources of patronage.

Apart from prospects of London and its surrounding areas Hollar had also drawn and etched views of English castles and abbeys. His last major voyage was made in 1668 to the North African colony of Tangier, which had been received by the English crown as the dowry of Charles II's Portuguese bride, Catherine of Braganza. An expedition under Lord Henry Howard, Arundel's grandson, was despatched to inspect the newly acquired territory and to contact the Moorish King El Rashid II Fafiletta. Hollar was sent to draw and map the country and stayed there one and a half years. His voyage back to England was enlivened by an attack by Algerian pirate ships, which was

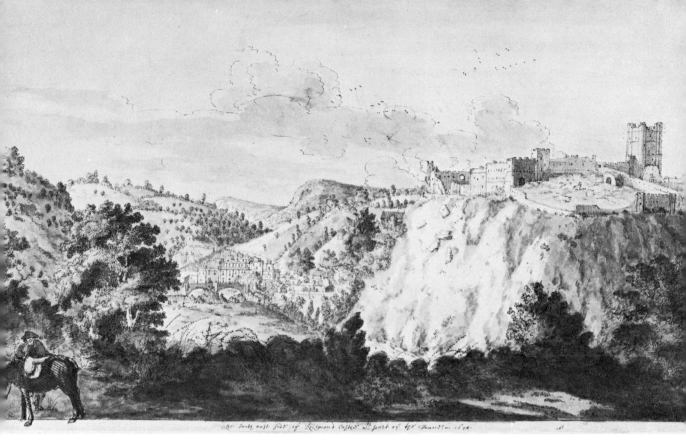

after back east ffoot of Richmond Castle wt part of ye towne in 1674.

16 Francis Place
(1647–1728) *Richmond
Castle from the South-East*,
1674. Pen and ink with
grey wash, the foliage
tinted in green. The
drawing displays a
tentative use of
watercolour in a prospect-
like composition with the
charming addition of a
man standing by his
horse.

successfully repulsed. The Treasury was reluctant to pay Hollar for his work and he finally had to settle for the sum of a hundred pounds.

Hollar died in distressed circumstances in Gardiner's Lane, Westminster. The bailiff apparently threatened to seize possession of what little he owned. Immensely hard working and yet abandoned by his aristocratic patrons and exploited by his publishers, Hollar's fortunes could hardly be said to forecast a glowing future for the topographical artist in England. His own directions to his biographer John Aubrey make rather pathetic reading: 'If you have occasion to ask for mee, the people of the house, then you must say the Frenchman limner, for they know not my name perfectly, for reason's sake; otherwise you may goe up directly' (*Aubrey's Brief Lives*).

By a strange coincidence Hollar's most distinguished English follower, Francis Place (1647–1728), began his professional life as a student of law – exactly the same career that Hollar's father had intended for his son. There the similarities in their professional fortunes end, for Place was an amateur who had grown up in reasonably affluent surroundings in the family's manor house at Dinsdale, County Durham. Vertue commented that 'he [Place] had means enough to live on' and 'passed his time at ease, being a sociable and pleasant Companion much beloved by the Gentry'.

Place's circle of acquaintances was wide, and included not only peers such as Lord Halifax, but merchants like Ralph Thoresby of Leeds, craftsmen such as the glass-painter Henry Gyles of York and the physician Dr Martin Lister. These three, with Place, were members of a group, comparable to other gatherings in Edinburgh and London, called the York Virtuosi. They met in the 1680s in Gyles's house in York for purely sociable reasons and to discuss topics ranging over a broad spectrum from science to art. A 'virtuoso', a

curiously difficult word to define, was a gentleman-scholar, a man with broad interests in all aspects of the world around him. As such an activity was predominantly a male prerogative it came under attack from Mary Astell in *An Essay in Defense of the Female Sex* (1696) in which she ridiculed what she felt to be the indiscriminate collecting activities of the virtuosi: 'He values a *Camelion*, or *Salamander's Egg*, above all the Sugars and Spices of the West and *East-Indies* . . . To what purpose is it, that these Gentlemen ransack all Parts of *Earth* and *Sea* to procure these *Triffles*?' One of the York Virtuosi, Ralph Thoresby, formed an extremely varied collection of objects at Leeds and to this 'museum' Place donated, amongst other things, Indian arrows, a shark's fin and the porphyry on which he ground his colours.

Place was, therefore, part of the new spirit of enquiry that flourished after the restoration of the monarchy in 1660, exemplified by the founding of the Royal Society of Arts in that same year. There was, too, a widespread and increasingly well-informed interest in history. The antiquarian Sir William Dugdale noted in 1655: 'Man without learninge and the remembrance of thinges past falls into a beastlye sottishnesse and his life is noe better to be accounted of than to be buryed alive.' Dugdale was the most famous of the new class of scholarly patrons under whom Hollar had had to seek employment on his return to England from Antwerp. Just as he had illustrated the treasures of Lord Arundel's collection, so he provided illustrations for Dugdale's publications, such as his monumental history of monastic institutions in England, the *Monasticon*, the first volume of which appeared in 1665. This publication was, in some ways, the forerunner of the numerous eighteenth-century topographical publications.

Francis Place, although he did produce work for some of the London print publishers, was free to pursue his own interests as he chose. His activities included pottery, illustration, mezzotint (a recently invented printmaking process), collecting prints and drawings and drawing landscape. This last interest stemmed partly from the same spirit of historical enquiry which motivated men like Dugdale. An inveterate traveller, Place visited Ireland in 1698 and notes which he compiled on the history of that country were probably made in connection with his travels there. His views of York, where he had settled by 1692, were finally published in 1736 in Francis Drake's history of that city, *Eboracum*, and his etched illustrations (based on the author's drawings) for a travel book, Jan Nieuhof's *Embassy to China*, are further evidence of the educated nature of much of the topographical illustration of the time. Nieuhof's book was published in 1669 and Place shared the task of illustration with Hollar. The two men would first have met some time after Place had travelled to London, aged seventeen or eighteen, to study law at Lincoln's Inn Fields. Place later recalled of Hollar that 'he was a person I was intimately acquainted withal, but never his disciple nor anybody else's, which was my misfortune'.

Referred to by several of his friends as 'the ingenious Mr Francis Place', his basic conception of landscape – the long, flat prospect executed in pen, wash and occasionally the limited use of watercolour – was undoubtedly shaped by Hollar and by Dutch landscape drawings. By the time he travelled to Ireland in 1698 Place had consistently begun to use watercolour washes in his work and in that sense can be regarded as one of the first artists of the English watercolour school, as far as landscape is concerned. But such a conclusion can only be reached with historical hindsight. Outside his admittedly broad circle

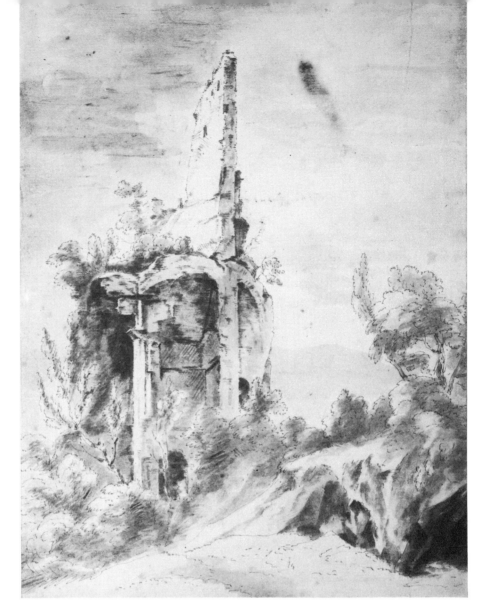

17 Thomas Manby (1633?–95) *Ruins of Hadrian's Villa.* Pen and ink with grey wash. Manby was one of the first English artists to draw the ruins and landscape of Italy and this drawing may have been in Place's collection.

of friends Place's art would have remained relatively unknown. His landscape drawings were never exhibited or sold and remained for generations with his descendants. That there was some interest in collecting landscape drawings in Place's lifetime can be seen from the few facts which are known about Place's own collection, which included drawings by continental artists and by Thomas Manby (1633–95), an artist who, according to one source, 'had been several times in Italy', probably in connection with the buying of pictures there.

Although he remained essentially an amateur, in many respects Place's career as a landscape artist presents a microcosm of the profession of the topographical artist as it was to emerge in the eighteenth century. London, as the capital city, was the centre for acquiring knowledge and experience. The printsellers and publishers of topographical prints provided a major source of patronage. Travel, symptomatic of a growing interest in this country, provided the means of experiencing new scenery.

Place was a frequent traveller, his last recorded trip being from York to Hull when he was seventy-five years old. His voyages abroad were probably limited to France and the Low Countries but at home, apart from his Irish journey in 1698, he is known to have visited the Isle of Wight, the north-east coast of England, the West Country, Scotland and Wales. According to a rather suspect account by Vertue (he also locates the incident in Derbyshire) it was on his Welsh tour of 1678, the year of the 'Popish plot', that Place was temporarily arrested and imprisoned as a spy.

Many of Place's journeys to more out-of-the-way localities must have been made on horseback, but travel to London and other major centres would have been greatly facilitated by the advent of the stage coach, which appeared in England in the first half of the seventeenth century. This advance in comfort would have been offset by the condition of the major roads which, due to the increase in traffic, sadly deteriorated. A series of ineffectual acts passed in the seventeenth and eighteenth centuries tried to regulate the effects of countless wheels, horses and heavy loads on the rutted and often extremely muddy highways of Britain. The situation was eased somewhat by the end of the 1700s due to the improvements in road technology, such as proper drainage and development of load-bearing sub-bases. The modernisation of Britain's road system was slow and haphazard, however, and virtually ceased with the introduction of the railway in the nineteenth century. It remains a sobering thought that generations of travellers and artists from Place onwards had to endure such great discomfort in travelling but persevered nonetheless. Indeed, with the coming of the railway in the nineteenth century something sacred in the experience of travelling seemed, to many, to have been lost. John Ruskin, for one, complained: 'Going by railway I do not consider as travel at all, it is merely being "sent" to a place, and very little different from becoming a parcel' (*Modern Painters*, vol. III, 1856).

Ruskin's outcry would not, one feels, have been shared by the Buck brothers, Samuel (1696–1779) and Nathaniel (fl. 1727–after 1753), two eighteenth-century topographers *par excellence* who published their numerous engraved prospects of the towns and cities of Great Britain between 1720 and 1753. Their preparatory drawings for their engravings were executed in monochrome wash only so they were not, strictly speaking, watercolourists, but their manner of production provides an interesting insight into the 'industry' into which the prospect developed. In March 1745 they announced from their London address of 'No. 1 Garden-Court, Middle-Temple', the impending production of six engravings of York, Hull, Scarborough, Leeds, Sheffield and Ripon – a convenient itinerary, in effect, for a previous summer's sketching. The engravings would not be ready until April and the delay was, they stated, due to 'The Badness of the Season having not only prolong'd their Time in taking the said Drawings, but prevented their waiting on many Gentlemen, who probably might have been Subscribers'. Such seasonal considerations and frequent difficulty of travel were to remain constant factors to the activities of the growing number of landscape draughtsmen in England in the eighteenth century.

2 Travellers at Home

– And shall we suppose it a greater pleasure to the
sportsman to pursue a trivial animal, than it is to the man
of taste to pursue the beauties of nature?
 REV. WILLIAM GILPIN, *Three Essays . . .*, 1792

By the end of the 1700s many of the areas of Great Britain still considered
beautiful today had become accustomed to annual summer incursions of
parties of visitors spurred on by the writings of men like the Rev. Gilpin and
by countless guide-books which were published during those years. In Jane
Austen's early work, *Love and Freindship* (from *Juvenilia* 1790–3), Laura,
recounting how she had been met by Augusta, relates:

She told me that having a considerable taste for the Beauties of Nature, her
curiosity to behold the delightful scenes it exhibited in that part of the World had
been so much raised by Gilpin's Tour to the Highlands, that she had prevailed on
her Father to undertake a Tour to Scotland and had persuaded Lady Dorothea to
accompany them.

There is almost a wearied ring to some of the contemporary opinions raised
on the subject of touring. Thus in Joseph Budworth's *Fortnight's Ramble to the
Lakes* (1792) one reads: 'It is now so meritoriously the fashion to make this
tour I dare almost say it will be thought want of taste not to be able to speak
about it.' Fourteen years earlier the *Monthly Magazine* had proclaimed: 'To
make the Tour of the Lakes, to speak in fashionable languages is the *ton* of the
present hour.'

 Scottish impatience with tourists would appear to have predated that of
their southern neighbours. In 1773 Lord Breadalbane observed:

We have had a great deal of company here this summer, sixteen often at table for
several days together; many of them from England, some of whom I knew
before, and others recommended to me, being on a tour through the Highlands
which is becoming *Le bon ton*, but sometimes a little troublesome. Being always in
a crowd is not agreeable. (Holloway and Errington *The Discovery of Scotland*)

 The brush and pencil accompanied many of these tourists whether they
were merely enthusiastic amateurs or professionals seeking to mine an increas-
ingly popular and lucrative vein of subject-matter. W. H. Pyne observed in
1815:

The rage for making tours which has so long distinguished the British people has
increased for several years until it has become the prevailing taste of the higher
families to explore the country in search of the picturesque. Numerous portfolios
are filled every summer with topographical studies made by amateurs, as well as
artists during these excursions. (*Etchings of Rustic Figures for the Embellishment of
Landscape*)

The image came to be seen as essential to the description of such activities.
Gilpin's friend and correspondent Canon William Mason (1724–97), in a

letter of 13 June 1772, endorsed the provision of sketches in Gilpin's manu-
script of his *magnum opus, Observations on the Lakes . . .* (1786): 'whereas verbal
ones only are never sufficient for me, insomuch that tho I have Mr Grays
[Thomas Gray the poet] acct of this very tour by me at present, I find a
constant want of accompanying sketches'. And by 1805, when *The Works of
the late Edward Dayes* was published, one finds the aspirant artist-traveller
advised that:

. . . his travelling should be the enlargement of his ideas; and go where he may, this
should be his primary object, both by reference to works of art, and to those of
Nature. To this end, the sketch-book should always be at hand, to enable him to
make each beauty that may occur his own; otherwise they may escape his
recollection.

One of the major attractions of touring in Great Britain, apart from 'curing
the evil itch of over-valuing fforeign parts', as Celia Fiennes put it, was the
relatively low cost when compared to that of making the Grand Tour on the
Continent. It can also be no coincidence that touring in Great Britain should
have reached new heights of popularity in the 1790s, when continental travel
was severely limited by the upheavals following the French Revolution and,
later, by the rise to power of Napoleon.

There were other equally important reasons, however, for the growing
attraction of the native countryside. The private carriage, the post-chaise and
the mail-coach immeasurably increased the traffic between Britain's major
centres. Arthur Young, in his *Northern Tour* of 1770, proclaimed that the
turnpike at Shap on the top of the Pennines was 'very good', although the
road at Greta Bridge (later immortalised by Cotman) was 'very rough and
broken'. C. Gray, in the text of a drawing-book illustrated with etchings by
W. H. Pyne and published in 1806, noted, in a nationalistic vein:

Stage-coaches, which are now extending themselves in one shape or another, to the
most remote parts of our island, have, combined with good roads, very much
tended to promote that universal intercourse, for which Great Britain stands the
first in Europe, or on the face of the earth.

As the enclosure movement and its partitioning-off of vast tracts of
hitherto open land gathered pace in the eighteenth century it must have
seemed to the traveller that man's control over the countryside spread ever
wider. Early-eighteenth-century writers such as Celia Fiennes and Daniel
Defoe demonstrated in their tours of Britain an essentially non-visual ap-
proach to the countryside they journeyed through. Mindful, no doubt, of the
destruction and halt to progress caused by the Civil War, they took especial
delight in signs of industry and agriculture. They were interested in the
economic achievement of contemporary Britain though, especially in the case
of Defoe, they were not above liberally spicing their accounts with historical
anecdote. This 'prosperity' approach differed markedly from the antiquarian
travels and exploration of historical monuments of men like Dugdale in the
seventeenth century and the Rev. William Stukeley in the eighteenth. Both
attitudes, however, had a significant effect on the aesthetic approach to nature
that subsequently developed.

As the merchant plied his trade between centres, or the families of the
gentry visited neighbours, spa-towns or the county race-week, they must
have felt increasingly at home in their immediate surroundings and the more
adventurous would have been tempted to venture farther afield to the

mountainous regions that were, on the whole, economically unproductive yet offered visual and physical challenges. Their 'sublimity' – that is, their ability to move the spectator to awe or pity – accorded well with contemporary aesthetic thought. Nestling in the valleys and by the rivers of many of these regions were the ruins of mediaeval monasteries and abbeys (plates 4, 5). The antiquarian interest, therefore, provided an added incentive to visit such outlandish parts of the country, and not only were these ruins part of national history, they were increasingly viewed as 'picturesque', as Gilpin noted (*Three Essays . . .* 1792):

But among all the objects of art, the picturesque eye is perhaps most inquisitive after the elegant relics of ancient architecture; the ruined tower, the Gothic arch, the remains of castles and abbeys. These are the richest legacies of art. They are consecrated by time; and almost deserve the veneration we pay to the works of nature itself.

The etymology of the word 'picturesque' is varied and complex. It derives from the Italian *pittoresco* ('from a picture') and, when first applied to the forms of nature, denoted an object or view as worthy of being included in a picture. The canon for judging 'picturesqueness' was provided by seventeenth-century Italian landscape, the works of Claude Lorrain, Gaspard and Nicolas Poussin, and Salvator Rosa. The truly picturesque tourist equipped himself with the appropriate guide-books, sketching-pads and a selection of viewing glasses, the best-known of which was the 'Claude glass', so named after the landscape painter, which was capable of giving a bluish cast to far distances – as found in the master's paintings. The glass itself was a slightly convex mirror, four inches in diameter, backed with black foil and cased like a pocket-book. Thomas West, author of the very popular *Guide to the Lakes* (first published 1778) advised:

The person using it ought always to turn his back to the object that he views . . . It should be suspended by the upper part of the case, holding it a little to the right or left (as the position of the parts to be viewed requires) and the face screened from the sun.

A selection of glasses was produced, including one named after the poet Thomas Gray, and the whole activity was satirised by the Rev. James

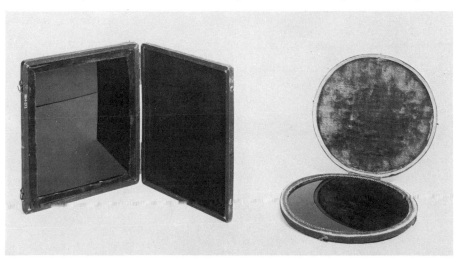

18 Two Claude glasses. The low-key reflections produced by the glass were thought to resemble the landscape effects found in the paintings of the seventeenth-century artist Claude Lorrain. The glass itself was essentially a slightly convex blackened mirror, though silvered mirrors were used on days too dark for the blackened kind.

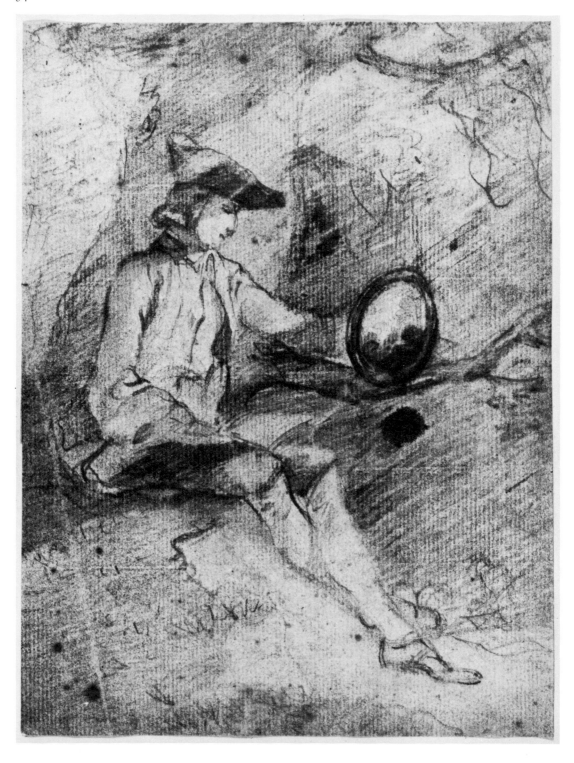

19 Thomas Gainsborough (1727–88) *Study of a man sketching using a Claude glass, c.* 1750–5. Pencil.

Plumptre in his comic opera *The Lakers* of 1798. Confronted with the view across Derwentwater to Borrowdale, Miss Beccabunga Veronica exclaims: 'Where is my Gray? Oh! Claude and Poussin are nothing. By the bye, where's my Claude-Lorraine? I must throw a Gilpin tint over these magic scenes of beauty.' The characters of the Rev. Plumptre's satire, although exaggerated, illustrate how the process of looking at nature had to be learned from scratch. It was not enough to express pure admiration, one had to justify enthusiasm by reference to the art of the past. If a scene did not conform it could, to varying degrees, be altered, as Miss Veronica recalled:

I have only made it picturesque. I have only given the hills an Alpine form, and put some wood where it is wanted, and omitted it where it is not wanted: and who could put that sham church and that house into a picture? It quite *antipathizes*. I don't like meretricious ornaments . . . so I have made the church an abbey, the house a castle, and the battery an hermitage . . .

Not all landscape was so drastically 'improved', however, and generally the professional artists who drew and painted such scenes remained faithful to nature's original, though they frequently embellished their compositions with Claudean framing trees and branches.

By the end of the eighteenth century artists, almost without exception, found a journey to the Lakes or North Wales obligatory and many ventured farther afield. The sketches made on these trips would serve as the raw material sometimes for decades of future work. Subjects which proved especially popular could be repeated as required. But to illustrate just how closely bound watercolour artists came to be to the 'touring routes' of the enlightened traveller one can turn to a non-professional artist, albeit of a professional standard.

John White Abbott (1763–1851) of Exeter was essentially an amateur. During the earlier part of his career he practised as an apothecary and surgeon and was, therefore, largely unconcerned with the commercial (as opposed to critical) value of his work. As far as is known he made only one extensive sketching tour outside his native county of Devon. This journey took place in the summer of 1791 and White Abbott's itinerary, which can be largely reconstructed from surviving watercolours, shows that he visited nearly all of the accepted regions of beauty of his time. From a visual point of view it was his own 'Grand Tour' of Britain. Travelling north he reached York by mid-June and only a week later he was sketching in Leith in Scotland. By the eighth of July he had begun a week's tour of the Lakes, after which he travelled south via Liverpool to Dovedale in Derbyshire and then towards home, returning via Warwick Castle and Glastonbury. Scotland, The Lakes, Lancashire, Derbyshire and Warwickshire are the regions he is known to have visited; the only glaring omission would appear to be that of Wales, especially the northern part of that country.

White Abbott's tour coincided with the great period of touring when most of the Rev. Gilpin's *Tours* of Great Britain had been published and acted as added stimuli to traveller and artist alike. Joseph Farington's *Views of the Lakes, etc, in Cumberland and Westmorland*, for example, was published in 1789, only three years after Gilpin's own book on the beauties of the Lakes. It is not so easy, however, to determine exactly when particular regions began to become popular with the public and with artists. Did the interests of the former precede the latter, or vice versa? On the whole it would appear that artists followed after the general trends set by summer tourists. Lord Breadalbane's

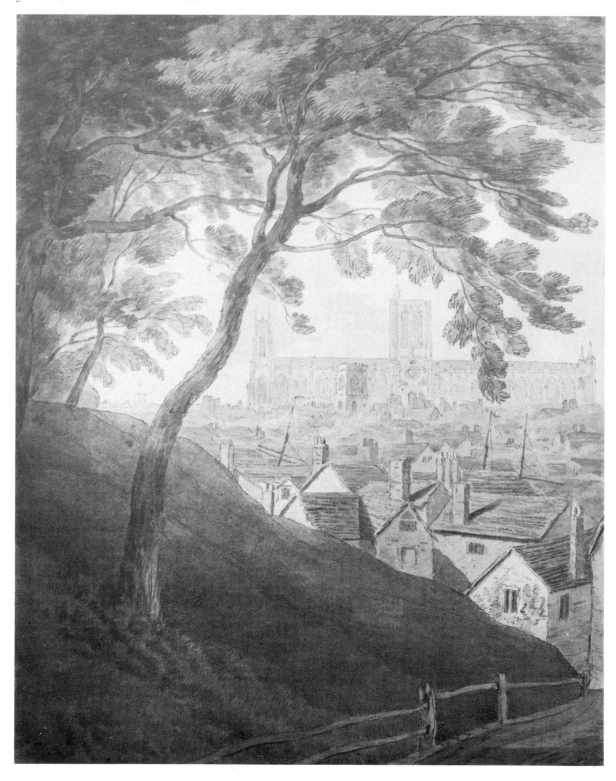

complaints (quoted above) at the excess of tourists in Scotland were made in 1773, when Scotland could hardly be claimed to have been fully exploited or publicised in visual terms, and as early as 1759 he had written to his daughter from Taymouth: 'It had been the fashion this year to travel into the highlands, many have been here this summer from England. I suppose because they can't go abroad.' Although Paul Sandby had been sketching in Scotland in the late 1740s and early 1750s it was not until 1778 that his Scottish views were reproduced in printed format and therefore available for wide circulation. Of course, there had been early landscape sketches of mountainous scenery made by artists in Britain but only on a very limited scale.

The Peak District, for example, would appear to have been one of the earliest regions to be so explored. The engraver George Vertue, to whose note-books we are so indebted, recorded having seen a pocket-book of Derbyshire sketches 'much in imitation of Salvator's manner' by Philip Boul who was a subscriber to Kneller's Academy in 1711, and the Netherlandish artist Jan Siberechts' (1627–c. 1700) *View of Beeley, near Chatsworth* is signed and dated *22 Augusti 1694* (21). It is not known why Boul was visiting Derbyshire but Siberechts was probably acting 'on commission', as he enjoyed considerable employment as a topographer of country houses. Continuing from Siberechts, it can be seen that in a number of cases the pattern of artistic exploration of the wilder parts of Britain was determined, and often initiated, by patrons and not by the artists themselves.

The patrons had many and varied interests. They included the antiquarian and naturalist Thomas Pennant (1726–98), the zoologist and botanist Sir Joseph Banks (1743–1820) and Sir Watkin Williams-Wynn (1749–89), collector, patron and amateur artist. The topographical artists who accompanied such men recorded the scenery they passed through and, on occasion, gave instruction to their patrons. (Much the same phenomenon occurred with regard to tourists abroad.) Although the sketches and subsequent prints that some of these artists (such as Paul Sandby) made are highly admired today, these patrons would generally have regarded their artistic companions as nothing more exalted in social rank than hired professionals. Pennant even went so far as to describe his faithful travelling artist Moses Griffith (1747–1819) as his 'worthy servant' though the following extract from a letter, written just before Pennant's second Scottish tour of 1772, may serve to explain some of his apparent highhandedness with regard to artists: 'By the usual folly and desultoriness of artists I am disappointed of my landscape painter at a moments notice.' The offending artist was William Tomkins (c. 1730–92) and it was as a result of Tomkins' defection that Griffith was employed on the tour, not only to depict antiquities and landscape but also to draw items of botanical interest as illustrations to Pennant's books on natural history.

The ancestral home at Wynnstay, south-west of Wrexham, was the starting point for a tour of North Wales undertaken by Sir Watkin Williams-Wynn with Paul Sandby in the late summer of 1771. Sandby is known to have acted as drawing-master to Sir Watkin in the previous year, as the Wynnstay account-book for 10 July 1770 states: 'Pd Mr Sandby for 46 lessons in Drawing, sketches in black chalk and painting masks £20–9–6d'. The accounts for 28 June 1771 read: 'Pd Mr Sandby for 3 drawings 40 Days loss of time in Wales at 2 Guineas per Day, Teaching as p Bill £150–0–od'. The '40 Days loss of time' probably refers to an unpaid bill from the previous year.

21 Jan Siberechts
(1627–c. 1700) *View of
Beeley, near Chatsworth.*
Watercolour and
bodycolour touched with
white. On settling in
England (possibly in 1674)
Siberechts, a painter from
Antwerp who had
formerly specialised in
pastoral and genre scenes,
concentrated on
landscape.

22 Thomas Hearne
(1744–1817) *Sir Joseph
Banks Bt.* Pencil.

23 Moses Griffith (1747–1819) *Hill with ruined tower and several figures*. Pen and watercolour. Inscribed *6 June, 1777*, this as yet unidentified drawing dates from a northern tour (primarily of Yorkshire) undertaken by Griffith with his patron Thomas Pennant, May–June 1777. The figures are probably members of the touring party.

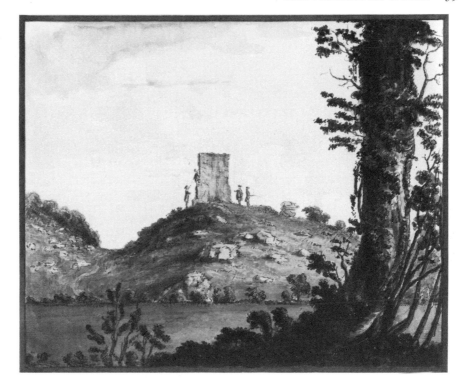

24 OVERLEAF LEFT Paul Sandby (1730–1809) *An artist sketching in Snowdonia*. Pencil and watercolour. This probably illustrates an incident from the 1771 tour. The artist in the drawing could be either Sandby or Sir Watkin Williams-Wynn.

25 OVERLEAF RIGHT Paul Sandby (1730–1809) *Chepstow Castle in Monmouthshire*. Etching and aquatint. The first print from Sandby's series of aquatints *Views in South Wales* (1774–5), based on drawings made on his tour of Wales in 1773 with Sir Joseph Banks and others. Some of the touring party are probably depicted in the foreground.

One hundred and fifty pounds must have been a considerable sum to Sandby. In 1768 he had been appointed drawing-master at the Royal Military Academy at Woolwich at a salary of one hundred pounds per annum, though his duties were light and constituted only one day's teaching a week.

The 1771 tour, which lasted two weeks, included visits to Dolgelly, Llanberis, Conway and Holywell and was undertaken in a clockwise direction. North Wales was just on the doorstep, as it were, and the purpose of the journey, apart from the social aspect, was a deliberate search for scenery for teacher and pupil to draw. Even when due allowance is made for the relative geographical convenience of the tour, 1771 was a very early date for a patron to take a party of friends and a visiting artist to view such wild scenery. The Rev. Gilpin's tour of the Wye, although undertaken in 1770, was not published until 1782.

The drawings and watercolours Sandby made in 1771 formed the basis for his first series of Welsh aquatints, dedicated to Sir Watkin and published in 1776. By the time Sandby had published his fourth set of Welsh views in 1786 he had drawn on his experience of North Wales for a total of twenty-five aquatints.

In the *Memoir* of his father, Sandby's son recalled:

He also travelled with Sir Joseph Banks, the later Dr Solander and Mr Lightfoot, upon a tour to the principality; and this journey he ever after remembered with the fondest delight, having experienced from Sir Jos. Banks an attention and kindness, which called forth in him the highest feeling of respect and affection for his liberal patron and worthy friend.

Whereas the Williams-Wynn tour was clearly prearranged with the picturesque in mind, the Banks tour of 1773 concentrated more on coastal areas

of interest to the botanist, although the mountains of North Wales were also visited. Again Sandby used his drawings as the basis for aquatints (published in 1775) and, as with the earlier Welsh tour, the order of the prints clearly reflected the routes the travellers had taken. Nothing is known of the financial arrangement between Banks and Sandby, although his son's account points to a particularly happy relationship between the two men.

Sandby was undoubtedly the most successful topographical artist of his day and his services were in higher demand than those of lesser men. Equally, his prints were of far greater artistic interest than the majority of pedestrian engravings and etchings of castles, abbeys and town prospects, and they would have whetted the appetites of artists and travellers alike. The inevitable ties between watercolours and printmaking had been drawn closer by the introduction into England of the aquatint process, which Sandby had been the first to use with any great success in this country. Prior to this there had only been the linear printmaking techniques of engraving and etching which were unable, unlike aquatint, to suggest the delicate wash qualities of watercolours. There was also, according to the engraver and publisher John Boydell (1719–1804), a dearth of sufficiently competent landscape engravers fit to reproduce many of the efforts of the eighteenth-century watercolourists. Although it had been used in very limited form in the seventeenth century, aquatint was first fully developed in 1768–9 by a French artist J. B. Le Prince (1734-81). In the aquatint process small particles of resin are deposited on the printing plate which, when immersed in a bath of acid, protect the area of the plate they cover from the *mordant* or biting action of the acid. The effect of a print produced in this manner is of a grainy texture, the tones of which can be darkened by reimmersing the plate in the acid. The areas which are to remain light in tone are protected from further biting of the acid by covering them with stopping-out varnish. Sandby modified the aquatint technique by employing a sugar-lift process, 'whereby marks were brushed onto the plate with a mixture of Indian ink and sugar, and then covered with the varnish. On its immersion in water the solution will rise, lifting off the varnish and exposing the brush marks.' (This description is taken from Richard T. Godfrey, *Printmaking in Britain*, 1978.)

The rise in popularity of the aquatint was swift and by the end of the eighteenth century it had been employed in many major publications. It was also suited to the increasing number of illustrated drawing-books which were being produced. W. H. Pyne, reviewing John Varley's *Treatise on the Principles of Landscape Design . . .* (1823) in the *Somerset House Gazette*, wrote of the advantages of aquatint: 'and here it may be observed, that amateurs, who wish to obtain to those indispensable qualities in landscape drawing, flatness of washing, and distinctiveness of masses, cannot adopt a readier method than by carefuly copying from the best aquatinta prints'. The wheel turned full circle in that the print imitated the drawing and was then used as a means of instruction for producing drawings.

Sandby's interest in, and ability to depict, hitherto little-known scenes were in no small part due to the early years of his career. At the age of eleven, in 1741, he joined the Board of Ordnance Drawing Room at the Tower of London. Five years later the Jacobite rising was ruthlessly put down at Culloden. Almost immediately the English set about a programme of re-inforcing the security of their position in Scotland. Barracks were repaired and rebuilt, garrisons reinforced, roads constructed, and a detailed survey of

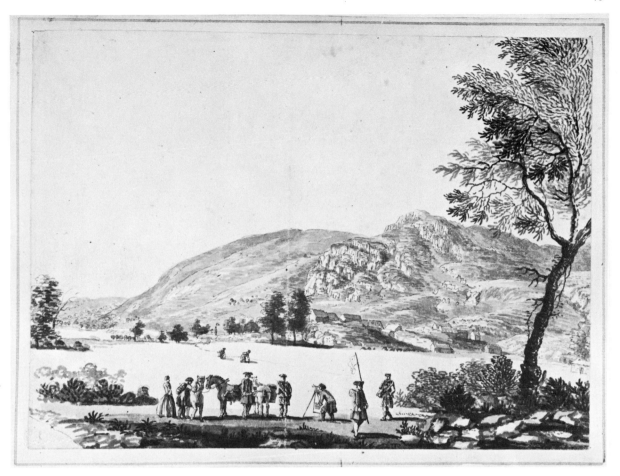

26 Paul Sandby
(1730–1809) *Survey Party
at Kinloch Rannoch*, 1749.
Pen, ink and watercolour.

the Highlands was begun in 1747. Sandby, as a trained topographical draughts-man, was probably in Edinburgh by early 1747 and one of his main tasks was to prepare the first draft of a large map of the north of Scotland based on information provided by surveying parties in the field. Occasionally he accompanied the survey team in the country and witnessed scenes such as that depicted in his watercolour, based on a sketch made on the spot in 1749, of a *Survey party at Kinloch Rannoch, Perthshire* (26). Apart from the opportunities his work afforded him of sketching the landscape, there was a technical link between Sandby's work as a cartographical draughtsman and as a landscape artist, for the conventional colours of ordnance maps – blue-green for water and yellow for land – could also be used in his landscape views.

Sandby visited more of Scotland than any previous English or Scottish artist and through his circle of friends there attracted other commissions. One delighted patron was James Ferguson, steward of the Duke of Queensberry's estate at Drumlanrig, who wrote:

He [Sandby] has made several drawings of the house and policy which I am persuaded you will be much pleased with. I was with him last week in Dumfries but the weather was so bad it was impossible for him to do anything material there . . . (*The Discovery of Scotland*)

Sandby's Scottish drawings were known and discussed long after he left

Scotland and men such as Pennant and the antiquarian Captain Francis Grose exchanged drawings by Sandby amongst themselves. Although he did not publish prints of Scotland until 1778, his sketches made in Scotland were later reinterpreted by him in watercolours of subjects such as Bothwell Castle which Sandby exhibited to London audiences at the Royal Academy. The Scottish prints, which first appeared in a publication called *The Virtuosi's Museum*, differed from the earlier drawings in that they deliberately emphasised the 'folk' character of the Highlands – the mountains appeared as more dramatic, and kilted onlookers were inserted. This change is symptomatic of the growth of public interest in such scenery and also of its commercial potential. By this date, too, one is entering into the 'age of Gilpin' (whose writings and letters are extensively quoted in C. P. Barbier's scholarly biography).

The Rev. William Gilpin (1724–1804) was born at Scaleby Castle, educated at Carlisle and St Bees School and in 1740 went up to the Queen's College, Oxford, to study for the ministry. After holding several curacies he became Master of Cheam School, Surrey, for twenty-five years, thereafter retiring to the living of Boldre in the New Forest where he built a Poor House and model school for the poorer parishioners. His charitable instincts and a desire to raise more funds for his school led him to sell his drawings at Christie's on 6 May 1802.

These drawings had been made in connection with the large number of

27 Rev. William Gilpin (1724–1804) *A Lake Scene*. Pen and wash on yellow paper. Gilpin's drawings were nearly all executed in monochrome and were not intended to be topographically accurate.

28 Richard Earlom (1743–1822) *Landscape with Narcissus, after Claude Lorrain*. Mezzotint. Claude's book of drawings the *Liber Veritatis*, records of his major paintings, was engraved in mezzotint by Earlom and prints such as these would have made the compositions of Claude available to wider audiences.

tours which he undertook from 1768 onwards. He was responsible, more than any other writer, for producing a new kind of travel literature – the picturesque tour. In his own words, Gilpin's basic conception of the picturesque was 'a term expressive of that peculiar kind of beauty, which is agreeable in a picture'. He, and many other tourists, would have frequently seen pictures, including landscapes by the Old Masters, in the course of their visits to country houses. In 1769, for example, Gilpin visited Norfolk principally for the purpose of examining Lord Orford's pictures at Houghton. The picturesque tourist could, and did, step from the picture-galleries of country houses out on to the terraces and was there able to compare the efforts of nature to the supposedly more exalted ones of the masters of the past. If a visit to a country house proved impractical engravings reproducing the masterpieces hanging there could be purchased at the nearest print- and bookshop, and the compositions of Claude, Gaspard and Salvator Rosa could be viewed in the prints of men like François Vivares, Arthur Pond or Richard Earlom. Indeed, Gilpin's first publication, published in 1768, was entitled *An Essay on Prints*.

Between 1768 and 1776 Gilpin undertook, in the summer months, a formidable range of excursions. His tours encompassed (in chronological order) Kent, East Anglia, the River Wye and South Wales, Cumberland, Westmorland and the Lakes, North Wales, the south coast of England, the west of England and the Highlands of Scotland. Travelling during the day he

would jot down what he called his 'Rough Thoughts' and at the end of each day these were more formally arranged into narrative accounts and sketches which would be reordered and polished during the autumn and winter at Cheam. His preoccupations during these travels were neatly expressed in a letter of 1789:

If you had seen as many lakes, and mountains as I have seen, they would put everything else out of your head. For my own part, whenever I sit down with a pencil and paper before me, ideas of rocks, and mountains and lakes always crowd into my head.

The crucial word in that letter is 'ideas'. Gilpin was not interested in a literal topographical account of what he had seen. As William Mason complained of Gilpin's *Wye Tour*, published in 1783: 'If a Voyager down the river Wye takes out your Book, his very Boatman crys out, "nay Sr you may look in vain there, no body can find one Picture in it the least like."'

Nevertheless, the book sold extremely well, although the early editions of Gilpin's works, and they were frequently republished, quickly sold out because they were printed in such small numbers. A critic in the *Monthly Review* complained of the first edition of the *Observations on the Lakes of Cumberland and Westmorland* (1786) that it had 'eluded the vigilance of our collector by the rapidity of its sale, the whole impression having been bought up in a few days'.

The 'landscape of ideas' was not one that was universally adopted by watercolour artists, although Alexander Cozens (*c.* 1717–86), 'blot master to the town', can be cited as the most successful of a group of watercolour artists in the eighteenth century who created landscapes that were unconcerned with literal truth to nature. Far more common were topographical watercolours produced for private patrons and, with a slowly increasing frequency that was finally to lead to the formation of watercolour exhibiting societies after 1800, for public exhibition. The uncertain status of these early watercolours is reflected in the descriptions given to them by the exhibiting artists. Whereas Paul Sandby, who was well in advance of his time, exhibited 'Three Landskips: in watercolours' at the first exhibition of the Society of Artists in London in 1760 and was the only watercolourist to be a founder member of the Royal Academy, Edward Dayes was still referring to his own watercolours as 'tinted drawings' in 1790.

The status of the watercolour was not a question that would have occupied the Rev. Gilpin. The majority of his drawings were produced in monochrome wash, later to be transformed when his tours were published into aquatint prints by a small team of artists. Gilpin's use of watercolour was infrequent, but by far the most interesting instance of this came in 1782 when he was encouraged by one of the many lady amateurs who sought his advice on drawing matters to try the new watercolours manufactured by the firm of Reeves: 'I have tryed these colours and find them of such excellent temper that they almost paint of themselves. For the present at least, I have relinquished my stained paper.' The attractions of the recent advances in the manufacture of watercolour could not be better illustrated and Gilpin even acquired a box of Reeves' watercolours for his own use. Comparing the new watercolours to the old he listed their advantages:

We procured them of colour-men, tempered, some in one way, and some in another. They never mixed harmoniously. Some were glazed: others sank into the

29 ABOVE LEFT
Alexander Cozens (*c.* 1717–86), plate 16 from Cozens's *A New Method of Assisting the Invention in Drawing Original Compositions of Landscape*, n.d. (1785). Aquatint. Cozens advocated the creation of imaginative landscapes based on both accidental and deliberate blots of ink on a sheet of paper which could then be elaborated by the artist.

30 LEFT Joseph Wright of Derby (1734–97) *Blot drawing in the manner of A. Cozens, c.* 1786–8. Ink. Wright had been interested in Cozens's landscape style since the 1770s so it is not surprising to find him using the 'blot' technique expounded by Cozens (cf. 29).

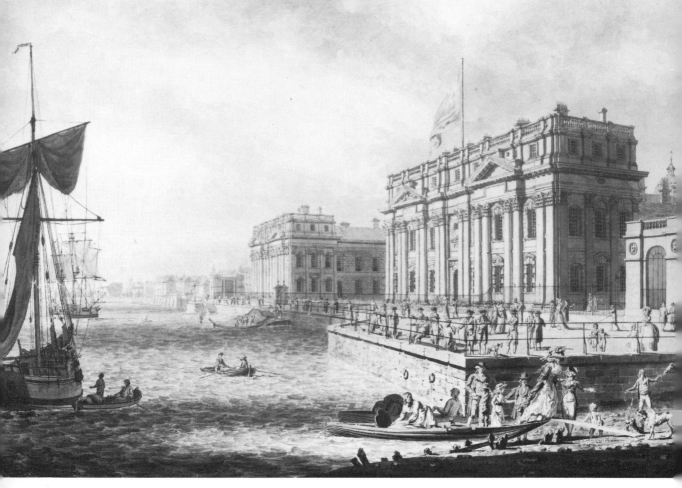

paper. There was no unity among them. But now you have all the colours you want, tempered exactly in the same way; and working with the greatest ease.

Shortly afterwards, however, Gilpin gave up using watercolours and admitted to Mason:

I must leave colours to the heaven-born geniuses . . . I think I can form some judgement of the harmony of colouring when I see it on a picture . . . but how to make reds, & greens, & greys dance into that harmony myself, I am utterly ignorant.

Thirty years later Gilpin, if he had still been alive, would have been able to choose from an ever-increasing number of published books of instruction in the use of watercolour. Those watercolours would have illustrated subjects he had been largely instrumental in making popular in his published tours. His writings, although they soon came to be satirised (most famously in Thomas Rowlandson's (1756–1827) illustrations for the *Tour of Dr Syntax in search of the Picturesque*) were regarded as valuable text-books in the art of looking at nature and his words can be matched up with any number of works produced by 'heaven-born geniuses'. Thomas Girtin's watercolour of *The Gorge of Wathenlath with the Falls of Lodore, Derwentwater*, for example, could almost serve as an illustration of the feelings the same scenery evoked in Gilpin in 1772 (see 33):

31 Edward Dayes (1763–1804) *Greenwich Hospital, London*, 1789. Pen, ink and watercolour.

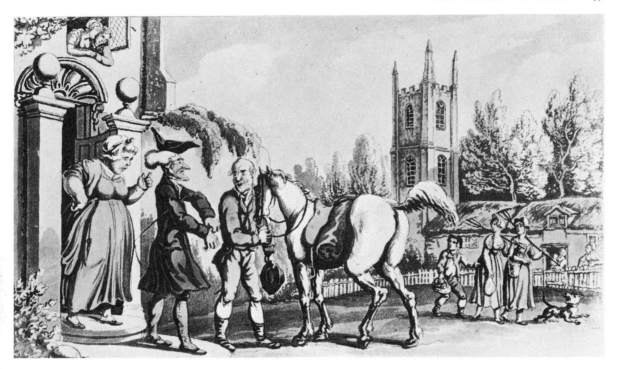

32 Thomas Rowlandson
(1756–1827) *Dr Syntax
setting out on his Tour to the
Lakes*. Hand-coloured
aquatint illustration from
*The Tour of Doctor Syntax
In Search Of the
Picturesque. A Poem*, text
by William Combe,
London, 1812.

Which way to Watenlath? said one of our company to a peasant, as we left the vale of Borrodale. 'That way,' said he, pointing up a lofty mountain, steeper than the tiling of a house. To those who are accustomed to mountains these perpendicular motions may be amusing . . . to see our companions below *clinging*, as it appeared, to the mountain's side; and the rising breasts and bellies of their horses, straining up a path so steep, that it seemed, as if the least false step would have carried them many hundred yards to the bottom.

Landscape became the dominant subject-matter in watercolour, so much so that it could be accused of offering a lack of variety to the spectator. Reviewing the summer watercolour exhibitions in London in *The Repository of Arts . . .*, June 1810, a critic complained:

The first thing that strikes an observer, both at Spring-gardens and Bond-street, is, the overwhelming proportion of landscapes; a proportion almost as unreasonable as that of the portraits at Somerset-House. In pacing round the rooms, the spectator experiences sensations somewhat similar to those of an outside passenger on a mail coach making a picturesque and picturising journey to the north. Mountains and cataracts, rivers, lakes and woods, deep romantic glens, and sublime sweeps of country, engage his eye in endless and ever-varying succession.

Here, then, was the scenery admired by countless picturesque travellers transformed into drawings, executed in the ever-improving watercolour paints and exhibited as fine art objects in the capital city. The professional artists who created these watercolours had to plan their sketch-gathering journeys along the routes of the stage or the mail-coach. Unless they were in the employment of a patron they had to budget their travels with care. One of the most systematic artists in this respect was Turner, who compiled lists of the places to be visited with notes of the intervening distances. According to one account quoted by Jack Lindsay in his biography of the artist:

33 Thomas Girtin (1775–1802) *The Gorge of Wathenlath with the Falls of Lodore, Derwentwater, Cumberland*. Pencil, pen and watercolour. Possibly executed in 1801, Girtin may have revisited the Lake District in the spring of that year.

He once told a friend that in some of his early rambles the price of the drawing – thirty pounds – did not pay for the expenses; whereupon he took to a broader, quicker style. Travelling for Mr Cadell it is reported that he declined to saddle the publisher with the expenses of a post-chaise, but took the ordinary mail coach.

Even when he had attained financial security Turner did not abandon his thrifty ways and the following note appears in a sketchbook he took with him on a visit to the Fawkes family at Farnley Hall, Yorkshire, in 1826:

Porterage, 2s.8d., Fare to Leeds £2.2s. Coachman 1s., Dinner at Eaton 5s.6d., Coachman – Scrooby, 1s.6d., Ditto 7s., Breakfast at Doncaster 2s.3d., Brandy & water, Grantham, 1s.6d., Coachman & Guard, 4s.6d., Total £3.2s.11d.

Not all artists were as careful as Turner. In 1798 Girtin undertook his first visit to North Wales. He was, as he told the artist and diarist Joseph Farington, accompanied by 'a young man from Norwich of the name of Moss – Girtin had no money, so Moss advanced him £20, and afterwards £5 more, all of which he expended, as he bore half the expenses with Moss, excepting for carriage horses and servant!' (*Diary*, 24 October) Rather more pathetic in tone was a letter from Samuel Palmer (1805–81), written on a tour of North Wales in 1835 to his friend, the artist George Richmond, in which he requested the loan of three pounds: – 'Had I conceived how much it would cost I would as soon have started for the United States as Wales'.

Turner's working for the publisher Cadell is just one of the innumerable instances of artists journeying throughout Britain to sketch native scenery which, in the form of folios of prints, could be sold to a public educated on the writings of Gilpin and other authors. A manuscript diary for 1798 kept by Edward Dayes, now in the Victoria and Albert Museum, reveals another source of income to have been the production of finished views in oils or watercolour based on sketches made on the spot. A typical entry is that for Friday, 13 April: 'Made two small views of Hagley and Pauslwalden for Walker'. Such views were made in large quantities and in rapid succession – three to four days were usually sufficient to begin and complete such pictures. Dayes had higher pretensions than mere view-making and devoted much more time to his 'historical drawings' such as that of *A Drawing of the fall of the Angels fm. Milton*, one of three such serious compositions he completed in 1798. He also contributed to the genre of travel-writing founded effectively by Gilpin. In 1803 he composed *An Excursion through the Principal Parts of Derbyshire and Yorkshire*, which was published posthumously in the *Works* of 1805. In the foreword Dayes indicated that scenery could be appreciated just as much for the opportunities it offered the draughtsman as for the aesthetic pleasure that it gave:

The lover of drawing, in particular, will be highly gratified: he will occasionally visit scenery as romantic as any in North Wales; water-falls of the very first character; religious houses, which for preservation and extent, are unrivalled; and castles, highly picturesque!

The sort of subject-matter listed by Dayes remained the staple diet of the watercolour artist, though nearly every reasonably accessible region of Britain came under the scrutiny of the pencil and the brush in a constant search to vary the jaded diet the watercolour exhibitions appeared to offer. And in the field of printed publications, too, new regions were explored. Based on his drawings and watercolours, William Daniell's (1769–1837) monumental

34 David Cox
(1783–1859) *Watermill,
Bettws-y-Coed*, 1849.
Watercolour.

series of three hundred and eight coloured aquatints, *Voyage round Great Britain . . . by Richard Ayrton, with a series of views . . . drawn and engraved by William Daniell, A.R.A.*, appeared in eight volumes between 1814 and 1825. Towns such as Southend, depicted by Daniell, were virtually unknown until the advent of the day-tripper in the nineteenth century, and any representation of them would have constituted far more of a novelty than it would today. In fact, there was something of a boom in the early nineteenth century in the depiction of seaside resorts which had themselves recently witnessed a period of growth due to better and cheaper travel. Constable, Callcott and a number of the Norwich school of artists including John Sell Cotman contributed to the new genre. In the case of Joshua Cristall (*c.* 1767–1847), an original member of the Old Water-Colour Society, one can see clearly how a particular artist's sketching of a locality influenced others to do likewise. Farington noted in his *Diary* for 11 May 1808: 'In consequence of Crystall's drawings made last summer, Ward sd a Host of Artists are prepared to go to Hastings'.

Countless other artists, in addition to Daniell, extended the visual exploration of Britain. Many of the watercolourists of the generation after Cotman, Turner and Varley were to venture much farther afield, to Spain and the Near East, for new material, yet still the sights of Britain held a strong attraction. Nearly every artist of note seems to have travelled to Wales, especially the north, as a sketching ground, although Farington (*Diary*, 6 February 1802) recorded: 'Turner thinks Scotland a more picturesque country to study in than Wales. The lines of the mountains are finer, and the rocks of larger masses'.

David Cox (1783–1859), after his first visit in 1844 to Bettws-y-Coed in North Wales, fell into a regular summer pattern of sketching there. He would leave his native Birmingham in late July or early August and travel by the old Grand Junction Railway via Chester and Rhyl to Conway where he was met at the station by an open Welsh car sent down from the Royal Oak at Bettws. A large bedroom was always reserved for him at that inn and on wet days he would spread out his work to dry on the spare bed there.

Cox was sketching a particular locality in depth and it is probably true to say that travelling *per se* in Britain was not the motivating factor it had been in the eighteenth century. In 1794 the Rev. Gilpin had advised that 'THE *art of sketching* is to the picturesque traveller, what the art of writing is to the scholar', and by the 1840s that advice had been well heeded.

3 Travellers Abroad

. . . And here I can not help observing with what new and
uncommon Sensations I was filled on my first traversing
this beautiful and picturesque Country – Every scene
seemed anticipated in some dream – It appeared Magick
Land –

THOMAS JONES, *Memoirs* (December 1776)

The wonder and excitement afforded by a foreign landscape, in this case the countryside round Rome, was well expressed by the Welsh landscape painter Thomas Jones (1742–1803), who resided in Italy from 1776–83. Dr Johnson observed that 'A man who has not been in Italy is always conscious of an inferiority' and certainly by the time of Jones's visit the same could be said of many landscape painters. Writing of the Romans' own social classifications of visitors to their city Jones claimed: 'The first Class consisted of the *Artisti* or Artists, who come here, as well for Study and Improvement, as emolument by their profession'.

'Study' and 'Improvement' imply decisions to travel that were consciously taken by the artists concerned. Such freedom of choice was only open to a limited number, however, and the reasons for artists working abroad were many and varied. Expeditions as diverse as those of Sir Walter Raleigh to Virginia in 1585 or Matthew Flinders to Australia in 1801 engaged topographical draughtsmen to record the landscapes and coastlines observed on voyages of discovery. Wealthy patrons included artists in their entourages to record the fabulous scenery passed through as they undertook the almost obligatory 'Grand Tour' in the eighteenth century. Learned bodies such as the Society of Dilettanti employed artists to depict the antique remains of Greece and the Near East. In the nineteenth century intrepid artists such as John Frederick Lewis and David Roberts explored hitherto unfashionable countries such as Spain or the Holy Land as they searched for new scenery with which to confront critics and public back in England. It will be seen that the variations on the theme of the artist-traveller are many and varied, but by tracing a number of often inter-related themes a more comprehensible picture emerges.

One artist-traveller already mentioned in this book was Wenceslaus Hollar but his duties abroad, the delineation of the colony of Tangier, can be seen to be fairly limited when compared to those imposed upon many other artists. Unfortunately, so few drawings of this type survive from the sixteenth and seventeenth centuries that it is difficult to point to specific examples from the earliest period of such exploration. A certain Thomas Bavin, who was to have travelled on an expedition to the southern part of New England in 1582, was expected to make graphic records of the coasts, harbours, encampments, unfamiliar flora and fauna, and of the types and customs of the natives encountered on that particular voyage. Three years later John White (fl. 1585–93) did actually travel on Raleigh's expedition to North America to found the first English colony there, named Virginia in honour of Queen Elizabeth.

35 John White
(fl. 1585–93) *The village
of Pomeiooc*. Black lead,
watercolour, heightened
with gold and white.

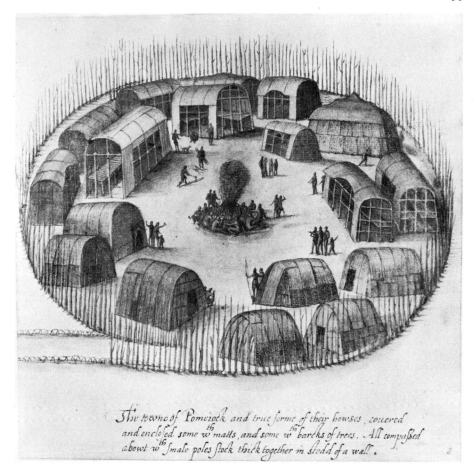

The towne of Pomeiooc and true forme of their howses, couered
and enclosed some wth matts, and some wth barcks of trees. All compassed
abowt wth smale poles stock thick together in stedd of a wall.

Thomas Hariot, an astronomer and mathematician, also accompanied the
expedition as scientific observer. The colony was established at Roanoke, but
by the following summer it was facing starvation and was fortuitously
relieved by Sir Francis Drake's fleet returning from plundering the West
Indies.

White returned as governor of a new settlement at Roanoke in 1587 but he
soon departed for England, leaving behind a granddaughter, Virginia, the
first child born of English parents in North America. On his last recorded visit
to America in 1590 he found the colony abandoned:

Wee found five chests . . . three were my owne, and about the place many of my
things spoyled and broken, and my bookes torn from the covers, the frames of
some of my pictures and Mappes rotten and spoyled with rayne, and my armour
almost eaten through with rust. (H. Honour, *The European Vision of America*)

The exact nature of White's original commission is unknown, nor can it
be ascertained whether his watercolours of Indian settlements and North
American wildlife were widely known or well received in the England of his
time. Some of them were, however, purchased in 1588 by the Flemish
engraver and publisher Theodor de Bry who had them engraved in Part I of
his *America* (1590) in which he also illustrated drawings of North America by

the French artist Jaques le Moyne, who had accompanied a French expedition to Florida in 1564.

White appears to have belonged to a line of now largely unknown topographical and documentary draughtsmen whose primary objective was the production of accurate representations of what they and their fellow voyagers had seen. He can also be seen as a very early forerunner of the considerable number of artists who were mainly employed in expeditions, many of them in the second half of the eighteenth and early nineteenth centuries when skilled draughtsmen had become more plentiful; their availability coincided with an increase in the number of expeditions undertaken. The reasons for employing such artists were well described by Captain Cook concerning John Webber (1752–93), who accompanied Cook's last and fatal expedition begun in 1776. Webber was employed 'for the express purpose of supplying the unavoidable imperfections of written accounts, by enabling us to preserve, and to bring home, such drawings of the most memorable scenes of our transactions, as could only be executed by a professed and skillful artist'.

The advantages of a draughtsman accompanying such expeditions were widely appreciated and, indeed, drawing had been considered a useful adjunct to a sailor's armoury since the establishment by Wren, Pepys and others of a drawing school at Christ's Hospital in 1693. Thomas Falconer, a friend of both Thomas Pennant and Sir Joseph Banks, extolled the virtues of coloured drawings in a letter of 1768 to Banks concerning his proposed tour of Lapland:

You take a designer with you, and it would be easy to sketch out some of the views. Travellers in general confine themselves to the works of Art; and by giving us only Towns or Churches, exhibit nothing but a tedious uniformity. The appearance of Nature is very varied in every Climate: an Alpine scene is different from a Derbyshire landscape; and if your designer would stain his drawing, it would point out the colour of the Soil and verdure, with the nature of the Rocks, and would enable us to have a full idea of the Country, which no descriptions possibly can.

In other words, factual drawings, uncluttered by too many artistic conventions, met the requirements of men like Falconer, Banks, or Matthew Flinders, who took the artist William Westall (1781–1850) on his expedition to Australia in 1801. Westall received a salary of three hundred and fifteen pounds per annum for his labours. These were of an essentially practical nature, as Flinders noted when his ship the *Investigator* was leaving Port Phillip: 'When the entrance was cleared, and five miles distant, Mr Westall took a view of it, which will be an useful assistance in finding this extensive but obscure port'. At one point during the journey Westall was shipwrecked on a reef in the Torres Straits and he did not return to England until 1805.

Prior to Westall's appointment, the post of draughtsman to Flinder's exhibition had been offered to Julius Caesar Ibbetson (1759–1817), who declined. Ibbetson had also refused employment nine years previously as the landscape draughtsman to Lord Macartney's embassy to China. Ibbetson's caution is most understandable when it is remembered that he had accompanied a slightly earlier and unsuccessful mission to China conducted by Charles Cathcart MP, who travelled as British Envoy to the Imperial Court of Peking. Ibbetson had been employed as Cathcart's personal draughtsman but, shortly after their frigate had left Java early in 1788, Cathcart had died and the

36 William Alexander (1767–1816) *Self-portrait*, 1790s. Pencil, ink and
watercolour. Inscribed *From myself, done at sea. 179 . . . W. A.*, this
somewhat piratical image presumably dates from 1792–4 when Alexander
accompanied Lord Macartney's embassy to China.

party had turned back, arriving in Plymouth in October of that year. Ibbetson complained of the voyage: 'I had great rewards held out to me, but I never received a shilling to this day'. He received no official compensation for loss of earnings, although the Cathcart family gave him a number of commissions.

By contrast, William Alexander (1767–1816), who travelled in Ibbetson's place on Lord Macartney's embassy, returned to England in 1794 with his sketchbooks filled and with a steady employment for the next few years illustrating the official account of the Embassy, which, although it successfully reached China, failed to establish a British Minister there. Between 1795 and 1804 Alexander exhibited sixteen Chinese landscapes at the Royal Academy and in 1808 he was appointed Keeper of Prints and Drawings at the British Museum with the rank of Assistant Keeper in the Antiquities Department (plate 7). Another artist whose travels abroad as an official draughtsman gave him steady employment for a while on his return to England was Thomas Hearne (1744–1817), who travelled in 1771 to the Leeward Islands as draughtsman to the new governor Sir Ralph Payne. After three and a half years in the West Indies making drawings of harbours, ports and of the scenery, he spent a further one and a half years back in England preparing his work for publication.

Obviously, the risks of foreign travel must have been considerable for an artist. Not only could the voyages themselves prove dangerous but, as in the case of Ibbetson, the expected commercial success could fail to materialise if one's objective were not reached for one reason or another.

Much nearer to home was the journey to Italy and, more especially, Rome that became almost obligatory to English *milordi* in the eighteenth century. By 1740 Lady Hertford was complaining that she found summer in Italy dreadful, due to the hordes of English visitors. (The term the 'Grand Tour' had first been used in Lassels's *Voyage of Italy* (1670): 'the *Grand Tour* of France and the *Giro* of Italy'.) By the middle of the eighteenth century it had become an established custom, whereby young English lords and gentlemen were sent by their parents with a tutor to accompany them as they learnt the social graces in Paris, ascended the Alps in their private carriages and then descended into Italy, the country of Virgil and then considered to be the *fons et origo* of European culture and learning. The countryside they would see there had already been anticipated for them, or so they thought, in the painted landscapes of Claude Lorrain that were hanging in so many English country houses. While the visions of Claude had whetted their appetite for the *campagna*, there was also the city of Rome, a museum of past civilisation and a museum in the modern sense in that Pope Clement XII had opened a museum of antiquities on the Capitol in 1734.

Viewed in retrospect, it seems surprising that more English watercolourists did not travel to Italy. One very probable reason was the expense of travelling there, especially as landscape artists (let alone watercolourists) were still very much considered to occupy the bottom rung on the artistic ladder and were not especially well recompensed for their work. Those who were fortunate had a patron or patrons supporting them. For example, Jonathan Skelton (fl. 1754–58) would appear to have received financial assistance from his patron William Herring of Croydon. In his correspondence with his benefactor Skelton often stressed what he found to be the relatively cheap cost of living in Rome. In a letter of 15 March 1758 he told Herring that 'you might live here for half the expence that you live att at present'. In another letter of 11 January in the same year he confided: 'Here are many very good Young

37 Jonathan Skelton (fl. *c.* 1754–8) *Lake Albano and Castel Gandolfo*, 1758. Pen, ink and watercolour. Skelton visited Albano in June 1758.

Englishmen, students in Painting here, most of them tell me that I cannot live for less than 60£ a year, but I know I can live for 40£ and maintain the appearance of a Gentleman' (*The Walpole Society*, vol. XXXVI). Letters relating to Skelton subsequent to his early death in Rome (possibly from a duodenal ulcer) indicate he lived very frugally and his estimate of the cost of living there should be treated with caution, though Italy was undoubtedly cheaper to live in than England.

Although a large number of Italian views by eighteenth-century watercolourists survive, it must be said that a greater number of British artists travelled to Italy not to draw the landscape but to study and draw after the antique and to learn from Renaissance art, often in an attempt to enter the field of history painting, then considered in academic circles to be the highest branch of the visual arts. There was no 'school' of British landscape painters in Rome as such and the nearest there ever came to being one there resulted from the informal friendships that sprang up in the 1770s and 1780s between John 'Warwick' Smith, Francis Towne, William Pars and Thomas Jones and John Robert Cozens.

Jones has left an amusing and highly informative account in his *Memoirs* of his journeys to and from Italy and of his life there. He came from a relatively wealthy family in Pencerrig, Radnorshire, studied landscape painting under Richard Wilson, and travelled to Italy in 1776. At Lyons he bought himself a

French grammar, 'but the Blunder was that this Grammar was for the purpose of Teaching a *Frenchman English*, & not an *Englishman French*'. His party ascended the Alps in mid-winter by mules:

Our 2 Chaises were taken to pieces the night before, at Lanenburgh & carried piecemeal on Mules, setting off 2 or 3 hours before us, & by the time we arrived at *Novalese* – they were put together again & ready for travelling . . .

They travelled on Saturdays and Sundays as well as weekdays and usually started at seven in the morning.

Italy was indeed 'Magick Land' for Jones, and he shared his enjoyment of the experience with his friends there (plate 6). At Naples in 1781 he acted as *cicerone*, or guide, to the Devon artist Francis Towne: 'I was able to conduct him to many picturesque Scenes of my Own discovery, entirely out of the common road of occasional Visitors, either Cavaliers or Artists, from Rome'. In April 1777, at Frascati outside Rome: 'Mr and Mrs Pars and my Self pass'd Our time very Agreeably rambling about and Making a Number of Views and Sketches of the different Scenes in this most picturesque Country'.

Pars was a close friend of Jones, who, as Jones recalled, 'would sometimes curse his fate, in being obliged to follow such trifling an Employment; as he called it – it was with the greatest difficulty his Friends could detach him from this favourite Study, and persuade him to apply to Portrait painting – in which line there was now a fair Opening'. The English had always shown a partiality for 'face-painting' and Pars had begun his career as a portrait painter, an art in which he was established by 1763. He had travelled to Italy in 1775 armed with a letter of introduction from the great antiquarian Horace Walpole to Sir Horace Mann, British Envoy at Florence: 'This will be delivered to you by Mr Pars, a painter who is going to improve himself in Italy.' The association of Italy with the 'improving' of an artist has already been mentioned and is perfectly illustrated by a remark of Skelton's concerning the resort of Tivoli, just outside Rome, in a letter of 1758: 'This antient City of Tivole I planly see has been ye only school where our two most celebrated Landscape Painters Claude and Gaspar studied.'

Pars maintained himself in Italy with the aid of a student's pension granted him in 1775 by the Society of Dilettanti. It was the Society's commission to him in 1764 to accompany Richard Chandler's expedition to the Near East which changed Pars into a landscape painter, according to Jones's reminiscences of the artist. The Society of Dilettanti (which still exists today) was founded in 1734 by a group of gentlemen who had travelled in Italy. Despite Horace Walpole's assertion that it was nothing more than a drinking club, it was seriously concerned with promoting the investigation and publication of the remains of the great civilisations of the past. In 1762 the Society had published the first volume of James Stuart and Nicholas Revett's *Antiquities of Athens*. Revett also accompanied Chandler's expedition 'to some parts of the East, in order to collect information and to make observations, relative to the ancient state of those countries, and to such monuments of antiquity as are still remaining'. As architect to the expedition Revett was paid a hundred pounds per annum, whilst Pars received eighty. In the preface to the first volume of the resulting *Ionian Antiquities* (1769) it was stated that 'the choice of a Proper Person for taking views and copying Bass Reliefs, fell upon Mr PARS a young painter of promising Talents'. The expedition visited Greece and the surrounding areas containing Ionian remains and returned to England in 1766

38 William Hodges (1744–97) *View on the Island of Otaheite.* Watercolour.

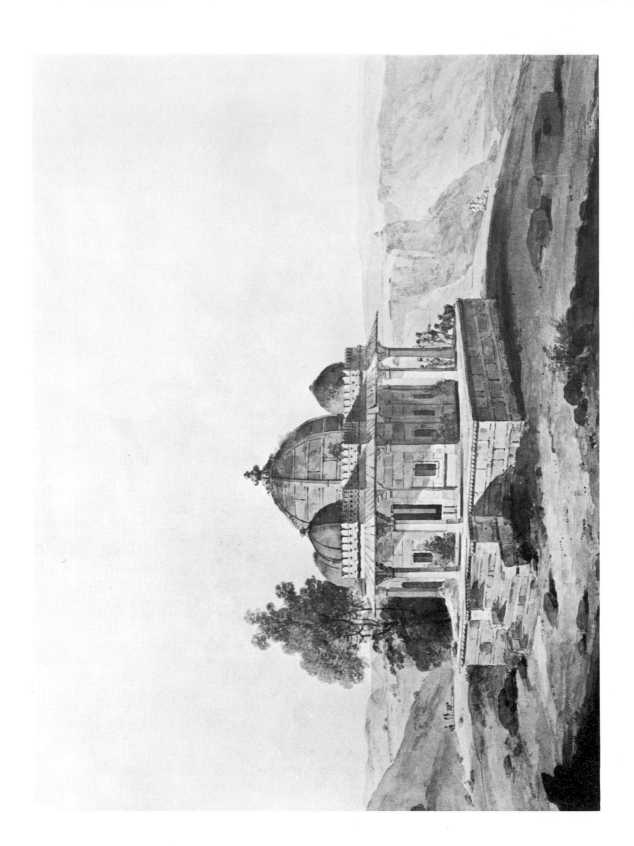

(plate 9). Pars's drawings were engraved by a number of artists for the *Ionian Antiquities* and his watercolours (seven of which were exhibited at the first exhibition of the Royal Academy in 1769) were presented to the British Museum in 1799 and must have enjoyed an independent success, for Sandby applied for, and received, permission to aquatint some of them.

Pars's Ionian drawings were funded by a society interested in the archaeological discovery of an area that was to become generally popular with tourists and artists in the nineteenth century, especially after the cessation of the Greek Wars of Independence in the 1820s. But as early as July 1814 the *Quarterly Review* was claiming that 'it is an introduction to the best company, and a passport to literary distinction to be a member of the "Athenian Club" and to have scratched one's name upon a fragment of the Parthenon.' This fascination with lands further afield was partly brought about by improvements in communications and also by the decrease in the importance of the 'Grand Tour' in the closing years of the eighteenth century (the French invaded Rome in 1798) and, except for the brief respite of the Peace of Amiens in 1802, the virtual impossibility of continental travel until the final defeat of Napoleon in 1815.

India, effectively under British control in the form of the East India Company, provided a useful source of revenue for portrait and landscape painters intrepid enough to make the journey. William Hodges (1744–97), who had travelled on Cook's second voyage of 1772–5 on board the *Resolution*, was in India from 1778–84 where he enjoyed the patronage of Warren Hastings. Remarking on the artistic potential of the sub-continent he later observed: 'Many tours in that interesting country might be undertaken by the enterprizing artist'. Hodges' work extended the tradition of view-making, hitherto mainly associated with Italy, and on his return from India he published his *Select Views in India, drawn on the spot in 1780–83*, in two volumes. It was dedicated to the East India Company, who subscribed for forty sets.

The scenery of India was further brought to the eyes of the British public by the publishers Edward and William Orme, who produced a number of illustrated books of Indian buildings and scenery. By far the most important topographers of that country, however, were Thomas Daniell (1749–1840) and his nephew William (1769–1837). They travelled to India at a time when the salaries paid by the East India Company were good and their employees were well able to afford to patronise a number of artists. By 1784, when the elder Daniell approached the Company for permission to work in India as an engraver, portrait painters such as Tilly Kettle and Zoffany had worked there and Hodges was busy aquatinting his Indian views ready for publication in 1786. Artistic competition in India was also less intense, so Daniell's ambition to work there could be seen to make good financial sense, especially when, as it turned out, he was a sufficiently good artist to be able to present India to the British public as a land of beautiful and picturesque views, very different in architecture and terrain from the more usual views of Italy.

Not the least remarkable aspect of Daniell's career in India (he was there from 1785/6–93) was the enterprise he displayed in financing his lengthy and arduous tours in that country. He began by spending his first two years mainly in Calcutta, then the chief Presidency town in India, producing the twelve plates of his *Views of Calcutta*, which were bought by the local residents. In January and February of 1792 he held two lotteries of his works

in Calcutta and the money raised helped to finance his travels with his nephew. Their tours were extensive and included the navigation of the Ganges and journeying to the sublime and picturesque prospects of the Himalayas, as well as to the Baramahal Hills and Mysore (the Third Mysore War was fought 1791–2). At Fatehgarh in 1789 they were joined by British officers, a troop of Horse and two companies of sepoys to escort them as they travelled through unsettled territory that was the land of the Mughal emperors. The Daniells were astute enough to realise that old campaigners in India would wish to buy pictures of the scenery where they had accomplished their former exploits and so they drew the dense forested country where Raja Chait Singh of Benares had held out against Warren Hastings in 1781 until he was eventually defeated.

In June 1793 the Daniells heard that France and England were at war and wisely decided to return to England, eventually arriving back in 1794 with a vast stock of monochrome and watercolour drawings. This invaluable collection of images furnished Thomas with raw material for a total of ninety-seven oil-paintings of Indian and eastern subjects which he exhibited in London at the Royal Academy and the British Institution. His attitude towards his often highly finished watercolours was that they were his private, professional property and, unlike his oil-paintings or his prints, were not for sale.

Between 1794 and 1804 the Daniells aquatinted the designs for their *Oriental Scenery* (1795–1808), which was published in six parts, each of which contained twenty-four coloured plates. The whole set sold for two hundred and ten pounds and it was so successful that a smaller, uncoloured edition was published between 1812 and 1816. The Daniells also published, in 1810, *A Picturesque Voyage to India by the Way of China*. Their work had two major influences: the Indian styles of architecture illustrated in their prints were adopted in a number of British buildings, the best known of which were probably the Pavilion and Stables at Brighton, and, in addition, the Daniells' success in India encouraged others, such as George Chinnery, to follow their example, and many years later they were still remembered as is demonstrated, albeit in a negative sense, by Edward Lear's unfavourable recollection of their work when he was at Benares in the 1870s:

How well I remember the views of Benares by Daniell, R.A.; pallid, gray, sad, solemn . . . Instead, I find it one of the most abundantly *bruyant*, and startlingly radiant of places full of bustle and movement. Constantinople and Naples are simply dull by comparison. (*Journals in India, 1873–7*, Harvard College Library)

In many of the British colonies (and ex-colonies, in the case of America) the drawing of the countryside was mainly performed by amateurs until the nineteenth century, when drawing-masters arrived and native artists and publishing firms began to emerge. In remoter corners of the globe the colonial population might have to await the arrival of a British-trained drawing-master to stimulate interest in the art. When John Skinner Prout (1812–95), nephew of the more famous Samuel, arrived in Hobart, Tasmania, in 1843 and gave a series of lectures on landscape painting one of the local ladies, a Miss Meredith, wrote: 'a landscape sketching and water-colour fever raged with extraordinary vehemence . . . The art that Mr. Prout taught and practised so well at once became the fashion.' Prout did not settle permanently in Australia and on his return to England he found a new prosperity (he originally left his native country due to lack of success there) by exhibiting and selling views of Australia.

40 Samuel Prout (1783–1852) *Church at St Lo, Normandy*. Pen and watercolour.

The initiative displayed by Prout was matched by many other artists in the nineteenth century and these artists were themselves part of a general widening out of the avenues of travel and an increase in the number of countries deemed worthy of visual interest. Switzerland and the Alps, although they had already been depicted in the eighteenth century by J. R. Cozens, Pars and Towne, blossomed from being merely a station on the way to Italy to being a centre for tourism, especially the Lakes of Lucerne and Geneva and the Bernese Oberland. Turner visited Switzerland no less than six times (see plate 10) and Ruskin found the scenery there to be of great visual and mineralogical interest.

While the essentially aristocratic concept of the Grand Tour all but disappeared in the nineteenth century, Italy retained its fascination for tourists and artists alike. R. S. Lambert claimed in 1935 that the third and fourth cantos of Byron's *Childe Harold* became 'the manual for a whole generation of tourists'. Certainly, no-one who read the following lines on Rome could fail to have been encouraged to visit there:

> Come and see
> The cypress, hear the owl, and plod your way
> O'er steps of broken thrones and temples, Ye!
> Whose agonies are evils of a day –
> A world is at our feet as fragile as our clay.

Samuel Rogers' *Italy*, a poetic travel book inspired by Byron, appeared in 1830 with engraved vignettes after designs by Turner. Ruskin first read *Italy* in about 1832, and in the following year he and his father pored over Samuel Prout's *Facsimiles of Sketches in Flanders and Germany*, a large book of lithographs with no text which was intended to resemble an artist's folio of pencil sketches. Ruskin's mother responded to their enthusiasm by suggesting they should visit such scenes in reality. During the preparations for what was to be the family's first continental tour copies were made from both Prout and Rogers' *Italy*.

The Ruskins represented the wealthier of the new type of travellers abroad. They were also typical of their age in that they travelled as a family. Besides the aristocrat an increasing number of tourists came from business (Ruskin's father was a sherry merchant) and the professional world. Although the Ruskins did travel as far as Italy in their own private carriage, less wealthy members of the middle classes contented themselves with excursions nearer to home, expecially France, Germany and the Netherlands, and their tastes were catered for by artists such as Samuel Prout (1783–1852) both in his watercolours and in his prints.

A generation of artists contemporary with Prout earned their living by providing drawings of continental towns and scenery that were then engraved for inclusion in the *Annuals* – relatively cheap compendia of landscape images that were produced in the decade 1830–40. Due to the recent invention of steel-engraving (a much tougher metal than the traditional copper) thousands of impressions of annuals such as *Heath's Picturesque Annual* could be printed and sold for a guinea or less. The annuals had three major effects. They increased the interest in continental scenery, they provided steady employment for a number of watercolour artists such as J. D. Harding, James Holland and William Callow, and they enabled these artists to become household names – something they would never have achieved through their

41 John Frederick Lewis (1805–76) *The Alhambra, Granada*, 1832. Watercolour and bodycolour

watercolours alone. As J. L. Roget commented in 1891 in *A History of the Old 'Water-Colour Society'*:

A new class of topographic works had arisen more suited to the cosmopolitan taste of the age. These were no longer confined as of yore to 'gentlemen's seats' and 'beauties' of Britain, but depicted scenes in foreign lands more or less remote . . . volumes of this class, got up more for the drawing-room table than the library shelf, bred and multiplied.

Although the tone is undoubtedly satirical, the following extract from the *Eclectic Review* of April 1824 indicates the increasing interest in stranger and more exotic lands:

How times are altered since the tour of Europe, the grand tour, was the *ne plus ultra* of gentlemen travellers! No one can now pretend to have seen the world who has not made one of a party of pleasure up the Nile or . . . across the Syrian desert. As for France and Flanders and Switzerland, our next-door neighbours, they may serve John Bull very well for a country-house; but to have seen those countries is no longer worth speaking of.

With the enormous increase in travel in the post-Napoleonic era novelty and freshness became the watchword of many of the numerous artists who sought to cater for the tastes of the new classes of travellers. Although relatively close in terms of geographical distance, Spain had remained hitherto largely unconsidered. Sir David Wilkie, who was in Spain from 1817–18, declared it to be 'the wild unpoached game reserve of Europe'. In an age of rapid publication, the financial rewards offered by the depiction of Spanish buildings and landscapes did not escape David Roberts (1796–1864), who travelled to Spain in 1832 and, despite the hardships of mosquitoes and cholera quarantine, wrote, 'my Portfolio is getting rich – the subjects are not only good but of a very novel character . . .' By the time that he had travelled on to Tangier he was able to state: 'My drawings without counting my smaller sketch books amount now to Two hundred and six finished sketches, the greater part coloured . . .'

Roberts was anticipated by a few months in his visit to Spain by John Frederick Lewis (1805–76) whose passport request had been written by Richard Ford, author of *Handbook for Travellers in Spain* (1845). Ford's letter gives an extremely interesting indication of Lewis's (and presumably Roberts's) motives for travelling to Spain to see the treasures of Madrid, the beauty and tranquillity of the Alhambra. Ford wrote: 'He [Lewis] is about to make a sort of picturesque tour of Spain, having orders for young ladies' albums and from divers booksellers . . .' Back in London Roberts and Lewis worked in friendly competition on their Spanish sketches, Lewis's *Sketches and Drawings of the Alhambra* being published in 1835, while Roberts's *Picturesque Sketches in Spain* appeared in 1837. Something of the impact of Roberts's and Lewis's work can be gauged from a remark by John Sell Cotman, who had seen watercolours by them at a meeting of the Artists' and Amateurs' Conversazione in the 1830s, in a letter to his artist sons back in Norwich: 'When compared to London Art we are as nothing . . . and I only wonder we have done so well as we have done.'

Although both artists travelled extensively elsewhere in Europe, their further major contributions lay in their exploration of the Near East. Lewis, after visiting Albania, Athens and Constantinople, sailed to Egypt and resided in Cairo from 1841–50 during which time he exhibited no drawings at the

42 Title-page to David Roberts's *The Holy Land* . . . Lithographed by Louis Haghe, London, 1842.

THE HOLY LAND

Syria, Idumea, Arabia, Egypt & Nubia.

FROM DRAWINGS MADE ON THE SPOT BY

David Roberts, R.A.

WITH HISTORICAL DESCRIPTIONS BY

THE REV? GEORGE CROLY, L.L.D.

LITHOGRAPHED BY

LOUIS HAGHE.

VOL. I.

LONDON, F. G. MOON, 20 THREADNEEDLE STREET,
PUBLISHER IN ORDINARY TO HER MAJESTY.
MDCCCXLII.

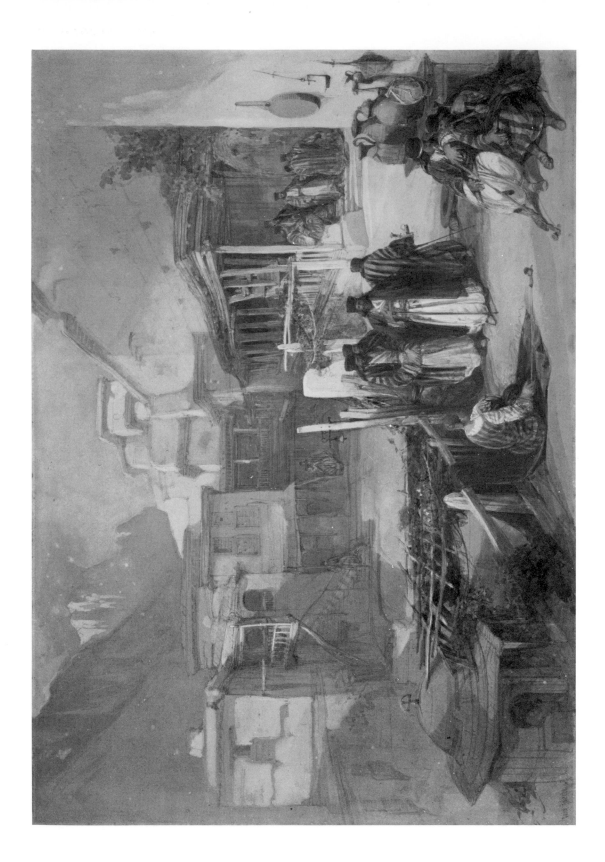

Old Water-Colour Society's annual exhibitions in London and was threatened with expulsion. Thackeray, who visited Lewis in Cairo in 1844, described him as living 'like a languid Lotus-eater' but Lewis had his revenge. His *The Hhareem* (now in the Victoria and Albert Museum) caused a sensation when exhibited in 1850 and on his return to England in 1851 he brought with him a vast amount of material as the basis for his future work. It seems ironic that in 1855 he was elected President of the Old Water-Colour Society on the death of Copley Fielding.

Roberts had also journeyed to Egypt. In 1838 he sailed directly to Alexandria and hired a boat with a crew of eight to travel up the Nile at a monthly cost of fifteen pounds. At one point the boat had to be temporarily sunk in the Nile to drown the rats that were on board. Though deploring the poverty of the inhabitants, he was greatly impressed by the temples. He wrote in his journal of the temple at Edfon: 'Though half buried it is more beautiful than if laid open, and reminds me of Piranesi's etchings of the Forum of Rome . . .' This judging and comparing of the unknown with the known was a common trait amongst travellers. Edward Lear, for example, wrote of Mussooric in India: 'The morning views over the Dun are lively, and recall Italy and Claude's pictures.' Indeed, many watercolours of the East and Australasia were composed on Claudean principles fusing the formula of classical landscape with details of unfamiliar foreign topography.

Early in 1839 Roberts left Cairo for the Holy Land. In terms of financial reward this was to be very much a 'journey to the Promised Land', for Roberts's resulting lithographs provided the British public with views of an area that had long held its fascination due to its biblical associations. In order to promote the publication of *The Holy Land, Syria, Idumea, Arabia, Egypt and Nubia* (1842–9), seventy-two of Roberts's original drawings for this work were placed on public display at venues round England. Roberts received three thousand pounds as the fee for reproducing his *Holy Land* compositions and was then able to sell some of his drawings; twenty-three to Lord Francis Egerton for five hundred pounds and a further fifty Syrian subjects for nine hundred pounds.

During his journey to the East Roberts had arrived in Jerusalem the day after the quarantine for cholera had ended and, after a stay there, proceeded to Lebanon. The attractions of his nomadic way of life were made clear in a letter to his friend Hay:

It is certainly the most independent sort of life there can be – no bills to pay – no waiters *waiting* for a gratuity – by daybreak the tents are struck and the camels loaded – and on our way for new places of interest.

Understandably, Roberts found the experience of his Near Eastern journey to be incomparable. In 1843 he went on a tour of Normandy and Brittany and found it unrewarding, partly due to the bad weather but also because 'the impressions made on my mind by Egypt are never to be effaced'. The rapid growth of printed images in the nineteenth century, especially the steel-engraving and the lithograph, meant that a wide range of the population, even if they were themselves unable to travel to Greece, Egypt or the Holy Land, were able to buy reproductions of drawings and watercolours by artists who had been there. The lithograph, a technique of printmaking invented in the 1790s by Alois Senefelder (1771–1834), assumed increasing prominence in England in the 1820s and was extensively used in the reproduction of

43 David Roberts (1796–1864) *The Convent of St Katharina, Mount Sinai* Watercolour.

44 Lithographic portrait of David Roberts by C. Baugniet, frontispiece to *The Holy Land* . . .

watercolours until the late 1840s. The process was based on the antipathy of grease and water. Designs were applied with a greasy lithographic chalk or pen and ink to the smooth surface of a specially prepared limestone. This preparation involved the use of acid, gum arabic and water in such a way that when lithographic ink was applied to the limestone it was attracted to the areas covered by the design but repelled from the damp areas of the rest of the stone. British aquatinters tried to quash the new technique by having a heavy import duty imposed on the 'Munich' lithographic stones. Increasing sophistication in the production of lithographs led to the development of the 'lithotint', patented by Charles Hullmandel (1789–1850) in 1840, in which lithographic ink was applied in washes, and of the 'chromolithograph' where a number of stones were used to effect a colour separation process, thus facilitating the full colour reproduction of watercolours.

The wider availability of more developed printed images was one of the differences between the eighteenth and nineteenth centuries. Watercolours themselves also became more numerous, partly because there were many more watercolour artists, but also because artists from 1805 onwards (the year of the first exhibition of the Society of Painters in Water-Colours) had regular facilities for exhibiting their work. Writing of the private views of the Old Water-Colour Society in his *Notes on Prout and Hunt* (1880) Ruskin remarked how Samuel Prout's European watercolours had enlivened the selection of primarily British views that were on show:

It became, by common and tacit consent, Mr. Prout's privilege, and it remained his privilege exclusively, to introduce elements of romance and amazement into this – perhaps slightly fenny – atmosphere of English common sense. In contrast with our Midland locks and barges, his *On the Grand Canal, Venice*, was an Arabian enchantment; among the mildly elegaic country churchyards at Llangollen or Stoke Poges, his *Sepulchral Monuments at Verona* were Shakespearian tragedy and to us who had just come into the room out of Finsbury or Mincing Lane, his *Street in Nuremberg* was a German fairy tale.

In 1858 no less than twenty-two members of the Society exhibited watercolours of continental subjects. The idea of the artist as traveller had well and truly come to fruition.

4 Societies and Clubs

It will be sufficient now to remark that within the last
five-and-thirty years, the art of painting in water-colours
has made the most stupendous advances towards
perfection.

Lo Studio (periodical), May 1833

This opinion, ventured on the occasion of a review of the annual exhibition of
the Old Water-Colour Society, would have been almost universally shared
by other critics of the time. While the tremendous improvement in water-
colour materials in the closing years of the eighteenth century certainly
contributed to the rise in popularity of the art, there can be little doubt that
the banding together of watercolour artists to form their own societies
provided the crucial impetus in bringing about a situation whereby water-
colours were widely bought, discussed and imitated. Before examining the
motives for what amounted to a minor artistic revolution in England it would
be as well to recount briefly the histories of the more important societies. The
course of events is often tortuous, hence the following preliminary framework.

The Society of Painters in Water-Colours was founded on the evening of
30 November 1804 at the Stratford Coffee House in Oxford Street. Its first
exhibition opened in 1805 at 20 Lower Brook Street in a house that had
originally been built for show or sale-rooms by Gerard Vandergucht in the
eighteenth century. Annual exhibitions followed and by 1808 the Society
was occupying rooms at 16 Old Bond Street (45). The next year saw another
move to Wigley's Rooms in Spring Gardens (an exhibition space which often
proved unsatisfactory) and in 1820 the venue was changed to William
Bullock's celebrated Egyptian Hall in Piccadilly. Two years later the Society,
which received the prefix 'Royal' in 1881, took over new premises in Pall
Mall East which they occupied until 1938 when, the property being under
threat of demolition from the owners, it moved to the quarters it still occupies
(at the time of writing) at 26 Conduit Street.

Two major rival societies were formed in the course of the nineteenth
century. The first, originally named the New Society of Painters in Miniature
and Water-Colours after two preliminary meetings at the Thatched House
Tavern, Great St James's Street, changed its title in the year of its opening
exhibition in 1808 to the Associated Artists in Water-Colours. Their first
exhibition was held at 20 Lower Brook Street (where the original society had
first exhibited). In 1810 this second society changed its name again to the
Associated Painters in Water-Colours and, after its financially disastrous
exhibition of 1812, disbanded.

A second rival to the original society sprang up in 1832 and called itself the
New Society of Painters in Water-Colours. It was probably from this date
that the original society was renamed the Old Water-Colour Society, the title
which still graces the pages of the journal published since 1923 by that body –
The Old Water-Colour Society's Club. The 'New Society' held its first exhi-

45 *Exhibition of the Society of Painters in Water-Colours 1808.* Aquatint illustration to Ackermann's *Microcosm of London*. Many of the exhibited works were of considerable size and were intended to rival oil-paintings in effect, as is reflected by the manner in which they were hung (cf. 46).

bition at 16 Old Bond Street (where the 'Old Society' had exhibited in 1808), removing from 1835–8 to Exeter Hall, and from 1838–83 to 53 Pall Mall East. In 1882 spacious galleries were specially built for the Society (by then known as the Royal Institute of Painters in Water-Colours) at 195 Piccadilly. The Institute is now in Carlton House Terrace. The societies mentioned above were concerned with providing venues for the promotion and sale of water-colours. For the sake of simplicity they will hereafter be referred to as the 'Old', 'Associated' and 'New' Societies.

The first question that needs to be asked when examining the appearance of these societies is, naturally, why there was a need for watercolour artists to separate themselves from the established artists' bodies, the most important of which was the Royal Academy, founded in 1768? The answer lay in the very nature of the Royal Academy itself. Although Paul Sandby had been one of the eight members of the first council of the Academy, that body was primarily concerned with encouraging an 'academic' British art, in which subject painting (be it religious, mythological or literary in derivation) was the most highly prized form, though portraiture and landscape were also exhibited. Engravers and watercolour artists, especially if they were not practitioners in oils as well, were given little consideration, and it was not

46 *The Exhibition Room of the Royal Academy at Somerset House 1808.* Aquatint illustration to Ackermann's *Microcosm of London.*

until 1943 that a watercolour artist as such was elected to Associate member-ship of the Academy. Watercolours were exhibited at the Academy on occasion – one has only to think of Paul and Thomas Sandby, William Pars, John Robert Cozens, Girtin or Turner – but they were often hung insensitively and swamped by oil-paintings.

Since 1780 the Royal Academy had been housed in Somerset House and probably from at least as early as 1795 (when seven watercolours by Turner were hung near to each other there) it was the council-room at the Royal Academy in which the watercolours were exhibited. According to the watercolourist Thomas Uwins (1782–1857), it was the popularity of the watercolours hung in this room which led to the idea of forming a water-colour society. In a short biography of the artist George Fennel Robson (1788–1833), written in 1833, Uwins recalled:

At this time the council-room, instead of being what the present arrangement makes it a place of retirement from the bustle of other departments, was itself the great point of attraction. Here crowds first collected, and here they lingered longest, because it was here the imagination was addressed through the means of an art which added the charm of novelty to excellence. (Mrs Uwins, *A Memoir of Thomas Uwins R.A.*)

The works referred to by Uwins in this respect were nearly all by Academ-icians, or by artists who became so in later years: 'the rich and masterly sketches of Hamilton, the fascinating compositions of Westall, the beautiful

landscapes of Girtin, Callcott and Reinagle, and the splendid creations of Turner'. It should be added here that lesser watercolour artists than the aforementioned fared correspondingly less well at the hands of the Academy, their works being hung, according to Uwins, 'between windows and under windows, sometimes in the darkened room with the sculpture, where if they had merit it could not be seen'. It has been plausibly suggested that it was the example of Turner's exhibited watercolours – more 'paintings' than 'drawings' in their power and complexity, and often very large in size – which acted as a catalyst to the formation of the first watercolour society. Turner, in fact, pre-empted the first watercolour society by having his own gallery built (probably a first-floor extension over the garden of 64 Harley Street, the house in which he had taken lodgings in 1799). Hanging space at the Academy (of which Turner had been elected a full member at the impressively early age of twenty-seven) was naturally limited and so, to facilitate the sale and exhibition of both his oils and his watercolours, he boldly opened his new gallery in 1804. Probably included in this first exhibition were his two great watercolours of *The Passage of Mt St Gothard* and *The Great Fall of the Reichenbach*, both of which were bought by his Yorkshire patron Walter Fawkes.

Unlike Turner, the Devon artist Francis Towne applied unsuccessfully for membership of the Royal Academy no less than eight times between 1776 and 1803. In a letter of 1803 to the miniaturist Ozias Humphrey, Towne bitterly repudiated 'the stigma of being called "a provincial drawing master"', claiming: 'I have never in my life exhibited a *Drawing*.' Towne, and many others, realised that if their watercolours were to receive wide critical acclaim they would have to be presented as 'paintings', not drawings in watercolours. Ironically, in the spring of 1805 Towne exhibited 'A Series of original Drawings of the most picturesque scenes' (191 in total) at the same premises in Lower Brook Street that were to be used later in the year by the Society of Painters in Water-Colours.

The ten original members of the Society were, by and large, minor artists. Most of them lived close to one another in the West End of London, four of them in George St, Hanover Square. Unlike many other art movements (the Pre-Raphaelite for example), they were not in the first flush of youth. Eight of the original members were born in the period 1762–9 and were, therefore, in mid-career. The prime mover in founding the Society was William Wells (1762–1836) who, in a printed circular to the leading watercolour artists of his day, had first put forward the concept of such a society with the Shakespearean exhortation: 'We oftimes lose the good we else might gain by fearing to attempt'.

Apparently Wells's fellow artists needed some persuasion before hurling themselves 'unto the breach' but the first exhibition was opened on 22 April 1805. It represented a new and exciting venture for a category of artists who hitherto had relied on their teaching practices, commissions for topographical books and (if they were lucky) private patrons to provide their incomes. The founder members, who included such diverse artists as Samuel Shelley (noted for figurative painting), Robert Hills (who specialised in animal scenes), Joshua Cristall (pastoral and genre painter) and John and Cornelius Varley (landscape artists), met with success. In the course of its six-week run the exhibition received nearly twelve thousand visitors and the *Morning Post*, in favourably reviewing the exhibition, remarked:

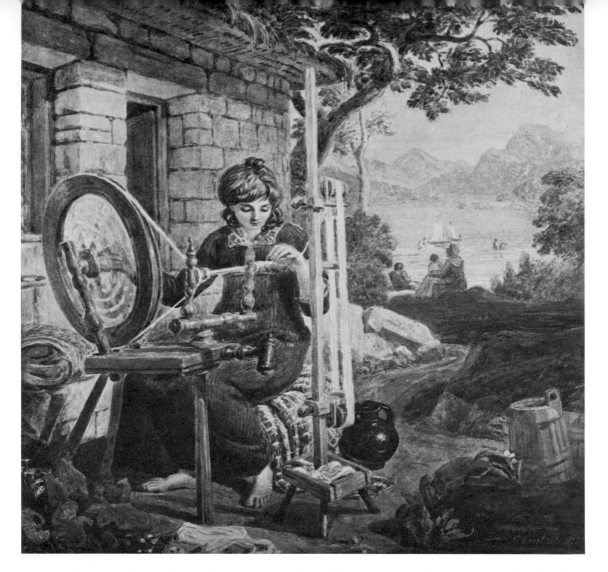

We trust, however, that we have said enough to waken public attention, and we have no doubt if there exist in this country any judgement of the works of British genius, that it will be amply displayed in the patronage and encouragement of the present undertaking.

Two hundred and seventy-five watercolours, resplendent in their gold mounts and frames, were exhibited, and the majority were of landscape subjects (one fifth of this category depicted Welsh mountain scenery). There was variety, however, and other categories included portraiture, genre, pastoral scenes in the manner of Claude and Poussin, and illustrations to classical authors, such as Ovid and Virgil. Compared to oil-paintings the prices were reasonable. Works by Samuel Shelley were the most expensive at an average of £26 10s 6d each, whilst at the other end of the scale Cornelius Varley charged an average of £3 14s 0d.

Business was conducted in a very organised manner. Members of the public paid one shilling as an admission charge and, with prices clearly stated in the catalogue, were required to leave a ten per cent deposit on any picture they wished to buy, writing their names and addresses in the book provided.

The exhibition found favour with many of the leading artists of the day.

47 Joshua Cristall (1767–1847) *The Cottage Door*, 1822. Pencil and watercolour.

48 Robert Hills (1769–1844) *A Chamonix*. Watercolour.

Joseph Farington, who wrote from a pro-Academy viewpoint, grudgingly noted in his *Diary* for 11 May:

The Exhibition of Painters in Water Colors in Brook St. I went to. The works did not make so strong an impression upon me as they appeared to have done on West, Hoppner and others, Hoppner on Thursday evening last expressed great admiration of Glovers drawings in particular. He said that He went from thence to *Turner's Exhibition* which after having seen the delicate and careful works at the former Exhibition where so much attention to nature was shown Turner's room appeared like a *Green Stall*, so rank, crude and disordered were his pictures. My opinion is that Glover's drawings were too artificial, – too equally detailed and finished, – and want that feeling & judicious expression which denotes a powerful & masterly mind & hand.

The following month Farington (20 June) had to concede the success of the

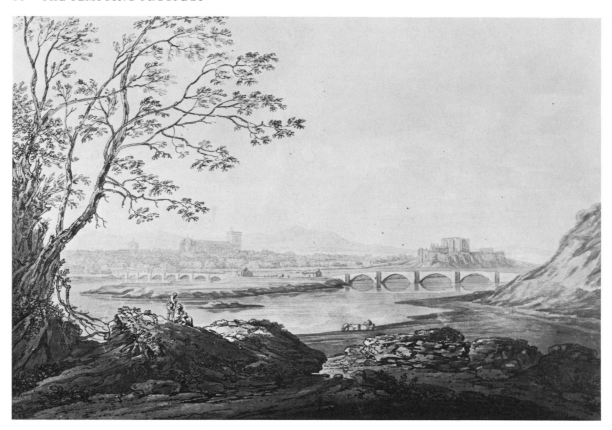

exhibition: 'All that were in the Exhibition at Brook Street were sold. – Glover is said to have sold drawings since He came to town to the amount of 700 guineas.'

As a result of the exhibition's success, it was decided to make it an annual event. Under the rules of the Society (whose members had to be 'of moral character') the profits of the exhibition, after carrying forward an amount for the expenses of the following year's exhibition, were divided amongst the members 'in sums proportioned to the drawings sent in and retained for exhibition'. In 1805 the sum available for this purpose amounted to about £272. This particular ruling was open to abuse, as Farington (19 April 1807) later noted of 'Warwick' Smith who 'had sent so many drawings as to swell the price of the whole beyond what some of the members thought reasonable, as upon it. He would claim too large a proportion of Dividend from the receipts of the Exhibition.'

There was an annual election of a President (the first incumbent being William Sawrey Gilpin, nephew of the Rev. William Gilpin) and of officers, and the number of members was not to exceed twenty-four. At the first anniversary meeting in November 1805 it was also decided that there should be a second class of member (not to exceed sixteen in number) with the title of 'Fellow-Exhibitor'. It is not difficult to find a parallel with the Royal Academy where, prior to being elected a full member, an artist was made an 'Associate' of the Royal Academy.

The fortunes of the 'Old' Society reached a relatively early peak. By 1809

49 Joseph Farington (1747–1821) *Carlisle, view across the River Eden*, late 1780s. Pen, pencil, ink and wash.

1 TOP Willem Schellinks (1627–78) *View of Fowey, Cornwall.* Pencil and slight watercolour, touched with pen and wash.

2 ABOᵛE Francis Place (1647–1728) *Scarborough Castle, from the North-West.* Pen and wash over black lead.

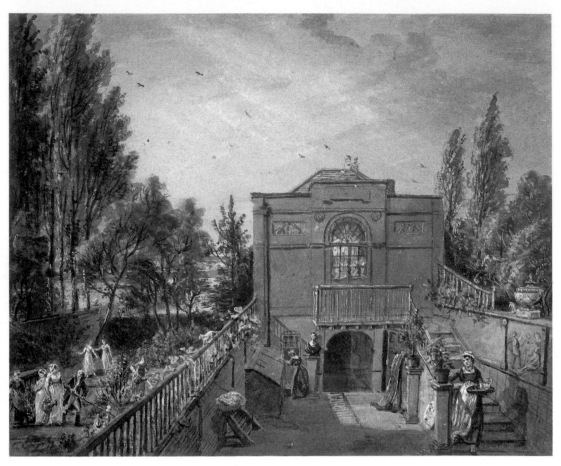

3 Paul Sandby (1730–1809) *Studio of the artist, 4 St George's Row, Bayswater*. Watercolour and bodycolour on grey paper. Sandby purchased this house in 1772 and lived there, in some style, until his death.

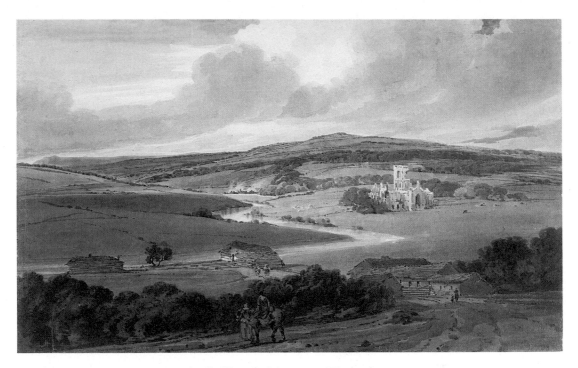

4　Thomas Girtin (1775–1802) *Kirkstall Abbey, Yorkshire*, 1800. Watercolour

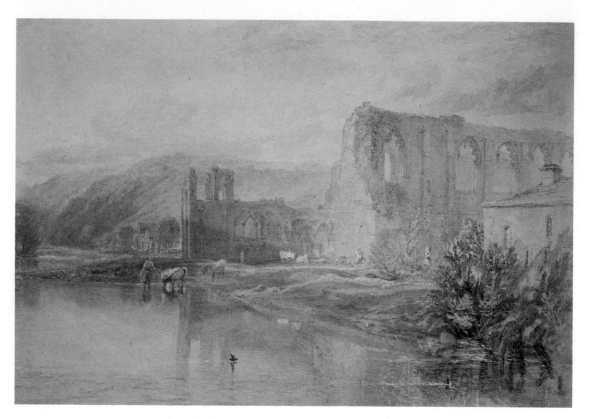

5 Joseph Mallord William Turner (1775–1851) *St Agatha's Abbey, Easby, Yorkshire, c.* 1819. Pencil and watercolour with white heightening. This is a good example of the watercolours Turner produced to be engraved in antiquarian publications, in this instance Dr Thomas Dunham Whitaker's *History of Richmondshire*, for which this design was engraved in 1822 by J. Le Keux.

6 ABOVE RIGHT Thomas Jones (1742–1803) *The Bay of Salerno.* Pencil and watercolour. In his *Memoirs* Jones recorded visiting Salerno on 17 November 1778: 'Tusday [sic] 17th Hired Mules & crossing the Promontory arrived at the top of the Precipices which hang over the Bay of *Salerno* on the other Side'.

7 RIGHT William Alexander (1767–1816) *Chinese Barges of Lord Macartney's embassy preparing to pass under a bridge,* 1796. Pencil and watercolour.

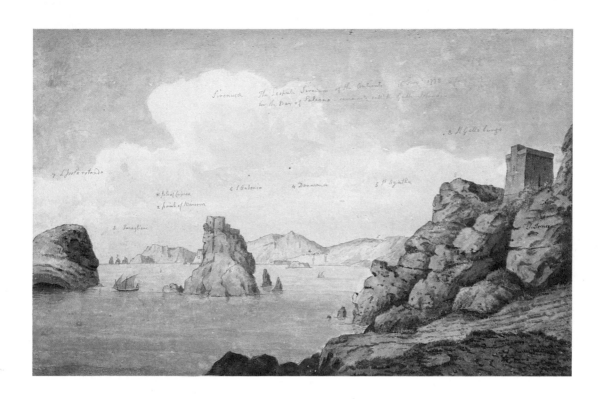

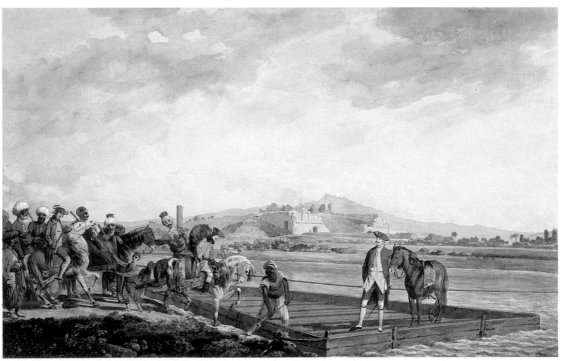

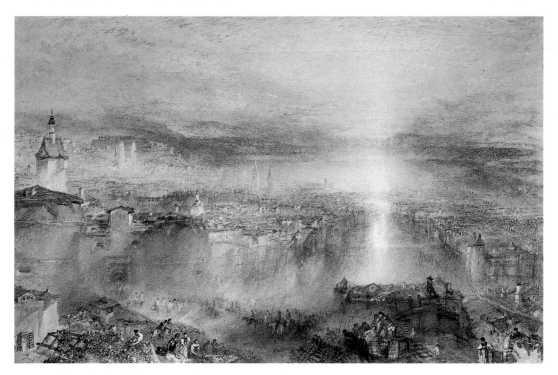

10 Joseph Mallord William Turner (1775–1851) *Zürich*, 1841–2. Watercolour.

8 ABOVE LEFT Francis Towne (1739/40–1816) *Tivoli from below the waterfalls*, 1781. Pen and watercolour. Although this page in an album of Towne's Roman drawings has suffered from spotting, the brilliancy of Towne's watercolour washes has survived due to the drawing having been kept in an album and protected from the harmful effects of daylight.

9 LEFT William Pars (1742–82) *View of the Temple at Miletus*. Watercolour. The travellers (Chandler, Revett and Pars) are shown crossing a broad stream on a horse ferry.

25

PENLEY CHURCH.

Mix a tint of indigo [], and begin with the upper part of the sky, passing the pencil backwards and forwards as described in the first example in colours, until the space is covered to the outline ; a tint of light red and indigo [] for the clouds ; while this is drying, wash a tint of light ochre over the church ; afterwards a pale tint of light red over the clouds, to subdue the whiteness of the paper ; the distance, indigo and a little lake [], finished afterwards with indigo ; then with a tint composed of gamboge, burnt sienna, and a little indigo [], put in the trees and fore-ground ; the path, light red, and a little indigo [] ; the roof of the church, lake and black [] ; the whole of the shadows upon the church, trees, fore-ground, &c. are put in with a tint composed of indigo, lake, and gamboge [] ; finish by using a little Vandyke brown as stains upon the church.

D

11 Hand-coloured aquatint of Penley Church with accompanying text from *A Series of Progressive Lessons intended to elucidate the Art of Landscape Painting in Water Colours*, 5th edn, published by T. Clay, 18 Ludgate Hill, 1823.

12 John Ruskin (1819–1900) *Study of ivy, 'Hedera helix'*, *c.* 1872. Pencil and watercolour.

the attendance was twenty-three thousand and, in addition to what came to them from the sales of their pictures, members received from the total of admission receipts a sum which represented nearly twelve per cent of the prices they had assigned to their exhibits. By 1812 the attendance at the exhibition was less than half that of 1809 and profits were negligible. Chivalrously excepted from any financial loss that members had to bear was Anne Frances Byrne (1775–1837), who was the first woman artist to be elected to full membership (1809). She was also exempted from any official duties.

Although it is difficult to pinpoint all the reasons, a number of factors must have contributed to the decline in the appeal of the 'Old' Society's exhibitions. The renewed wars with France inevitably lessened the buying public's ability and willingness to invest in works of art. Equally, the novelty of the watercolour exhibitions must have worn off. Whereas Farington (20 June 1805) quoted his fellow artist Callcott as saying of the first exhibition that 'the demand for drawings is very great', by 1808 the history painter Benjamin Robert Haydon recounted 'That a Gentleman had laid a wager of 20 guineas that in *three years* there will be no water colour drawings' (Farington, 1 June 1808). Rivalry and jealousy also played their part and a supporter of the Royal Academy and recently founded British Institution such as the connoisseur and collector Sir George Beaumont 'reprobated the rage for water colour drawings' (Farington, 1 June 1808) to the extent that Callcott observed that he 'believed Sir George Beaumont had done much harm to the Water Colour painters by His cry against that kind of art'.

Oversaturation of the market was also partly to blame. One of the drawbacks of the 'Old' Society had been its severe restriction on the number of members and the fact that only members were allowed to exhibit there. By the early nineteenth century there were more than enough artists working in watercolours to justify, or so it seemed, the founding of another body, the 'Associated' Society. An entry in the Minute Book (7 January) of that institution for 1808 (the year of its opening exhibition) reveals that it intended to play down the inevitable rivalry with the elder society. It was resolved 'That the members of the Socy of Painters in Water Colours, be presented with Tickets of Admission to the coming Exhibition; & that their Secretary be requested to transmit their names for insertion'. Furthermore, in their 1808 exhibition catalogue, it was clearly stated: 'they were not influenced by any sentiment of hostility or opposition to the Society which originated a few years ago, under a similar appellation'. Their appeal to prospective members lay in the immediate possibility of full membership to applicant artists. As a certain P. Henderson wrote: 'I certainly would prefer being a Member of your Society than an Associate of the other . . .' (Minute Book 15 July 1807). More illustrious artists than Henderson, such as John Sell Cotman, Samuel Prout and David Cox (President in 1810), were to exhibit with this society and it would generally be true to say that, for the brief period of its duration, the 'Associated' Society offered the viewing public watercolours of a better quality (or so it would seem to us today). There was also a greater variety of subject-matter. Landscape was not so predominant and there were, in comparison with the 'Old' Society, more portraits, still-lifes and so on. The rules of the Society also stated members were required 'to furnish five original subjects at least, of which or any greater number, two-thirds may consist of Portraits, but the remainder must be works of imagination'. 1812, however, was a disastrous year for the 'Associated' as well as for the older society and in

spite of admitting oil-paintings in an effort to boost sales, the landlords seized the contents of the show in lieu of rent, the chief sufferer being David Cox who lost a whole year's work without any financial compensation.

The 'Associated' Society disbanded and the elder society very nearly followed the same course. At a meeting at the house of Robert Hills, with William Havell in the chair, it was resolved that 'the Society . . . do consider itself dissolved by this night'. There had, however, been a proposal by John Glover, President for that year, to admit oil-paintings to the exhibitions. Although this was rejected, a reform group met in John Varley's house to found a 'society for the purpose of establishing an exhibition consisting of oils and watercolours'. Practical expediency triumphed over original principle (i.e. that watercolour should stand on its own as an alternative to oils) and for the next eight years paintings in oils were admitted to the reformed society's exhibitions. This innovation, apart from obviously offending the scruples of some of the members, only lasted until 1820 when, with takings down for that year, it was decided that oil-paintings had been a contributory factor to this decline and they were refused admission to the annual exhibitions. Reaffirming the Society's original aims, their manifesto for 1821 boldly proclaimed:

Within a few years the materials employed in this species of painting, and the manner of using them, have been equally improved by new chemical discoveries and successful innovations on the old methods of practice. The feeble tinted drawings formerly supposed to be the utmost efforts of this art, have been succeeded by pictures not inferior in power to oil paintings, and equal in delicacy of tint and purity and airiness of tone.

In celebration of its move in 1823 to new premises in Pall Mall East, the 'Old' Society granted itself the accolade of a 'retrospective' show, a loan exhibition from private collections of over two hundred watercolours, many of which had been exhibited at the Society in preceding years. Amongst the lenders were King George IV, the Duke of Argyll, William Blake, the distinguished collector and author Thomas Hope (who, given his enthusiasm for the Neo-Classical, suitably lent *Suburbs of an Ancient City* by John Varley) and the publisher and entrepreneur Rudolph Ackermann. The range and distinction of the lenders to this exhibition gives ample justification to the observations made in Ackermann's *Microcosm of London*, vol. II: 'But the patronage of the rich and the liberal has been extended in a more substantial manner; the sums they have given for many of the works exhibited by this society, rival the prices paid for any other kind of paintings.'

As far as the 'Old' Society was concerned, however, there was one continuing cloud on the horizon, its exclusivity. Ackermann's *Microcosm* had censured this aspect of the Society's conduct and roundly proclaimed: 'The public must be fed with variety as well as excellence'. In sharper vein Arnold's *Magazine of the Fine Arts* (May 1834) pinpointed the ingrown monopoly of the Society:

. . . the members of this little *junta* do not see the folly of being thus jealous of their privileges, for some of them, in their unbounded indulgence in that vice, coupled, as we may suppose, with an inordinate thirst of lucre, pour their contributions into this exhibition in such overwhelming numbers, as in a great measure to neutralise its general excellence, which, be their talent what it may, they cannot fail to do by imparting to the ensemble so predominating an air of sameness.

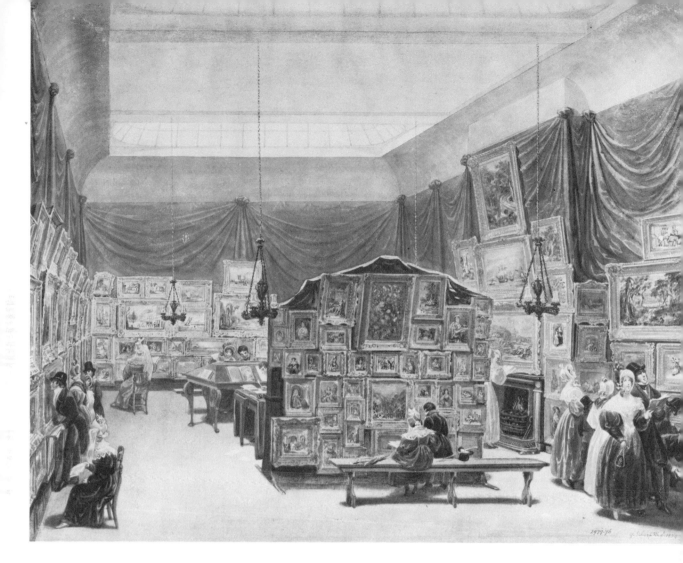

50 George Scharf (1788–1860) *The Gallery of the New Society of Painters in Watercolours, Old Bond Street*, 1834. Watercolour. The watercolours on display demonstrate the wide variety of subject-matter encompassed by watercolours at this time – landscapes, seascapes, still-lifes, genre pictures and others illustrating literary and historical subjects.

Chief among the offenders was Anthony Vandyke Copley Fielding (1787–1855) who had 'manufactured single-handed, the moderate complement of half a hundred' for the 1834 exhibition. At least Copley Fielding was not as devious as one of the original members of the Society, John Claude Nattes (*c.* 1765–1822), who had been expelled in 1809 for exhibiting works by other artists as his own productions in an attempt to gain from the exhibition a larger dividend than that to which he was entitled. It was hardly surprising, therefore, that yet another alternative watercolour society should have been formed. The 'New' Society, founded in 1832, numbered among its members artists who, on the whole, could be said to have been lesser talents, such as Joseph Powell, W. Cohen and G. S. Shepherd. There was an elected membership but other artists were allowed to exhibit and these included more illustrious names such as James Holland, Thomas Shotter Boys and James Stark. This liberal attitude to non-members was short-lived and from 1834 the exhibitions were restricted to members only in an effort to stop artists deserting to the 'Old' Society. The penalty for resigning without the other members' consent was twenty guineas.

Against this background of rivalry and bureaucracy that seems to have

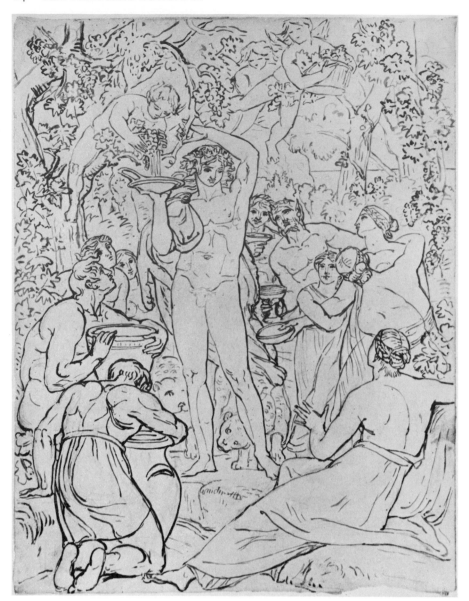

51 Possibly by Alfred Edward Chalon (1779–1860) *Bacchus and the Grapes*. Sepia wash. The drawing illustrates lines from Milton's *Comus*. The Chalon brothers were closely associated with the third society from its founding until its final meeting in 1851 and it eventually became known as 'The Chalon Sketching Society'.

characterised so much of the societies' conduct there were formed smaller sketching clubs of groups of artists who were concerned not so much with the very necessary struggle to obtain recognition and proper financial reward for those working in watercolour, but with the improvement of their own art, most especially in intellectual content.

In 1799 a small group of artists including Girtin, Francia and Robert Ker Porter formed a sketching club 'for the purpose of establishing a school of Historical Landscape, the subjects being designs from poetic passages'. It only lasted a few months but was replaced by another club commonly known as 'Cotman's Drawing Society', of which John Varley was a member. In 1808 a third society was formed, 'The Society for the Study of Epic and Pastoral Design'. Founded by Frances Stevens and John James Chalon, many of its early

52 John Partridge (1790–1872) *The Sketching Society at a meeting in 1838 presided over by Partridge*. Pen, ink, wash and white heightening. The artist resting his left elbow on the table is Thomas Uwins (see 93).

members (limited to eight in total) were also associated with the 'Old' Society, artists such as Havell, Pyne and Hills. They met at each other's houses in rotation every Wednesday evening from November until May each year. The host was president for the evening and was obliged to provide painting materials and nourishment, bread, cheese and beer, which gave rise to the society also being known as the 'The Bread and Cheese Society'. In return he was allowed to keep the drawings produced (between six and ten pm) that evening but not to sell them. The drawings were bound in folios and discussed and criticised at the next meeting. Technique (the sketches were in mono-chrome wash, apart from a few exceptions during the last eleven years of the Society's existence from 1840–51) was less important than subject-matter. The Bible, Shakespeare, Walter Scott and classical mythology were the main sources from which the subject for the evening's sketching would be set. It was doubtless the activity of this Sketching Society which caused watercolours of more elevated subject-matter to appear at the main watercolour societies' exhibitions. The Society should be seen as an important (and cerebral) influence in the background of watercolour activity. Distinguished visitors to the Society's evenings included Constable, Landseer, David Roberts and, in 1842, Queen Victoria, who set the theme of the evening's sketching as 'Desire'! On another occasion she chose 'Elevation', and the Society also presented her with nine drawings which she had selected.

53 Samuel Jackson (1794–1869) *A sketching party in Leigh Woods*. Watercolour and bodycolour. Jackson was one of a group of amateur and professional artists that flourished in Bristol in the early nineteenth century. Leigh Woods is a famous beauty spot the other side of the Avon Gorge from Clifton.

Royal involvement with drawings and watercolours was not limited to the Sketching Society. In 1852 Queen Victoria and Prince Albert visited the 'Old' Society's exhibition and the Prince Consort voiced his opinion on the correct mounts for watercolours to the artist William Callow (1812–1908), as the latter noted in his autobiography in 1908:

Prince Albert had a long conversation with me respecting art, and wanted to know whether the drawings would not be improved by white mounts, when I explained that the drawings were framed close up, in accordance with the rules of the Society, to prove that they could stand the gilt as well as oil paintings.

Today we are used to viewing or studying watercolours in cream or white card mounts, often with lines of framing wash colour added. It is considered no disgrace for a watercolour to be viewed as a 'drawing' or even a preliminary sketch. In the late eighteenth century watercolours had also been mounted in white-cream or greyish mounts with tinted borders and were most usually kept in folios or bound into albums. The advent of the watercolour societies' exhibitions changed everything. Often placed in heavy gold frames (usually without even a gold mount) watercolours were, in the words of W. H. Pyne, 'displayed in gorgeous frames, bearing out in effect against a mass of glittering gold, as powerfully as pictures in oil'. Reviewing landscapes in watercolour by Varley, Fielding and Cox which were exhibited at the 'Old' Society in 1824, Pyne referred to them as small 'cabinet pictures' and it was such that they were hung in the nineteenth-century collections. The artists involved were convinced that their watercolours should be so framed, as it was only in this way that they could be compared to and found equal to oil-paintings. Martin Hardie plausibly suggested that dealers, too, would have wanted watercolours so packaged, as they presented the Birket Fosters, David Coxes and Copley Fieldings which passed through their hands as 'value-for-money' purchases to the *nouveaux riches* collectors of the nineteenth century, whose drawing rooms already contained plush and gilt Victorian furniture. By the 1860s it would appear that the folio of drawings had come back into fashion. In a letter dated 13 November 1864 (letter in the Victoria and Albert Museum library) Dante Gabriel Rossetti informed James Smetham:

The great thing with dealers now is to get men of name to make moderate sized water-colours for mounting. Of these they make portfolios – one of each man – & sell the collection to cotton spinners and the like. It is far more profitable to them, & to the artists too, than anything else can be.

It should be noted here that Rossetti was referring to watercolours being used in a reproductive sense as copies after better-known paintings or book-illustrations.

The provinces, too, shared in the promotion of watercolour in the nineteenth century. Artists' societies and annual exhibitions sprang up in a number of provincial centres in the first half of the century. In Bristol, for example, an informal society, probably based on the London Sketching Society, was formed at the beginning of the nineteenth century and numbered among its members both professional and amateurs. For the talented artist, however, John Sell Cotman's assertion that 'London, with all its fog and smoke, is the only air for an artist to breathe in' probably held true. The most important centre for watercolour outside London was Norwich, where the Norwich Society of Artists exhibited, for the most part uninterrupted, from 1805 to 1833. Unlike other provincial centres, watercolours do not appear to have

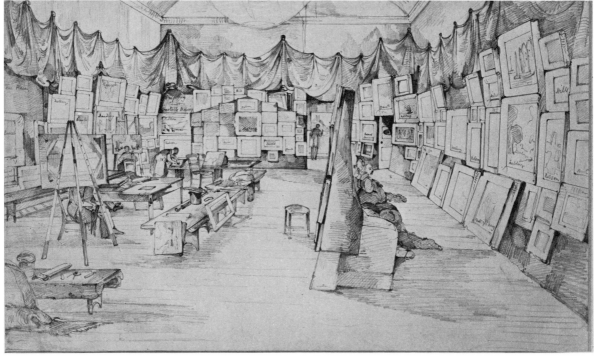

been exhibited there separately from oils, which gives some indication of the esteem in which the medium was held locally. Elsewhere outside London it was more normal for oils and watercolours to be separated and for prizes for the latter medium to be correspondingly lower. The only London-based artists who exhibited at Norwich were those with Norfolk origins, such as John Sell Cotman.

Watercolours by nationally known artists could be used to bolster an exhibition outside London, as occurred with the first exhibition comprised solely of watercolours to be held in Manchester, at Daniel Jackson's Gallery, 83 Market Street, in 1827. Here the stars were men such as Cox, Glover, Varley and Copley Fielding. In 1831 the Northern Society of Painters in Water Colours held their first exhibition in Newcastle-upon-Tyne and the Scottish Water-Colour Society was founded in 1878. While no provincial centre (not even Norwich, where there was always plenty of work on show but a depressing lack of patronage) could equal London in the amount, variety and quality of watercolours available, there was certainly a general awareness and appreciation of the medium. A glance at any provincial newspaper of note will reveal many advertisements for drawing-masters willing to instruct clients in the use of watercolour. There was also, especially in the nineteenth century, the phenomenon of the 'drawing-book', sold at better provincial booksellers, in which amateurs could read and instruct themselves in John Varley's, David Cox's and many other artists' precepts of watercolour painting.

The watercolour societies gave unity and strength (as well as very important publicity) to the great number of artists practising in the medium, but the sales at the annual exhibitions, although they provided a new and welcome source of income, can only have represented the icing on the cake which, almost without exception, was provided by fees earned from teaching. Even John Glover, reported by Farington to have earned seven hundred guineas at the first exhibition of the 'Old' Society in 1805, was also observed to be earning five guineas a day from teaching. It was in the master-pupil relationship that watercolour most impressed itself upon English society. Before leaving the watercolour societies, however, one can turn to Ruskin (as ever) for a last lingering look at their fate. By the middle of the nineteenth century the watercolour exhibitions were certainly well established and occupied a comfortable niche in the fabric of English art. The 'Old' Society's exhibition of 1856 was especially pleasing and comforting to Ruskin:

On the whole, the exhibition is greatly above the average; and the public seem to have discerned this, for the little bits of blue which the artists like to see completing their harmonies of colour, are now wanting to very few of the pictures. I am heartily glad to see this; for of all modes of spending money in self-indulgence, none are perhaps so collaterally kind, as the encouragement of an art so healthy and pleasurable as Water-colour Painting. (*Notes on some of the principal pictures exhibited in the rooms of the Society of Painters in Water-Colours*, 1856)

54 ABOVE LEFT John Crome (1768–1821) *Houses and Wherries on the Wensum, Norwich*. Pencil and watercolour. Crome, mainly through his teaching activities, was the most successful of the Norwich artists and was one of the prime movers in the foundation of the Norwich Society of Artists in 1803.

55 LEFT John Frederick Lewis (1805–76) *The Old Water-colour Society Gallery*, 1870. Pencil.

5 Drawing-Masters

. . . can you inform me the nature of teaching at Yarmouth,
as I am a perfect stranger to teaching school-fashion?
Saving for the best scholar's it's but a sorry drudgery and
only calculated for money-making when a man fags from
door to door merely for the pound sterling.
JOHN SELL COTMAN, letter to Dawson Turner,
17 December 1811

The profession of teaching has always presented something of a dilemma to
the creative artist, and Cotman's lament could well be echoed by many art-
school teachers today. Some artists are temperamentally suited to teaching
and some are not. John Constable, when offered the post of drawing-master
at the new Military College at Marlow, refused such employment and wrote
to his friend and follower John Dunthorne: 'had I accepted the situation
offered it would have been a death blow to all my prospects of perfection in
the Art I love'.

A happy contrast is provided by the figure of John Malchair (1729–1812)
who taught drawing to the undergraduates and younger residents of Oxford
from 1760 until the last years of the eighteenth century. He also taught music
until, in 1792, a gang of rowdies threw oranges during a concert and broke
the better of his two violins. Such was Malchair's popularity that a thousand
pounds was subscribed by friends and pupils and an annuity of a hundred and
fifty pounds was purchased for him. He was clearly a very sympathetic
teacher and in his (unpublished) treatise on teaching landscape drawing he
confessed that 'the task is rather difficult, for nothing is so humiliating to a
learner as the master's telling him that the very thing which he cannot do is
extremely easy'.

Malchair's career coincided almost exactly with the rise of the profession of
the drawing-master in England. In 1800 (*Diary*, 1 August) Farington called on
the elderly artist: 'He [Malchair] mentioned how much the Arts had advanced
in this country, and said that when He first taught musick and drawing in
London [in 1754] there were only 5 or 6 drawing masters – viz. P. Sandby –
Bonneau, who had been brought from the Spa by some ladies, – Chatelain –
& a few others, – now said He there are hundreds . . .' This observation is
borne out by the growing number of newspaper advertisements placed by
drawing-masters in the second half of the century. These artists often offered
drawing or painting materials for sale as well as their professional instruction
in the use of them (57). For example, E. W. Craig announced in the *Leeds
Intelligencer* for 20 January 1794 that he 'most respectfully acquaints the LADIES
and GENTLEMEN of LEEDS . . . that his PUBLIC SCHOOL will be opened as usual . . .
DRAWING and FANCY PAINTING are taught, in the most approved and fashion-
able Style . . . Mr CRAIG's WATER-COLOURS having met the Approbation of
some of the first ARTISTS in the Metropolis . . . as superior in Brilliancy, and
much more pleasant to Use than any others offered to the Public'. It was
against such a background that Lady Catherine de Bourgh, in Jane Austen's

56 John Baptist
Malchair (1729–1812) *The
Garden of Shute Barrington,
D. D., Christ Church,
Oxford*. Pencil and
watercolour. Malchair
obtained the post of leader
of the Music Room 'band'
at Oxford through the
good offices of Shute
Barrington. This
particular watercolour has
suffered seriously from the
fading of the colour
pigments due to exposure
to daylight.

Pride and Prejudice (1813), was shocked to hear from the heroine Elizabeth Bennet that none of the Bennet sisters could draw: 'That is very strange. But I suppose you had no opportunity. Your mother should have taken you to town every spring for the benefit of the masters.'

Except in fashionable centres such as London or Bath, the drawing-masters constituted something of a singular phenomenon. Peter De Wint (1784–1849) followed an annual pattern of teaching during the late spring and early summer, travelling round England and Wales in the late summer sketching new material, and spending winter at home working up his finished paintings and watercolours. Later in life his programme became somewhat less flexible in that he spent most of his year in London and his summer travelling was often confined to Lincoln (his wife's native town), where he had bought a house in 1814. Nevertheless, his seasonal division of activities was typical of many artists.

De Wint taught drawing in watercolours, but prior to the end of the eighteenth century pure watercolour was not generally used for teaching. Pen and ink and pencil were the basic media in which instruction was given by the drawing-masters, who would only occasionally advise the addition of a few coloured tints. Indeed, Edward Dayes, in his posthumously published *Works* (1805), was convinced that too many colours in the hands of a novice could only spell disaster:

ARCH.ᴰ ROBERTSON,

PRINT-SELLER and DRAWING-MASTER,

in Savill Row Passage, adjoining Squib's Auction Room

Sells great variety of ITALIAN, FRENCH **and** DUTCH **Prints and Drawings;**

Best Swiss-Crayons, variety of Drawing Paper, Port Crayons, all sorts of Italian and French Chalks, Colour-Boxes, the best black Lead and Hair-Pencils, Indian Ink, Port-folios with or without Leaves, Ladies black Tracing Paper; and very fine Transparent Dᵒ for Etching, with Copper-Plates prepared for Dᵒ Etching Needles &c. &c. &c.

Visiting Cards, Engraved in the most elegant manner;

Great choice of Paper-Hangings in the newest Taste.

N.B: Sandby's works in Aqua Tinta, to be had complete

Prints Framed & Glazed, and Drawings neatly fitted up.

all sorts of Stationary Wares.

57 The trade card of Archibald Robertson. The variety of trades which many drawing-masters had to pursue to make a living is well illustrated in this late eighteenth-century example.

One great inconvenience the student labours under, arises from the too great quantity of colours put into his hands; an evil so encouraged by the drawing-master and colour-man, that it is not uncommon to give two or three dozen colours in a box, a thing quite unnecessary.

It need hardly be added that the rise of the drawing-master did the cause of the colourman no harm whatsoever.

The specialised watercolour drawing-master developed from the much older tradition of the general drawing-master. Renaissance etiquette had demanded that a gentleman should be able to draw. Baldassare Castiglione, in his *Book of the Courtier* (first published in English in 1561 and widely read) had cited precedents for this from classical antiquity. He also proclaimed the practical use of drawing, namely recording geographical features and architectural landmarks while engaged upon travel or upon military campaigns. Further, he stressed the spiritual benefit of drawing, the combination of beauty in art and in nature. Castiglione's literary successor in England was Henry Peacham, whose *The Compleat Gentleman* (1634) has already been referred to. Peacham's advocacy of watercolour as the gentleman's preferred medium was echoed by John Ruskin over two hundred years later, and the reasons given were very much the same; both authors claimed that painting in oils (the obvious alternative) required too much effort and was also messy and odorous!

The early history of drawing-masters in England is obscure largely due to the absence of available facts. The case of John Dunstall (see Introduction) is one of the few exceptions to this and his manuscript treatise, *The Art of Delineation*, paraphrased Castiglione in its recommendation of drawing for having a spiritual purpose as well as lawful delight and usefulness.

Usefulness was certainly the prime reason for drawing being introduced into the curriculi of English schools and military academies. In 1692 the governors of Christ's Hospital consulted the diarist Samuel Pepys as to whether they should appoint a drawing-master for the boys in the Mathematical School, and Pepys replied in the affirmative, stating that drawing would be useful for all trades. The architect Sir Christopher Wren was also approached and he replied most forcefully: 'Our Natives want not Genius, but education in that which is the ffoundation of all Mechanick Arts, a practise in designing or drawing to which everybody in Italy, ffrance and the Low Countreys pretends to more or less.' Accordingly, the governors appointed William Faithorne the Younger (1656–1701) to teach drawing for three afternoons a week at twenty pounds per annum. (He was dismissed from his post in 1696 due to his dilatory habits.) Approximately one year later what was possibly the earliest drawing school in the country was established in the St Paul's area of London by Bernard Lens II (1659–1725) and the engraver John Sturt. So, by the beginning of the eighteenth century drawing was taught privately to royalty and to the nobility and was slowly being established in various academies as well. Bernard Lens III (1682–1740) was given a Royal appointment as a limner and was drawing-master to Horace Walpole, and probably to the Duke of Cumberland and the Princesses Mary and Louisa. As Martin Hardie pointed out, Lens may well have been the first of the fashionable drawing-masters.

Another member of the Lens family, Edward, also enjoyed employment as drawing-master at Christ's Hospital. He was succeeded in this post by a more

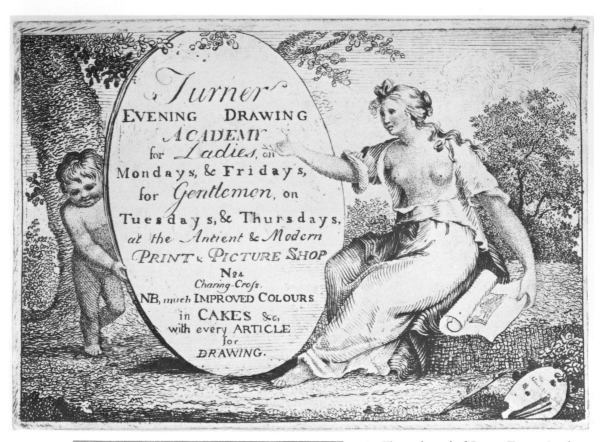

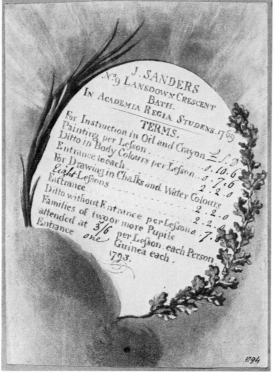

58 The trade card of George Turner. In a letter of 7 November 1928 (Heal collection) Henry Batsford informed Ambrose Heal that Turner's 'Academy' existed 1770–1800. Apart from the card's emphasis on the improved nature of the watercolour cakes that were for sale it is interesting to note that the drawing classes were segregated by sex.

59 The trade card of J. Sanders. According to the trade card, Sanders had been established in Bath since 1769, though the addition of the prices in manuscript indicates they presumably increased over the years to the level quoted for 1793.

famous artist, Alexander Cozens (*c.* 1710–86), who was the successful candidate from amongst five applicants for the job – some indication perhaps of the increasing popularity of the profession. Appointed in 1749, Cozens was forced to resign only five years later because of complaints of falling standards amongst his pupils. Prior to their acceptance as apprentices at sea the boys entrusted to Cozens's care would have been taught the delineation of ships, headlands and coastlines – a very practical course of instruction, though one that can hardly have given any great satisfaction to an artist who is now justly credited as being one of the first truly 'poetic' and 'sublime' English landscape artists.

Cozens benefited in the material sense, however, from his frequent employment as a drawing-master, a profession in which he enjoyed considerable popularity. In a draft of a letter to William Hoare, a painter at Bath, he excused himself for the non-delivery of some promised drawings:

The [greatest *erased*] best Excuse I have Sr. in vindicating myself is that being so much employed in Teaching Drawing, both at Eton School & private Scholars in London altho I have a great deal of Business bespoke on my favourite Subject [of *erased*] [Draw making Drawing *erased*] Composition of Landscape, yet I have so little time to make Drawings especially in Winter that I am forced to solicit & rely on the utmost stretch of yr. Good nature and Patience of my Friends and Employers. (*The Walpole Society*, vol. XVI)

Amongst Cozens's pupils at Eton was the young Sir George Beaumont, who was to be such a staunch opponent of the widespread fashion for watercolour painting in the early nineteenth century. This may well have been due to the nature of the instruction he received from Cozens, who taught an essentially linear, artificial and 'picturesque' type of landscape drawing which was at a considerable remove from the 'painting' in watercolours that became fashionable in the nineteenth century.

'Picturesque' draughtsmanship was also taught by a number of French drawing-masters who came to teach in England in the eighteenth century, particularly after the wars with France ended in 1763. W. H. Pyne later ridiculed two such masters, Pillement and Chatelain, for producing landscapes in black chalk that were 'the veritable beau-ideal of the landscape regions of the shepherds and shepherdesses of the French opera'. Continuing his denigration of this picturesque trend, he (rightly) noted its effect on Gainsborough, whose style during his years at Bath would have influenced by example the 'polite idlers' of that fashionable spa town. Whatever the merits or otherwise of Pyne's case, his commentary provides a most revealing indication of how radically taste had changed by the 1820s when he was writing.

As Cozens, and a steadily increasing number of artists, earned their living teaching, so, too, was the instruction in drawing taken up in a greater number of institutions. In 1743 John Fayram had been appointed first drawing-master at the Royal Military Academy at Woolwich to teach gunners and engineers the delineation of plans and designs. Fayram's salary was three shillings per day, but by 1767 his successor, Gamaliel Massiot, had his salary advanced to a hundred pounds per annum 'on account of the loss of his private teaching by his constant attendance at Woolwich'. The following year the Academy appointed a man they considered to be better qualified for the post, Paul Sandby, at the same salary but on the understanding that he was only required to carry out his duties one day per week. After his period of service as

draughtsman to the Board of Ordnance Survey of the Scottish Highlands in the 1740s Sandby would have been well acquainted with the requirements for military drawings. Coloured drawings made by officers could be used to illustrate military reports and these same officers often submitted their drawings of engagements in which they had fought to professional printmakers, who translated their efforts into newsworthy engravings to be sold throughout the country. Drawings were also used for the illustration of artillery manuals.

In 1802 a junior department of the Academy was set up at Great Marlow and drawing was included in the course of instruction. The Inspector-General of Instruction at Great Marlow, General Jarry, wisely stated: 'Everything which is put down in writing of necessity takes on some colour from the opinion of the writer. A sketch map allows of no opinion.' The quality of artists employed at that institution was high. William Alexander was employed there from 1802–8 and William Sawrey Gilpin (first President of the Old Water-Colour Society) joined the staff in 1806.

The military colleges were transferred to Sandhurst from 1812–13 and instruction in drawing continued to form part of the curriculum. After 1845 entrance was decided on merit and a preliminary examination was introduced for officers, which included a test in drawing. Prior to the examinations aspirant officers often engaged private drawing-masters in the hope of improving their results.

The East India Company also desired its officers to be trained in drawing and in 1809 founded its own college at Addiscombe where drawing was taught. W. F. Wells, who had been so instrumental in the founding of the first watercolour society, was drawing-master there from 1812–36. Bored wives in India could also, apparently, benefit from instruction from the drawing-master. Emma Roberts, in her *The East India Voyager* (1839) advised 'outward bound' ladies 'to study under a good master and to understand the principles of the art; for there is little in the way of tuition to be had in India and no paintings from which amateurs can take hints for their improvement'.

From about the middle of the eighteenth century drawing began to be included in the syllabi of local schools. The earliest instance noted in Norwich, for example, was in 1761 when a drawing-master from London, probably one of the ubiquitous Lens family, was engaged by the Rev. Mr Latournelle to teach at the latter's Academy. Drawing was offered as an optional subject and classed in the same category as fencing, dancing and music. In addition to carrying out his duties at Latournelle's Academy John Lens also instructed pupils privately at his house in St Stephen's Street or in their own houses. He taught young gentlemen drawing and painting in watercolours and the five orders of architecture. From about 1763 he appears to have given up the profession of drawing-master and to have become 'an eminent land steward'.

While there was an undoubted increase in demand for drawing-masters, it was not a profession which always guaranteed lucrative employment. John Lens abandoned his activity in that field and, forty years later, one can cite the case of R. Bonington in Nottingham, father of the famous watercolourist Richard Parkes Bonington (1802–28). Between 1797 and 1801 Bonington senior had to change his business premises no less than four times. In 1801 his wife set up an academy for young ladies at which her husband was to teach drawing. Five years later Bonington's career had changed course and he was selling prints, drawings, drawing materials and fancy articles in a shop. Later

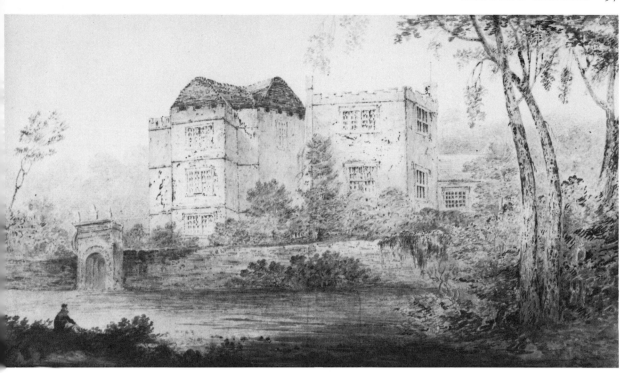

60 William Pearson
(fl. 1789–1813), *Heythrop
House, Gloucestershire*,
1803. Pencil, chalk and
watercolour. Pearson
evidently flourished as a
provincial drawing-
master and the
commonplace book at
Brandsby, Yorkshire
(home of Cotman's future
patrons, the Cholmeleys)
records, in 1798, several
visits by 'Mr Pearson, ye
drawing master from
Rippon'.

advertisements reveal he also offered music, writing papers, optical glasses and camera obscuras for sale. By August 1817 the family had been forced to sell off all their stock and had moved to Calais.

The genteel nature of drawing as a leisure activity rapidly led to it becoming largely the prerogative of female pupils. A typical newspaper advertisement illustrative of this was that placed by R. Barlow, a former schoolteacher, in the *Norwich Mercury* for 7 January 1792:

N.B. Young Ladies taught at their own appartments the following arts, viz. Pencils, India, Ink, Chalks, Crayons, Dry Colors; Water-Painting on Silk, Satin, Tiffany &c. also a beautiful new-invented Drawing on Vellum or Paper, performed with Worsteads, which indicates the present fashionable print-work and aqua-tint prints so exactly as to deceive the nicest eye.

With the boom in watercolour painting at the beginning of the nineteenth century, it evidently suited drawing-masters to flatter potential female customers. David Cox's remarks on the increased prestige of watercolours, in the preface to his *Light and Shadow, in Imitation of Indian Ink* (1812), lack subtlety but were probably most effective. He stated that it was 'with feelings of national exultation, that we can ascribe, in a great degree this improvement in so elegant a department of the fine arts to our lovely countrywomen. It is the cultivation of the study of drawing in watercolours, by the enlightened ladies of our time, that the best artists have owed their encouragement . . .'

If the female pupils were well bred and their families offered congenial hospitality there is no doubt that the drawing-master's life could be an extremely pleasant one. In contrast to his later, unsuccessful, years in his native Norfolk, John Sell Cotman in the period immediately leading up to his famous 'Greta' drawings of 1805–6, enjoyed an exceptionally happy relation-

ship with the Cholmeley family of Brandsby in North Yorkshire. The Cholmeleys, like so many county families of the time, had already had experience of employing drawing-masters. The commonplace book for Brandsby records that William Pearson of Ripon and Henry Cave of York had already taught at Brandsby but, on 7 July 1803 the entry reads 'Mr Munn and Mr Cotman came'. Cotman was engaged upon a sketching tour of northern England with his fellow artist Paul Sandby Munn (1773–1845) and it appears that an introduction to the Cholmeleys had been arranged by Sir Henry Englefield, a patron of Cotman's and Lady Cholmeley's brother. Sandby Munn departed for London in early August but Cotman remained with the Cholmeleys until late September and was to return again in the following two summers. Just as Turner enjoyed a fruitful relationship with the Fawkes of Farnley and Girtin was patronised by the Lascelles of Harewood, so was Cotman taken up by the Cholmeleys of Brandsby to the extent that they arranged tours for him throughout Yorkshire and introduced him to their friends, such as the Morritts of Duncombe Park, the Belasyses at Newburgh and the Fairfaxes at Gilling Castle. As far as one can tell it was not Cotman's method of teaching so much as his personality and social manner which cemented his friendship with the Cholmeleys. While Mrs Cholmeley found Sandby Munn 'rough peculiar mannered', 'Cotty', as the family called him, was 'more mannered and gentlemanlike'. She admired the 'genius and simplicity of his character and [his] kindheartedness and benevolence' so much that he became almost one of the family, 'the child of the parents and brother to their children'. (There were four children, one of whom, Harriet, composed a piece entitled 'Cotmania'.)

Cotman's lack of commercial success with his drawings and watercolours forced him to rely extensively, for most of his career, upon teaching. Whereas in Yorkshire he was fortunate to find particularly sympathetic patronage, in Norfolk he suffered in the open market, as it were, from competition from the very successful teaching practice of John Crome. In the decade 1810–20 he was also engaged in producing etchings of an architectural nature to the extent that the potential attraction of his style probably suffered. As a former pupil Charles Palmer recalled: 'In my school days I took lessons in drawing from Mr John Sell Cotman . . . His style is peculiar to himself and not generally admired, as it is almost exclusively devoted to the delineation of antiquarian objects, in which, however, it is most admirable; and it is a matter of regret that I had not the benefit of instruction for a longer period' (*Diary and Journal of Charles Palmer, F.S.A.*, 1892).

It was obviously crucial to a drawing-master's success for his style to be deemed fashionable. Much of the instruction offered consisted of straightforward copying of a particular master's style. William Payne (fl. 1776–1830) deliberately evolved a reproducible manner with the result that, as W. H. Pyne recalled, 'for a long period, in the noble mansions of St James's Square, and Grosvenor Square, and York Place, and Portland Place, might be seen elegant groups of youthful amateurs, manufacturing landscapes, *à la Payne*.'

Another artist noted for technical innovation was the Yorkshireman Francis Nicholson (1753–1844) who settled in London in 1803. Notes compiled by a member of Nicholson's family for an unpublished biography of the artist reveal something of the success enjoyed by the fashionable drawing-masters of the time:

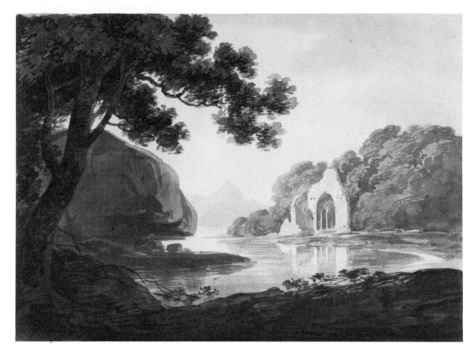

61 William Payne
(fl. 1776–1830) *Ruin, Lake
and Mountains*. Pencil and
watercolour. This
example illustrates the
rather mechanical style of
many of Payne's
watercolours.

The opening of the Water-Colour Exhibition in the year 1805 may be dated as the commencement of Mr Nicholson's fame and success in London. In conjunction with Glover, Varley, Prout and others an advance in the art of water colour painting was made such as to astonish and call forth the admiration of the public. The next step, after admiring, was to imitate the work of these artists and for some years after their doors were beset and the streets where they resided thronged with the carriages of the nobility and gentry. It became an absolute craze among ladies of fashion to profess landscape painting. They eagerly paid their guineas an hour for the privilege of witnessing the progress of a picture by their favourite professor. (Quoted by Hardie, vol. III)

Short-cuts in technique could also ensure a master's popularity. John Glover (1767–1849) evolved a split-brush technique whereby the hairs of the brush were divided by thin wire so as to obtain several sharp points which could be used for painting the foliage in a watercolour. Glover taught extensively both in London and in the country, with corresponding differences in his tuition fees. Farington recalled (*Diary*, 20 April 1808):

In the country He [Glover] goes from family to family, & has 2 guineas a day at each House. He begins a drawing His pupil standing by and having proceeded as far as He considers it to be a lesson leaves it with his pupil to copy . . . He gives lessons in London in the same manner, but has *two guineas* for a lesson of *three Hours*.

An alternative method of instruction to the direct teacher-pupil relationship was the purchase of drawing manuals which could be studied at home at the pupil's leisure. As early as 1775 Sayer and Bennett in London were advertising over two hundred such manuals for sale, though many of the eighteenth-century texts were, to a large degree, paraphrases of one another. They were concerned, above all, with the drawing of the human figure, and landscape was often relegated to sections at the ends of such books. These sections usually dealt with the formal type of landscape that was to be found

in engravings after Claude or Gaspard Poussin. In addition, texts and illustrations were not integrated, although this changed around the beginning of the nineteenth century, when the illustrations in drawing-books were increasingly placed strategically in the text and much more emphasis was placed upon both landscape and the use of watercolour. Readers were taken, with the aid of appropriate illustrations, step by step through the various stages of execution of landscape watercolours. John Laporte's *The Progress of a Water-Coloured Drawing* (*c.* 1805), for example, showed the same composition many times over in its sequence of execution, proceeding from the line drawing through the addition of shading and colouring to the finished watercolour. The same approach was adopted by David Cox in his *A Series of Progressive Lessons* (1811) illustrated with aquatint prints by G. Hunt after watercolours by Cox. In the printed instructions for colouring the plates in this book there were included hand-coloured oblong patches of the colours which the reader should employ to achieve the correct results in his or her imitations of Cox's work (see plate 11). Such a relative degree of sophistication in the manner of instruction could only have been offered in the knowledge that the reader had access to a standardised range of manufactured watercolours and, as was demonstrated in the Introduction, this was indeed the case by the early nineteenth century. Whereas earlier books of instruction on the use of watercolour had been primarily concerned with the correct mixing of the colours, those produced by Cox's time were able to concentrate on giving advice on the artistic *use* of watercolour materials.

The greatly improved manufacture of the watercolour paints offered for sale to amateurs was undoubtedly one reason why learning to paint in watercolours became such a popular pastime in the early nineteenth century. The public attention focused on watercolour by the watercolour societies' exhibitions would have been equally significant in fostering a desire to draw and paint in emulation of artists such as Cox and John Varley. Furthermore, the recent advances made in printing technology meant that, with the introduction of aquatint and soft-ground etching in the latter half of the eighteenth century, illustrations in drawing-manuals could reproduce, to a large degree, the original qualities of drawing in chalk or crayons and the tonal effects of washes in drawings.

Another method of instruction was that provided by copy drawings circulated by artists and dealers for pupils to study. The origins of the idea can be traced back to Rudolph Ackermann, who at the very beginning of the nineteenth century had started to circulate prints after compositions by Girtin, Payne and other artists. Cotman adapted this scheme for the circulation of his own original copy drawings and advertised his 'Circulating Collection of Drawings' in the *Norfolk Chronicle*, 22 July 1809:

J. S. Cotman will attend the delivery of the drawings to the subscribers, that he may facilitate their copying them by his instructions.
Days of delivery Mondays and Thursdays, between the hours of twelve and two.

The collection contained a total of six hundred drawings and a quarterly subscription ticket cost one guinea – a much lower rate than that charged for individual tuition. David Cox also provided copy drawings for distribution, though he sold the drawings to dealers, who then supplied country drawing-masters with material for their pupils to copy. The ready market in the provinces was probably determined by an over-concentration of drawing-

62 Hand-coloured soft-ground etching frontispiece to *The Young Artist's Companion* . . ., a series of progressive lessons in watercolour painting by David Cox, London, 1825.

masters in London. For example, Farington noted (*Diary*, 2 November 1810): 'A *good drawing master* is now wanted at Exeter. Such a one would find employment in the town and in the neighbourhood.'

The provision of copy drawings was discussed by the engraver John Burnet (1748–1868) in his fictionalised *The Progress of a Painter in the Nineteenth Century* (1854). Burnet related how printsellers and dealers not only supplied amateurs but furnished libraries with examples of artists' works to be lent out to schools and their pupils. The artist in this book, David Scaife, would manufacture them for half a crown each 'and supply the shops, not by dozens, but by hundreds. He would pencil out twelve compartments and, after adding the landscape outlines, would soak the whole sheet in water and then quickly add the washes of colour.' This was one solution to the mass production required by such a procedure.

While many pupils were content merely to copy in such an undemanding fashion, others expressed their dissatisfaction. Elizabeth Turner, daughter of the Yarmouth banker and patron of Cotman, Dawson Turner, wrote to her father (5 October 1822):

Not only has Mr Varley [John Varley] with most unwearied diligence sought to show us every way of copying his drawings, he has also tried to make us compose and explained to us all those principles of composition which, after many years of hard fagging, he discovered himself. But, alas! all his endeavours are vain. We can copy, and that is all. (*The Walpole Society*, vol. XXI)

The mediocrity of much of the drawing that was taught in the nineteenth century was strongly criticised by Ruskin in *The Elements of Drawing* (1857). Earlier manuals, Ruskin (who was a distinguished amateur artist himself, see plate 12) claimed, 'propose to give the student a power of dexterous sketching with pencil or watercolour, so as to emulate (at a considerable distance) the slighter work of our secondrate artists'; for Ruskin 'the best drawing-masters are the woods and hills'. Nevertheless, Ruskin himself was subject to the vagaries of fashion and in 1841 had exchanged the tuition of Copley Fielding for that of James Duffield Harding (1797–1863), who was supplanting Fielding as the most successful drawing-master of his time.

As the nineteenth century progressed watercolour painting continued to be a popular pastime with amateurs and enthusiasts, though distractions such as cheaper and more widely available pianofortes encroached upon the drawing-masters' hold on the genteel affections of young ladies. The sons and daughters of the rapidly growing middle classes and, indeed, of the increasingly educated working classes, learned to draw and paint at institutionalised academies and not only at the masters' studios or in the privacy of their own homes. The Government School of Design, initiated in 1836, and the interest in industrial and applied art design aroused by events such as the Great Exhibition of 1851, also served to push amateur watercolour painting into the background, compared to the high fashionability it had formerly enjoyed. Watercolours by the great names of the early nineteenth century fetched higher prices at auction and, it might be surmised, seemed like other highly prized fine-art objects to be beyond the powers of imitation of the amateur. Photography, on the other hand, attracted an increasing number of professionals and amateurs from the middle of the nineteenth century onwards, and the photograph album often replaced the drawing album in Victorian drawing-rooms.

6 *Amateurs*

My father belonged to a generation which divide painters
into the serious and the amateur, according as they used
oil or water.

EVELYN WAUGH, *Brideshead Revisited*, 1945

The many books of instruction for the amateur on the use of watercolour that
are still being published would seem to indicate that the opinion of the
narrator's father in Evelyn Waugh's masterpiece remains valid today. The
immediate advantage of watercolours over oils lies in their comparative
simplicity and ease of use. Watercolour materials are light and compact when
compared to the equipment required for painting in oils. Watercolours also
require less time for their execution than oil-paintings. It should come as no
surprise, therefore, to find that the store-rooms of many of our public
galleries and museums and the libraries of our country houses contain count-
less sheets and portfolios of drawings and watercolours which bear witness to
the popularity that the execution of watercolours has enjoyed amongst
amateur practitioners of both sexes in this country for the past two hundred
years. In the middle of the nineteenth century Tom Taylor gently observed of
amateurs' efforts in 1857: 'Who knows not those delightfully blue distances,
and slightly woolly foregrounds, and occasionally wooden figures, and that
questionable perspective, which does not prevent these amateur performances
from giving the intensest pleasure in the making' (Taylor, *A Handbook to the
Water Colours, Drawings and Engravings in the Art Treasures Exhibition*).

While the motivation for amateur sketching very often came from a simple
desire to indulge in a pleasurable pastime (the Rev. Gilpin prefaced his *Three
Essays* (1792) by stating he had 'practised drawing as an amusement, and
relaxation, for many years') it should be remembered that, since the late
Renaissance, an ability to draw had been considered a desirable quality for a
young gentleman and, if he embarked upon a military career, it could be a
necessity. Antiquarians, historians and travellers had also, for obvious reasons,
found drawing of use, but it was not until the latter half of the eighteenth
century that drawing became generally 'fashionable' and the word 'amateur'
was widely used in this context.

One reason for this upsurge of interest was, as has been already indicated,
the greater availability of suitable drawing and painting materials. The
number of watercolour artists worthy of emulation had also increased and
there was, in addition, a growing number of native drawing-masters who
were supplanting earlier immigrant French drawing-masters such as Chatelain
and Gravelot. The Newcastle artist T. Beilby, for example, announced in the
York Courant, 28 November 1769 that he proposed opening a 'Drawing-
School' in Leeds 'to initiate the young Ladies and Gentlemen of this Town
into a knowledge of the several Branches of that polite and useful Accom-
plishment'. Drawing, therefore, was coming to be regarded as one of the

social graces to rank with music, needlework, dancing or fencing.

The spa-town of Bath was of particular interest as far as gauging the pulse of the fashionability of drawing in the latter half of the eighteenth century is concerned. Alexander Cozens taught there and Gainsborough was a resident 1759–74. Neither artist could be termed a watercolourist in the true sense of the word for many of their landscape drawings were essentially monochrome and executed in wash or chalk, though both occasionally employed water-colours. Both artists, however, had distinctive drawing styles and had many imitators, a fact which was strongly criticised by W. H. Pyne, writing in 1824. His comments are more interesting, in the present context, for their reference to the great popularity of Cozens's and Gainsborough's styles rather than for any technical observations. According to Pyne, Cozens 'had a host of scholars for several seasons, who rewarded him most munificently for his wonderful discovery!', while Gainsborough 'unwittingly set the fashionable world agog after style . . . The copyists, or rather dabblers in his new style, were full grown amateurs, polite idlers at Bath . . . The Gainsborough mania was long the rage; and there are yet some antique beaux and belles of *haut ton*, who recall their many friends who, with themselves, were stricken with this sketching phrenzy, and smile at Bath and its varieties, as they talk of the days that are gone' (*Somerset House Gazette*).

Gainsborough had no formal pupils in Bath but in the 1780s was extensively patronised by the royal family and taught drawing to Queen Charlotte and a number of the royal princesses. Henry Angelo's recollection of this reaffirms the popularity that Gainsborough's style then enjoyed: 'Her majesty took some lessons of Gainsborough, during the then fashionable rage of that artist's eccentric style, denominated Gainsborough's moppings' (*Reminiscences*, 1828). Gainsborough's drawing style had a wide influence in later, professional circles, largely through the efforts of Dr Monro (see pp. 131–2), who possessed several of the artist's sketches and directed younger artists to copy them.

Fashion played its part, too, in the encouragement amateurs received from the early watercolour exhibitions in London. Ackermann's *Repository of Arts* . . . (1813) noted of the first such exhibition in 1805: 'In every polite circle the conversation turned upon the Exhibition in Brooke Street, and every artist of established reputation was prevailed upon to become a teacher of his art.' The fully coloured drawings of artists like Cox, Varley and De Wint became the objects of admiration and emulation, though it is generally apparent from the surviving examples that few amateurs were capable of the technical sophisti-cation achieved by these masters and often reverted to less demanding formulae for their sketches which in technique usually harked back to the essentially monochromatic drawing styles of the eighteenth century.

It is generally true that amateurs belonged to the aristocratic and land-owning classes, and the majority were young ladies for whom an ability to draw was viewed as a social achievement and improved the prospects of marriage. Their activities were satirised in a skit which appeared in 1787 and was later quoted by Thornbury in his *Life of Turner* (1862):

What a fine, clear morning! I will do my sky. Betty! tell your mistress if anyone calls, I can't be seen – I'm skying. Betty! Betty! bring me a pan of water, and wash that sponge: it is really so hot, I cannot lay my colour smooth.

Mrs A. M. Hall, the wife of the editor of the magazine, the *Art Union*, contributed a sentimental dramatic story entitled *The Old Drawing Master* to the July issue of the magazine in 1839 in which she described the trials and

64 RIGHT ABOVE Peter De Wint (1784–1849) *Gathering the Corn.* Watercolour.

63 RIGHT Dr Thomas Monro (1759–1833) *Cows and sheep by a stream, after Gainsborough*, 1817. Black chalk on blue paper. Monro's style was closely modelled on that of Gainsborough.

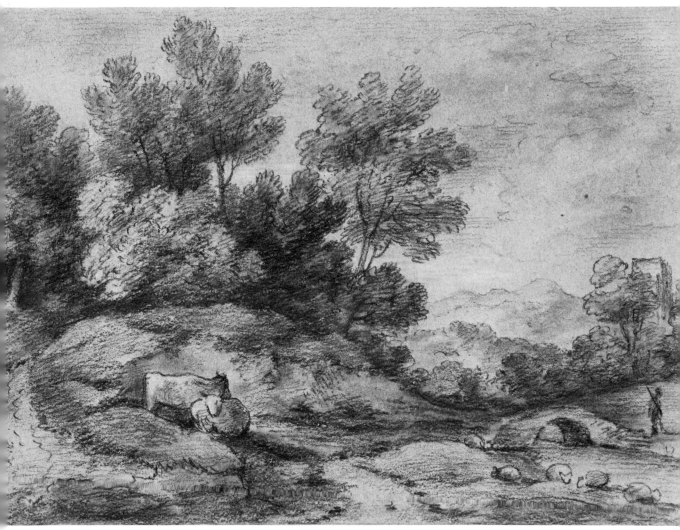

65 Coplestone Warre Bampfylde (1720–91) *Pear Pond, Hestercombe, Somerset*. Pencil and wash. The arts of landscape drawing and gardening are well combined in this drawing by the amateur Bampfylde, who was responsible for laying out the park of the family estate at Hestercombe near Taunton.

66 Joseph Wright of Derby (1734–97) *The Rev. d'Ewes Coke, his wife Hannah and Daniel Parker Coke MP, c.* 1780–2. Oil on canvas. Hannah was evidently an amateur artist as is shown by the portfolio of sketches she holds and by a sheet of studies of trees which peeps out from the edge of her portfolio.

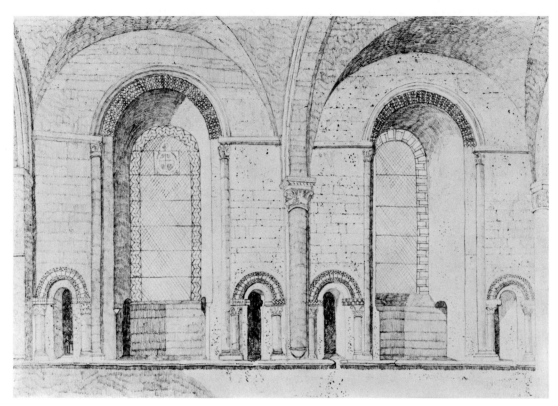

67 Elizabeth Rigby,
Lady Eastlake (1809–93)
*The Abbey Church of the
Holy Trinity at Caen, north
side of the choir*, 1825.
Pencil. This is a copy after
an etching by John Sell
Cotman from his
*Architectural Antiquities of
Normandy*, 1822.

68 Henry Edridge
(1769–1821) *Amelia Long,
Lady Farnborough, c.* 1820.
Pencil and watercolour.

tribulations in the 1790s of an old French drawing-master called Monsieur La Trobe. Speaking in a heavy French accent, he complained to his pupils:

You are all sweet, kind young ladies, you very sweet, and good, *ven you not draw*, and monche, monche de tops off your crayons, and lose Engee rubbere, and mark skies green, and grass blue; you are all most charming ven you away from your lessons.

Elizabeth Rigby (1809–93), who was an amateur artist herself and later married the first Director of the National Gallery, Sir Charles Eastlake, recalled comments made at the expense of lady amateurs by John Wilson (later professor of agriculture and rural economy at Edinburgh University, 1854–85) at an Edinburgh dinner table in the early 1840s. He claimed he had once mistaken one of their drawings of a waterfall for a pair of trousers hanging out to dry and another of a cluster of hills at the head of Loch Long for a party of naked soldiers just risen from bathing! Miss Rigby, or Lady Eastlake as she was later to become, had been a pupil of John Sell Cotman, and she produced numerous continental views including an especially interesting series of sketches executed between 1838 and 1841 while on a visit to a married sister living in Revel in Russia.

Possibly the most celebrated of all the lady amateurs was Amelia Long, Lady Farnborough (1772–1837), whom Roget classed as 'a talent that might fairly rank with professors of the living school'. The respect she gained amongst professional artists enabled her to be an honorary exhibitor at the Royal Academy from 1807–22 and at the British Institution in 1825. Her interest in art was doubtless encouraged by her husband, Charles Long, whom she married in 1793. He was also an amateur artist and an influential collector, owning works by Claude, Gaspard, Rubens and Gainsborough, and he acted as artistic adviser to both George III and George IV. It was probably in 1796 that Amelia Long became Girtin's pupil; according to Roget, 'Girtin besides offering aid to professional bretheren was beginning to be in request by amateurs'. He taught a number of women artists 'from the highest ranks of society [but] he told everything to his favourite pupil Lady Long . . . He would point out the time of day, the cast shadows and particular effect suited to the time and scene etc – a mode of teaching far in advance of the time.'

In 1800 Girtin moved to St George's Row where Roget presumed Amelia Long and Lady Glover were 'doubtless . . . frequent visitors'. The former executed a number of highly competent copies after some of Girtin's finest watercolours and as an able, well-informed artist must be placed at the forefront of lady amateurs. After Girtin's death her style changed to a less demanding imitation of the styles of Dr Monro and Henry Edridge. Personal friendship with an artist of note could raise the standard of an amateur artist's work far higher than that normally achieved in a slightly impersonal master-pupil relationship or via the even more indirect tuition provided by drawing-manuals.

Occasionally women assumed the profession of drawing-mistress themselves; thus in the early 1790s Mrs Schetky formed a class for teaching drawing to ladies in Edinburgh and later one can cite the trade card (70) of the daughters of John Thomas Smith (1766–1833), Keeper of Prints and Drawings in the British Museum from 1816 to his death, who taught drawing in addition to etching and painting in oil. Mrs Schetky died in 1795 but her husband, J. C. Schetky, continued as a drawing-master in Edinburgh and was

69　Amelia Long, Lady
Farnborough (1772–1837)
Landscape with a river.
Wash and black chalk on
blue paper. The drawing
was probably executed
when Amelia Long was
staying with the Earl of
Mulgrave at Mulgrave
Castle near Whitby.

THE MISSES SMITH.
Daughters of
M.^R SMITH
Keeper of the Prints in the
BRITISH MUSEUM,
TEACH
DRAWING, ETCHING, & PAINTING IN OIL.

MISS SMITH'S TERMS
Drawing Six Lessons....1.1.0
Etching Four Ditto......1.1.0

MISS J. SMITH'S
Drawing Six Lessons 1.1.0
Painting in Oil Four Ditto 1.1.0

22, CARMARTHEN STREET,
One door from Upper Gower Street.

70　The trade card of the
Misses Smith.

71 Henry Edridge (1769–1821) *Portrait of a young nobleman sketching near a country house*, 1796. Pencil, grey and brown wash. This picture is typical of the small whole-length wash and watercolour portraits in which Edridge specialised. In 1806 he informed Farington that he had raised his prices for such works from fifteen to twenty guineas.

engaged by Lady Balcarres to give drawing lessons to her daughters, the Ladies Elizabeth and Anne Lindsay. Family drawing classes were especially popular around the turn of the nineteenth century in Edinburgh, as the artist James Nasmyth recalled:

Edinburgh was at that time the resort of many county families. The war raged abroad and prevented them going to the Continent. They therefore remained at home, and the Scotch families for the most part took up their residence in Edinburgh. There were many young ladies desiring to complete their accomplishments, and hence the establishment of my sisters' art class. It was held in the large painting room in the upper part of the house. It soon became one of the most successful institutions in Edinburgh . . . The Nasmyth classes soon became the fashion. In many cases both mothers and daughters might be seen together in that delightful painting room. (James Nasmyth, *An Autobiography*, 1833)

The senior figure in this 'academy' was the well-known Scottish landscape painter Alexander Nasmyth (1758–1840), the father of James. It was Alexander's daughters who essentially ran the art classes with occasional advice from their father. Expeditions led by them, supplied with picnic and sketching equipment, were organised to the fashionable beauty spots around Edinburgh such as Duddingston Loch, Salisbury Crag, the Braid Hills and the Pentlands. The more ambitious of the lady amateurs could also exhibit their works in Edinburgh from 1808, when the earliest series of annual exhibitions was first established in the city. Amateurs, as has been seen in the case of Amelia Long, were also able to exhibit at the Royal Academy in London, where an element of competition amongst amateur artists had been introduced by the Society of Arts as early as 1790. In that year they offered 'Honorary Premiums for Drawings for the best drawings by sons or grandsons, daughters or granddaughters, of peers or peeresses of Great Britain or Ireland', also for 'the best drawing of any kind by young gentlemen under the age of twenty-one' and 'the same premiums will be given for drawings by young ladies . . . N.B. Persons professing any branch of the polite arts, or the sons and daughters of such persons, will not be admitted candidates in these classes.'

No doubt drawing-masters were justifiably proud of their pupils who were awarded such premiums but many amateurs were content to pursue their hobby in a less competitive atmosphere. After his retirement to Vicar's Hill in the New Forest, the Rev. Gilpin attracted a circle of lady admirers (for which he was much teased by his correspondent William Mason) to whom he gave frequent and generous advice on drawing and sketching. Most of these lady amateurs came from the aristocracy and many of them were highly intelligent. He frequently exchanged drawings with them and on 22 April 1784 wrote to Mason:

I have just been working for another Lady, whom I have the honour to number among those I have pleased; the young countess of Sutherland. I tell *you* these things, because I know they excite your envy. I am not acquainted with her; but I understand she draws; & is pleased with my manner: and a common acquaintance intervening, I have just sent her a specimen of my art.

A close correspondence developed between Gilpin and Mary Hartley although they only met each other once in 1787. She was the daughter of David Hartley, whose theories laid the foundations for the Associationist school of psychology; she was a competent amateur artist herself and kept Gilpin informed in her letters of the social and artistic life at Bath. A particularly interesting exchange concerned their opinions of John 'Warwick'

Smith. Gilpin, who had a personal dislike of the artist anyway, was of the opinion that 'the taste of the town had spoiled him. He is too smooth. He wants spirit.' This disapproval was echoed by Mary Hartley who acutely observed how readily amateurs favoured a style that was virtually mechanical and easily followed (letter to Gilpin, 14 February 1789):

I have been told by many people what his method of proceeding is. much as you describe. at least he tells ladies & gentlemen so. they are so much delighted with it. & repeat it to one another; like the receipt for soup. 'First you lay on red, & then you lay on blue, & then you lay in the greys, for the air-tint in the distance, &c, &c, & so, you know, any body may make as good a drawing as Smith's, because, you see, you proceed exactly in the same way.' I had these directions the other day from a gentleman who shewed me his own drawings, then mixed some tints for me in Smith's manner, & told me that he thought Pocock's drawings too warm, & Smith's too cold; but that he intended to mix their two different manners & to produce *something* – which I understand we were to conceive wou'd be far *superior* to both.

Mary Hartley's strictures seem mild, however, when compared to those directed by W. H. Pyne against William Payne (fl. 1776–1803) who, in the early decades of the nineteenth century, cultivated a split-brush style similar to that devised by John Glover that was easily capable of reproduction by pupils and amateurs:

The method of instruction in the art of drawing landscape compositions had never been reduced so completely to the degenerate notions of this epoch of bad taste as by this ingenious artist.

One source of contamination for amateurs would have been Ackermann's *A Treatise on Ackermann's Superfine Watercolours* (1801), where readers were exhorted to study Turner, Girtin and Westall, to avoid the seduction of Gainsborough's 'blottesque' (a definite change in fashion) and to profit by the 'pleasant' unrealities of Payne. At the end of the book were two pages of advertisements listing prints for amateurs to study from by artists such as Girtin, Payne and Pyne and, looking slightly further ahead into the century, there is no doubt that the numerous dramatic engravings produced after Turner's watercolours led to many ambitious (and frequently garish) amateur productions in imitation of the master's style.

It may seem slightly ironic to find the Rev. Gilpin criticising others for evolving reproducible systems of composition when he himself, in his writings, advocated his own easily reproduced methods. Although his influence, both through his writings and through his personal contacts, has earned Gilpin a prominent position in the history of English art and aesthetics, he can also be regarded as one amongst many of the clerical profession who were attracted to drawing and sketching. A cursory glance through the standard histories of English watercolours reveals, in addition to that of Gilpin, the names of clergymen such as William Bree, James Bulwer, John Eagles, the two John Fishers (uncle and nephew, the latter of whom became Archdeacon of Salisbury and a close personal friend of John Constable), Robert Hurrell Froude, John Gardnor (72), Thomas Gisborne, William Mason, John Swete and Joseph Wilkinson and there were doubtless many more. One priceless asset, which the clergy shared with the lady amateurs, was the opportunity and time for leisure activities. They were often the younger sons of the nobility or gentry, were educated at Oxford or Cambridge and, apart from

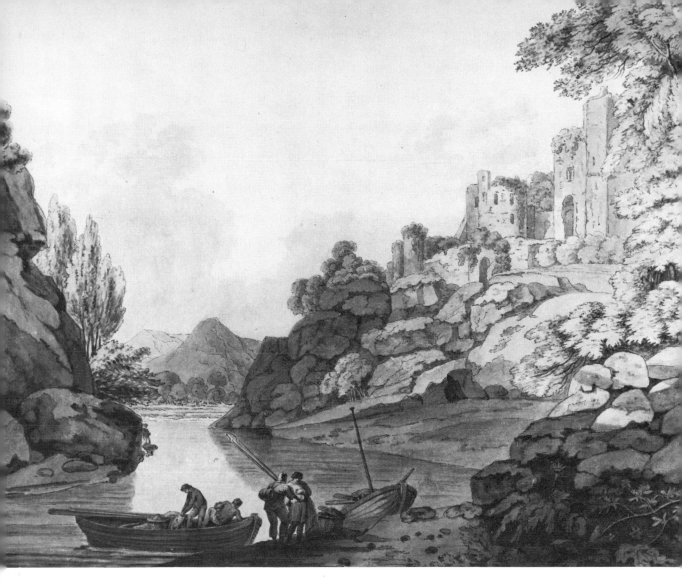

72　Rev. John Gardnor
(1728?–1808) *Kilgerran
Castle, Pembrokeshire.* Pen
and watercolour.

their pastoral duties, were free to follow literary, philosophical or artistic pursuits.

One of the most accomplished artists (to judge from the few surviving examples of his work) of the group listed above was the Rev. Thomas Gisborne (1758–1846). Educated at Harrow and Cambridge he was given, in 1783, the perpetual curacy of Barton-under-Needwood in Staffordshire and settled at Yoxall Lodge, a property which he had inherited from his father. He was the author of a number of moral tracts and from his undergraduate days enjoyed a close friendship with the reformer William Wilberforce. Gisborne himself campaigned in Derbyshire and Staffordshire for the abolition of slavery. He also came to know well the most distinguished painter of that region, Joseph Wright of Derby (1734–97), who painted a fine portrait of Gisborne and his wife in 1786 (74). Wright and Gisborne used to sketch together (in 1793 they were both in the Lake District) and they played the flute in each other's company in the evenings. In 1792 Gisborne became acquainted with the Rev. Gilpin, with whom he thereafter corresponded frequently. Gisborne was especially interested in experimenting in new

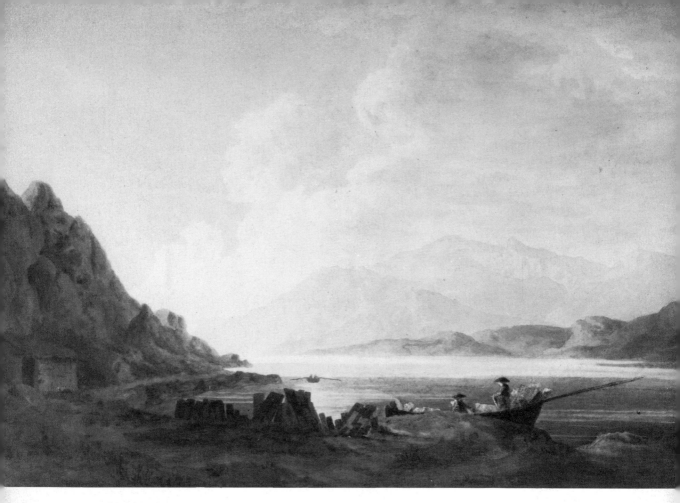

watercolour techniques. He learnt from the artist John 'Warwick' Smith himself of a somewhat mechanical method of laying in watercolour washes and in 1800 corresponded with Gilpin on the subject of bodycolours. Earlier that year Gilpin had been introduced by one of his pupils, Lady Neale, to the professional artist John Laporte (1761–1839) who was Lady Neale's drawing-master in London. Laporte was well-known for his landscapes executed in bodycolours and Gilpin was, at first, delighted with them. He wrote to Mary Hartley and to Gisborne on the subject but their replies were not encouraging. Gisborne expressed his scepticism in the following terms in a letter to Gilpin dated 29 December 1800:

Now for drawings in body-colours. I am not at present a convert to your opinion of the superiority of that method; but I am willing to listen to reason. I admit that I have not been in the way of seeing many good drawings in body-colours . . . I should therefore like to know what vehicle Mr Laporte uses to mix up his colours, on what substance he draws, what white he employs, & in short any particulars you please to communicate.

Gilpin found himself forced to agree with Gisborne that bodycolours were too complicated and best left to professional and competent artists. The questioning attitude of men like Gisborne was in direct contrast to the many slavish imitators in London and elsewhere of particular artists' styles.

The Rev. Gilpin's father, Captain John Bernard Gilpin (1701–76), was also an amateur artist and had put his drawing ability to good use during his

73 Rev. Thomas Gisborne (1758–1846) *Scene in Wales.* Watercolour.

74 Joseph Wright of Derby (1734–97) *The Rev. and Mrs Thomas Gisborne,* 1786. Oil on canvas. Gisborne's portfolio doubtless contains some of his sketches of the scenery of Needwood Forest (near his home at Yoxall Lodge) which he eulogised in a poem of 1795, *Walks in a Forest.*

military career. His list of personal acquaintances included the topographer
Samuel Buck and the antiquarian Thomas Pennant, and he taught and
encouraged his children and friends to paint and sketch. Just as the Rev. Gilpin
can be cited as one of the numerous clergymen who were interested in
drawing, so can his father be grouped with a number of amateur artists who
pursued military careers. The inclusion of drawing in the curricula of a
number of military academies has already been discussed, but a considerable
number of distinguished officers evidently enjoyed drawing and sketching for
their own sake. The Rev. Gilpin's pupil, Lady Neale, was married to Sir
Harry Burrard Neale (1755–1813) who, while a prisoner of war of the French
at Lille, had found sketching a useful activity to help pass the time during his
period of captivity. Another member of the same family, Captain (later
Admiral) Sir Charles Burrard (1793–1870), executed competent watercolours
of landscapes and marine subjects, some of which recalled early incidents in
his naval career, such as a naval engagement with the French in which he took
part at the age of thirteen. Other members of the Burrard family with artistic
inclinations included Harriet and Mary Anne, daughters of Colonel William
Burrard, both of whom came into contact with the Rev. Gilpin. Harriet
would 'run up to Vicar's hill with her little sketches; & he [Gilpin] was glad to
overlook, & correct them, as he always found her diffident of herself; and
ready to take advice'. Indeed, it was frequently the case that amateurs could be
found grouped in families, the enthusiasm of one member firing that of
another.

Other military amateurs included Colonel W. Gravatt (active c. 1790), a

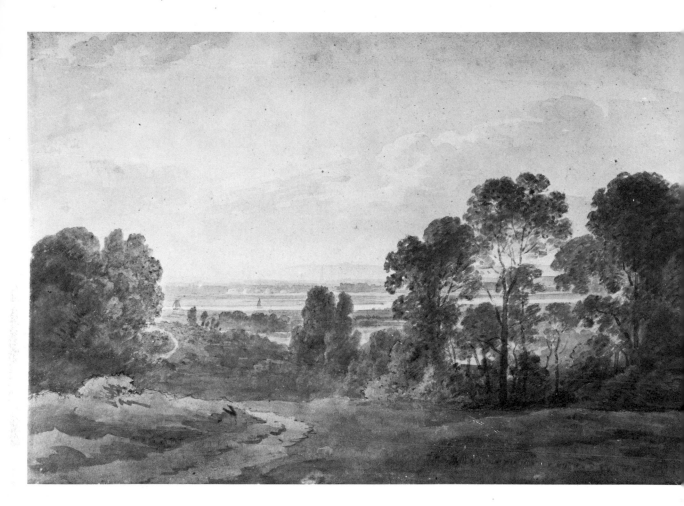

76 Sir George Bulteel
Fisher (1764–1834) *Near
Charlton, overlooking the
Thames.* Pencil and
watercolour.

friend and imitator of Paul Sandby, and General Sir George Bulteel Fisher KCH (1764–1834), who probably studied drawing under Sandby at Woolwich Military Academy. He was one of the first watercolourists to work in Canada (he was on active service there in the 1790s) and he also fought with Wellington in the Spanish peninsula against the French. His nephew was John Fisher, John Constable's friend, to whom Constable confided his opinions of his uncle's paintings in 1824:

The Colonel has some of his heartless atrocious landscapes in Seymour Street & has sent to consult me on them. How shall I get out of such an infernal scrape. Truth is out of the question. Then what part can I play – praise is safe – & the whole of no consequence – ? (R. B. Beckett, *John Constable's Correspondence*, vol. II, 1964)

Even a cursory examination of the names and reputations of amateurs which have survived reveals how important a rôle personal acquaintance played in the interchange of ideas between drawing-masters and pupils and professionals and amateurs. Certain figures stand out as being at the centre of such exchanges and the Rev. Gilpin immediately springs to mind in this respect. Another important link figure was the musician and drawing-master John Malchair, whose advice on drawing matters was sought by a number of distinguished amateurs who were either undergraduates at Oxford in the

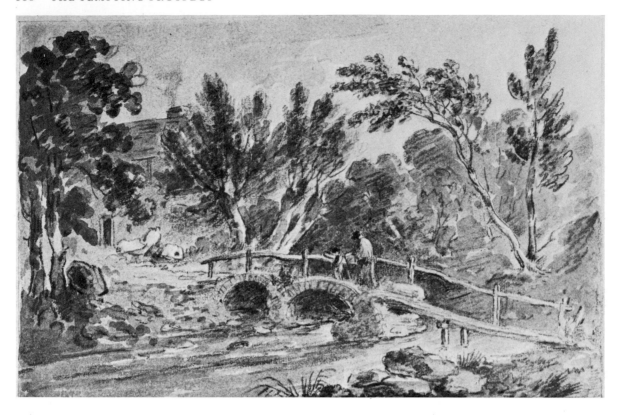

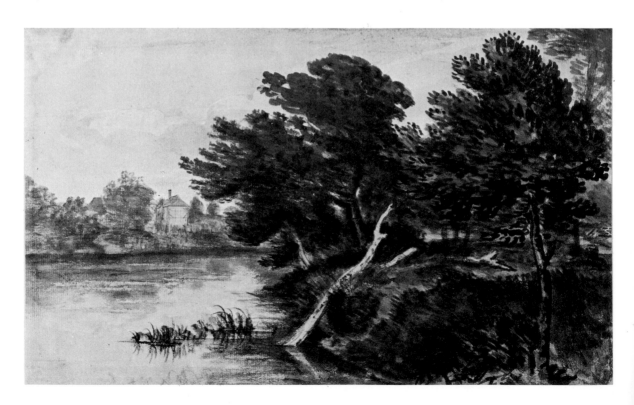

second half of the eighteenth century or who consulted him during their visits to that city. Many of his pupils had, in fact, first been taught drawing by Alexander Cozens when at school at Eton. Amongst those who profited from Malchair's tuition were Heneage Finch, fourth Earl of Aylesford (1751–1812), whose mother was renowned for her needlework pictures and whose two brothers were also capable landscape draughtsmen, Robert Price of Foxley in Herefordshire (1717–61), who was the father of Uvedale Price, the theorist of the 'Picturesque', Oldfield Bowles of North Aston (1739–1810), whose acquaintances included Thomas Jones, Farington and Sir George Beaumont (the last of whom was also taught by Malchair), and the musician Dr William Crotch (1775–1847), who was appointed organist at Christ Church, Oxford, at the age of fifteen and who probably knew Malchair better than any of his other pupils.

An enthusiasm for the scenery of Great Britain provided the stimulus for the sketching activities of many amateurs, just as it did for professional artists. Sir Richard Colt Hoare recorded in his *Memoirs* (manuscript at Stourhead): 'The love of drawing, and of picturesque scenery, which most frequently influenced my motions induced me to turn my thoughts towards Wales in the summer of the year 1793.' Foreign views commanded increasing attention as well, and the young Colt Hoare recalled of a visit to Lake Nemi: 'On the border of the lake was formerly a temple dedicated to Diana to whom the adjoining groves were sacred. Here also I found ample occupation for my pencil and quitted these classical scenes with regret.'

In the nineteenth century tourists no longer restricted themselves to the Grand Tour and, with the greater freedom of travel after the end of the Napoleonic wars, they ventured farther afield, though Italy still received more than its fair share of tourists, as Thomas Uwins complained in 1830:

What a shoal of amateur artists we have got here! I am old enough to remember when Mr Swinburne and Sir George Beaumont were the only gentlemen who condescended to take a brush in hand, but now gentlemen painters rise up at every step and go nigh to push us from our stools.

The great Dr Waagen, Director of the Royal Gallery of Pictures in Berlin and author of *Treasures of Art in Great Britain* (1854) remarked in that publication: 'It is not too much to say that the greater number of the English tourists of each sex return home laden with sketch-books commemorative of their impressions.'

The well-established route to India continued to provide many amateurs in the nineteenth century with new and fascinating costumes and scenery to sketch and record but other areas attracted amateurs as well, although not in such great numbers. The Middle East was first brought to the public's attention by archaeologists such as the Swiss Jean Louis Burckhardt (1784–1817) whose detailed observations on Syria and the Holy Land were published in 1822. Professional watercolourists such as Roberts, Lewis and W. H. Bartlett painted that region in the following decades, and amateurs, too, sketched there. Commander Robert Moresby (active 1820s–50s), for example, was employed by the East India Company Navy between 1829 and 1834 to survey the Red Sea area with a view to establishing the best course for steamers proceeding to and from Suez, and he executed a number of watercolours of the area in his own curious, slightly primitive style. Mrs Maria Harriet Matthias (active 1850s) was a wealthy and enterprising amateur who essentially sketched the same tract of the Middle East as David Roberts had

77 ABOVE LEFT Sir George Howland Beaumont Bt. (1753–1827) *Near Cheltenham*, 1802, page 29 from an album entitled *Sketches from Nature*. Black and white chalk and wash on blue paper.

78 LEFT Dr William Crotch (1775–1847) *The Mill at Heathfield*, 1809. Black chalk and watercolour.

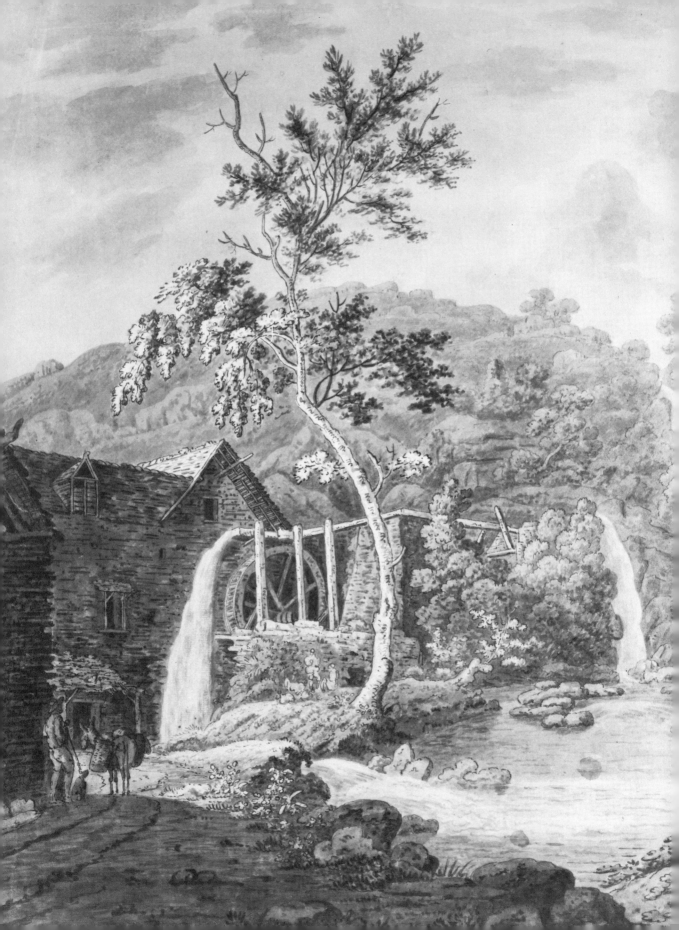

two decades previous to her own journey from Alexandria to the Holy Land.

Amateurs' travels often took them to regions where professional artists had not ventured and their work was, on a number of occasions, re-interpreted by professional artists in the form of watercolours or prints for the domestic market in Great Britain. This practice gathered pace in the nineteenth century, one example being Commander Robert Elliot's views of India, which were adapted by Cotman, Turner, Cox, Prout and others for a publication entitled *Views in India, chiefly among the Himalaya Mountains* which appeared in 1838. It was edited by Emma Roberts who, in her *Scenes and Characteristics of Hindostan* (1835), had commented adversely on the sending of drawings from India back to England:

Drawings made in India, and sent to England to be engraved, are subject to much deterioration in the process, from the negligence of persons, wholly unacquainted with the peculiarities of the country, to whom they are entrusted, and many of the cheap productions of this class, from the pencils of very able amateur artists, are rendered almost worthless by the ignorance and inaccuracy of those persons who are supposed to prepare them for the engraver.

This view was by no means universal and the artist William Henry Bartlett (1809–54), who did much of this sort of work, maintained in the *Art Journal* (January 1855): 'I have known books of foreign travels made up by London authors from very slight, and even trivial notes: whilst the illustrations have been produced by skilful artists at home, from elegantly frivolous sketches, or scratches.'

Although foreign views constitute a special category, it was not unknown for amateurs to influence professionals in other respects. The young John Constable, for instance, learnt much of Gainsborough's sketching manner from the Ipswich amateur George Frost (1745–1821), and other amateurs from whom he learnt were Sir George Beaumont and John Fisher.

A rather extraordinary episode of amateur-professional collaboration was that recorded by Mrs Dawson Turner concerning John Sell Cotman, who undertook a series of Normandy tours in 1817, 1818 and 1820 in order to make the preparatory drawings for his series of etchings *Architectural Antiquities of Normandy* (1822). Cotman took with him either a camera lucida or Varley's graphic telescope (see p.18) – it is not certain which – to assist him in the intricate drawing of architectural outlines. Whichever instrument it was, he was presented with it by Sir Henry Englefield, who was an early patron of both Cotman and Varley. Evidently Cotman found the instrument difficult to use at first and Mrs Dawson Turner reported that her daughter Elizabeth, who was a pupil of Cotman's and who, together with her mother and sisters accompanied him for some of his 1818 visit to Normandy,

. . . who has such excellent sight and can use the camera lucida with so much ease, has been of the greatest service to Mr Cotman. His sight is by no means equal to hers, and she has a rapidity which is fully his equal so that, on the whole she is better qualified in the use of the instrument than he. There were no less than five drawings completed by this means yesterday between him and her. I do not mean finished drawings, but with all the lines in the right places and memoranda on the margins of all needful to be known towards making finished drawings.
(S. D. Kitson *The life of John Sell Cotman*)

79 Sir Richard Colt Hoare Bt. (1758–1841) *Watermill, near Carwen, North Wales*. Pen and wash.

Amateurs were not without experience of such drawing instruments. Alexander Nasmyth had recommended his pupils in Edinburgh to use mechanical aids

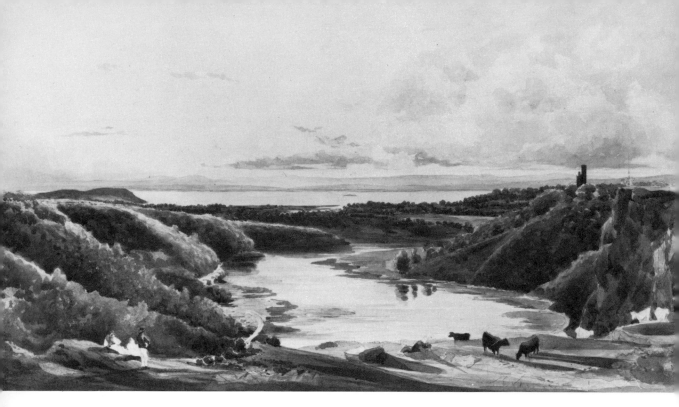

and one of Paul Sandby's Scottish watercolours depicts lady Frances Scott with Lady Elliot, using a camera obscura (see p. 6).

Although professionals often relied for a substantial part of their livelihoods on the income to be derived from teaching amateurs, there can be little doubt that, in official circles, they viewed their own artistic efforts as separate and distinct from those of their amateur friends and pupils. The watercolourists, in particular, seem to have been protective of their professional status and when two amateurs applied in 1824 to the Old Water-Colour Society to be made Associate Exhibitors they were refused. Perhaps the most embittered remarks concerning the relations of professionals to amateurs came from an anonymous contributor to Arnold's *Library of the Fine Arts* in 1831:

The prevalence amongst certain self-adulating amateur artists thus cutting up the works of professional artists of reputation, is, to say the least of it, a rather ungracious return for the indulgence with which the professor almost invariably views the attempts of the amateur.

In general, though, artists were capable of gracious generosity towards the efforts of amateurs if they were merited. John Sell Cotman wrote to Dawson Turner in 1834 of the Rev. James Bulwer: 'and fortunately for *me* he draws and *colors* admirably, and this is not my opinion only . . .' Bulwer was also a patron of Cotman's and men such as he must have represented, for the professionals, the perfect type of amateur, for amateurs played an important rôle not only in the painting of watercolours themselves, but also in the patronage of professional artists and the collecting of their work.

80 Rev. James Bulwer (1794–1879) *The Severn and Avon from Clifton Downes.* Pencil and watercolour. Immediately prior to his move to London in the late 1820s Bulwer had been curate of St Mary's Redcliffe, Bristol.

7 Patronage and Collecting

Let no one suppose, while he elbows duchesses and
dowagers, bishops and cabinet ministers, St James-street
club-men and sober citizens, bilious barristers, over-done
politicians and out-at elbows artisans, rosebuds of Belgravia
with the nursery dew still on them, and hardened old
harridans tough with the sun and storm of fifty seasons, in
those pleasant rooms of the old and new water-colour
societies in London, that the art which thus levels classes,
callings, ranks, and ages is of yesterday.

TOM TAYLOR, *A Handbook to the Water Colours, Drawings
and Engravings in the Art Treasures Exhibition*, Manchester,
1857

The Manchester exhibition at Trafford Park was intended as a celebration and
showpiece for the fine arts in Great Britain. It was opened, with great
ceremony, by the Prince Consort, and was of a size and splendour to rival the
Great Exhibition held at the Crystal Palace in 1851, which had been devoted
to industrial art and design. By the middle of the nineteenth century no
representation of British art would have been held to be complete without a
section devoted to the achievement of the native watercolour school. As Tom
Taylor rightly noted, watercolour had a long history and the watercolour
display arranged at Manchester stretched right back to the seventeenth
century, including examples by such predecessors as Rembrandt and Jordaens.
Watercolour had, in many ways, become the art form which 'levels classes'.
Ruskin's *Modern Painters* functioned as a handbook for collectors and in his
Notes (1880) on Samuel Prout and William Hunt he commented on the
suitability of watercolours for the middle classes:

Drawings of this simple character were made for . . . the second order of the
middle classes more accurately described by the term 'bourgeoisie'. The great
people always bought Canaletto, not Prout, and Van Huysum, not Hunt. There
was indeed no quality in the bright little watercolours, which indeed could look
other than pert in ghostly corridors, and petty in halls of state; but they gave an
unquestionable tone of liberal-mindedness to a suburban villa, and were the
cheerfullest-possible decorations for a moderate-sized breakfast parlour, opening
on a nicely-mowed lawn.

Clearly, one could not descend below the 'bourgeois' stratum of British
society and expect to find patrons and collectors, even of humble Prouts or
Hunts, but the rise of new professional and industrial classes in the nineteenth
century had had a profound effect on the whole business of buying and selling
art. A somewhat oversimplified view of the situation was given by Thomas
Uwins in a letter of 1850, though it should be remembered that he was
referring to oil-paintings and not to watercolours:

The old nobility and land proprietors are gone out. Their place is supplied by
railroad speculators, iron mine men, and grinders from Sheffield, &c., Liverpool
and Manchester merchants and traders. This class of men are now as much in the

hands of dealers as the old black collectors [i.e. collectors of Old Master paintings] were formerly. But they do not love darkness and will only deal with their contemporaries.

81 William Henry Hunt (1790–1864) *Bird's Nest and Apple Blossom.* Watercolour.

Although he could not be classed as a contemporary, Paul Sandby had for long been considered to be the founder of the British watercolour tradition. The historical importance of his work was recognised by the inclusion of fifteen of his drawings in the Manchester exhibition, though a glance at contemporary sale records reveals that, in financial terms, his work, like that of many of the eighteenth-century topographers, was not highly prized and examples could often be purchased for a few guineas. Even the drawings of John Robert Cozens, whose importance in the formation of both Girtin's and Turner's styles is fully recognised today, could be bought on average for the relatively modest price of ten to twenty pounds each. Sandby and Cozens, however, belonged to an age when individual patronage, usually of the 'nobility and land proprietors', was of prime importance and they were not working for an open market in watercolours, such as that which developed in the nineteenth century.

It has already been shown that the income to be derived from teaching played a major part in many artists' livelihoods. In the eighteenth century this was often connected with, and supplemented by, direct patronage from the nobility and landed gentry. In a number of instances artists were directly

employed to record foreign scenery for English gentlemen, thus John 'Warwick' Smith (1749–1831) was in Italy 1776–81 under the patronage of George Greville (1746–1816), second Earl of Warwick. Like many patrons of water-colour the Earl of Warwick was an enthusiastic amateur and was interested in the fashions and technology of the medium. He was probably instrumental in securing the secrets of the aquatint technique for Paul Sandby and an anecdote related in the *Somerset House Gazette* . . . (1824) describes his interest in the Yorkshire artist Francis Nicholson's development of a 'stopping-out' tech-nique, whereby heightening in watercolours could be achieved without recourse to bodycolours. The informant of this story began his account by recalling the Earl of Warwick's 'portfolios, containing the works of *Sandby, Rooker, Cozens, Warwick Smith*, and others of the water-colour school'. Here again is reference to the fact that earlier collectors did not generally frame their drawings, but mounted them in albums to be kept in their libraries and perused at social gatherings or in the quiet satisfaction of the owner's privacy. The German entrepreneur Rudolph Ackermann (1764–1834) noted in 1813: 'Amongst the most polite circles, the library [had] become the place of refined amusement in the long evenings, not only within town houses, but during their residence at country seats . . .' Indeed, Ackermann himself, at the weekly receptions he held on Wednesday evenings in the library of his house at 105 The Strand, 'The Repository of Arts', was as responsible as anyone for cultivating this habit. He was an important publisher of books, especially those with aquatint illustrations, and also sold prints, drawings and drawing materials.

A somewhat alarming exception to normal storage or hanging practices was that of the physician Dr Thomas Monro who, on his retirement to Bushey near Watford in 1821, pasted his collection of watercolours directly onto the walls of his house and nailed strips of gilded wood between them to give the appearance of frames. This course of action may well have been suggested to him by the fashion, developed in the eighteenth century, for 'Print Rooms' in country houses, such as that at Woodhall Park, Hertford-shire, where the prints were decorously arranged and stuck directly to the walls. It is also worth recalling that the viola da gamba player Carl Friedrich Abel (1725–87), who was a close friend of the artist, pinned his collection of Gainsborough drawings to the paper-hangings in his apartment. The whole question of the portfolio, as opposed to the frame, was raised in a later context (see pp.150–2) by the Scottish dentist turned artist James Orrock (1829–1913):

On the other hand, as to portfolio drawings being better preserved than framed ones, I would instance the Varleys I lent to the Institute exhibition. Those drawings belonged to a collector named Davis, who lived in Cheshire. They were always, while in his possession, kept in a portfolio, and I framed them almost three years ago, when I bought them at Christie's, and although brilliant and late drawings, they are not more so than those in my collection which have always been in frames. (B. Webber, *James Orrock, R.I.*)

It is now recognised that drawings which have been kept in portfolios are generally in better condition than those hung in frames, due to their not having been exposed to the damaging effects of light. Exceptionally fine examples of drawings kept in portfolios or albums are those by Francis Towne (plate 8) contained in the two volumes of his Roman views, posthum-ously presented at the artist's request, through the offices of his friend James White, to the British Museum in 1816 – surely one of the earliest instances of a

82 ABOVE John 'Warwick' Smith (1749–1831) *Naples from Capo di Monte*. Pencil and watercolour.

83 Charles Gore (1729–1807) *The two temples of Agrigentum, Sicily*. Watercolour. Gore accompanied the young Payne Knight on his tour of Sicily in 1777. After a number of years spent in Italy Gore settled in Weimar in 1791 and became a close friend of Goethe.

84 Charles Gore (1729–1807) and Thomas Hearne (1744–1817) *Mount Etna, from the convent of Nicolisi.* Watercolour. In his journal of his Sicilian visit Payne Knight recorded visiting Mount Etna on 27 May: 'The lava of 1669 erupted just near Nicolisi, and the surrounding district is still covered with dry, black ash expelled on this occasion.

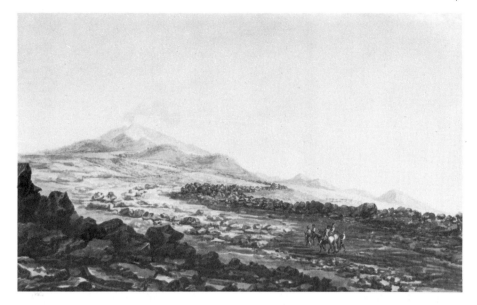

85 Thomas Hearne (1744–1817) *Wooded Glen at Downton, Herefordshire.* Ink and wash. Hearne made a series of watercolours for Payne Knight of the grounds at Downton. This drawing is probably a preparatory drawing for one of them and depicts the River Teme in the Vale of Downton.

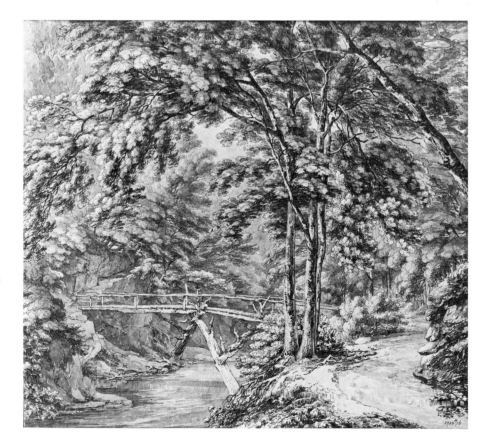

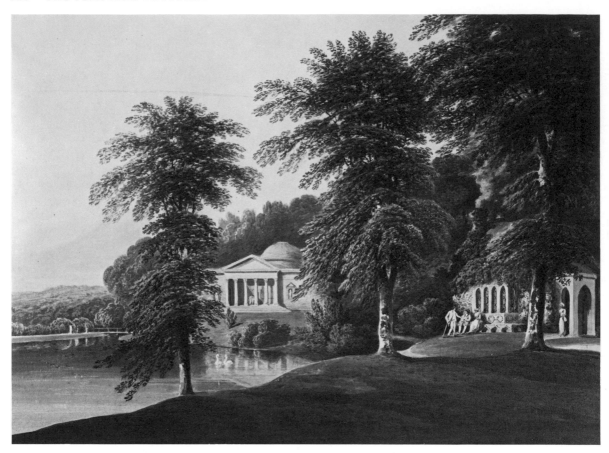

watercolourist's concern for the institutional safeguarding of his work for posterity.

Towne was on good terms with 'Warwick' Smith when the two artists were in Italy and they returned to England over the Alps together in 1781. An artist who travelled twice to Italy, on each occasion in the company of illustrious patrons from the landed gentry, was John Robert Cozens (1752–97). The first of his two journeys to Italy was undertaken in 1776/7 with the distinguished writer and collector Richard Payne Knight (1750–1824). One of the surviving records of the tour was an album of fifty-seven predominantly monochrome wash drawings, later inscribed *Views in Swisserland, a present from Mr. R. P. Knight, and taken by the late Mr Cozens under his inspection during a Tour in Swisserland in 1776*. Payne Knight's vast collection of drawings, antique bronzes and coins was bequeathed to the British Museum in 1826. From the arrangement of one of the volumes of his drawings, devoted entirely to the topography and antiquities of Sicily and containing watercolours by Cozens, Hearne, Charles Gore (1729–1807) and by the German artist Philip Hackert, there is reason to suggest that Payne Knight was contemplating the publication of an illustrated volume on the history of that island. As early as 1774 Payne Knight had also begun to design the house and grounds of his family estate at Downton in Shropshire and he was to become, through his writings, one of the most important figures in that celebrated late-eighteenth-century controversy on the true nature of the 'Picturesque'.

86 Francis Nicholson (1753–1844) *The Pantheon and the Gothic Cottage at Stourhead, Wiltshire.* Pencil and watercolour with white heightening. The buildings and gardens of Stourhead were designed for Henry Hoare II (1705–85), grandfather of Sir Richard Colt Hoare, and were extensively based on the landscapes of seventeenth-century painters such as Claude Lorrain which greatly influenced the English traditions of landscape gardening and painting.

His prime literary combatants in this often amusing and highly important chapter in the history of British aesthetics and landscape gardening were his neighbour Uvedale Price and the landscape gardener Humphry Repton. Repton made frequent use of watercolours to illustrate to prospective patrons the 'improvements' he wished to suggest for their parks and gardens. Payne Knight had his own landscaping achievements recorded by Thomas Hearne in a charming series of watercolours depicting the grounds at Downton. Other prominent landowners turned landscape gardeners who had their achievements recorded in series of watercolours included the banker and writer on art Thomas Hope (1769–1831) who, in the 1820s and under the direction of the architectural historian John Britton, engaged William Henry Bartlett, Penry Williams and others to record in a series of highly finished watercolours the grounds of his house, the 'Deepdene', near Dorking in Surrey. Similarly, another whose wealth derived from banking, Sir Richard Colt Hoare (1758–1838), engaged Francis Nicholson (86) in 1813 to depict the gardens he had planted at Stourhead. More generally, country house portraiture had been practised (at first in the form of oil-paintings) since the seventeenth century and by the time of the great age of watercolours one can find drawings by Girtin of Harewood House in Yorkshire for Edward Lascelles and both oils and watercolours by Turner for William Beckford of his ill-fated Fonthill Abbey in Wiltshire.

William Beckford (1760–1844) is rightly remembered as one of the most eccentric of English patrons. Possessed of an undeniably difficult and capricious nature, he was ostracised by much of English society due to a scandal that broke in 1784 concerning his affections for the youthful William Courtenay. Whereas the prevailing antiquarian taste of his time was for the classical, Beckford professed a fascination for the Eastern and the exotic. His first literary work, *The Vision*, was written when he was seventeen and was dedicated to his drawing-master and confidant Alexander Cozens. Cozens encouraged Beckford's oriental interests and introduced him to Ossian and to *The Arabian Nights*. Their friendship was exceptionally close, as Beckford confided to Lady Hamilton in 1781: 'I have no friend like you to sustain my spirits and receive my ideas. Except Mr Cozens, whom you have heard me so frequently mention – not an Animal comprehends me.'

Beckford expressed a desire to Cozens to see work executed by the artist's son John Robert and, evidently satisfied, engaged him to travel as his draughtsman on his third continental journey undertaken in 1782–3. The two men travelled together as far as Naples where they parted in September 1782, Cozens staying a further three months sketching around the coastal area of the Gulf of Salerno. Cozens was back in England by November 1783 and much of his itinerary can be accurately traced from the seven surviving sketchbooks of his tour which are now in the Whitworth Art Gallery, Manchester. Cozens was ill while in Naples and convalesced at the villa of the British Envoy, Sir William Hamilton, at Portici. Hamilton wrote to Beckford in October 1782:

Cozens passed a day with me here. The vermin plays a good stick upon the violoncello, which was a fine discovery. We played 4 hours. He is very firm as to time and is a lover of Handel which suited me. He has made some charming sketches but I see by his work that he is indolent as usual.

For the nine years following his return to England, Cozens was employed on commissions for watercolours of Swiss, Austrian and Italian subjects based

near Brixen — June 7

on the sketches made during his journey. Some of his subjects proved extremely popular with collectors and up to eight or nine versions of some of his compositions are known to have been produced, though the most important series was obviously that for which he had received the original commission from Beckford. On 10 April 1805 Beckford sold at Christie's ninety-four drawings by Cozens, 'a capital and truly valuable Collection of High Finished Drawings, the whole executed by the eminent Artist the younger Cozens, during a Tour through the Tyrol and Italy, in company with an amateur of distinguished taste'. Beckford's first biographer, Redding, stated in a manuscript biography of 1846 that Beckford displayed Cozens's drawings because 'they recalled the most agreeable days of his life', and 'he delighted in drawings that reminded him of "the lively scenes he had visited in his youth, when all was fresh to him and he believed himself an inspired child of Nature!"' In his *Memoirs* Beckford recalled that on the way to Italy he had run 'into the woods, admiring the delicate foliage on all sides, whilst the artist Cozens drew the huts that were scattered about the landscape.'

The inventory of Beckford's collection reveals that he acquired watercolours on quite a considerable scale, including eighteen 'drawings' and an album of one hundred sketches by Bonington, and an album of twenty-six 'drawings' of Eastern scenery by Prout, Copley Fielding, Shotter Boys, Cattermole and others. Even more numerous than his collection of Cozens was that of drawings and watercolours by 'Warwick' Smith, twenty-six framed and one hundred and fifty-six unframed. His letters reveal that Beckford felt he needed the ageing artist's company in the lonely Abbey and paid him 'at least two or three guineas a day', for which Beckford thought Smith might as well earn his keep by drawing. Beckford nicknamed Smith 'Father Bestorum' on account of his age, in Beckford's eyes, making him

87 John Robert Cozens (1752–97) *View in the Tyrol, near Brixen*. Pencil and wash. Dated *June 7* [1782], this drawing is on page 12 in volume 1 of Cozens's Beckford sketchbooks.

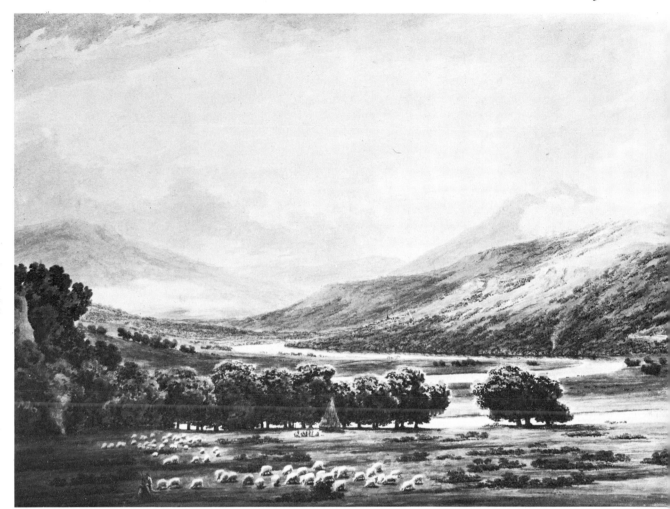

88 John Robert Cozens (1752–97) *View in the Tyrol near Brixen: The Valley of the Eisak.* Watercolour. This is one of a number of finished watercolours of this subject by Cozens based on his drawing in the Beckford sketchbook (87).

'father' of all the 'beasts' at Fonthill, and Beckford's references to the artist in his letters were frequently derisory: 'It is not worth discussing the Father accompanying me; deaf, roguish and gaping, he would be a drag on me and on all my surroundings; a fellow hardly presentable, in Arcadia he would be a disgrace and not an object of admiration . . .' Shut away in Fonthill in an exile from society determined partly by his own character and partly by expediency, Beckford was no stranger to hatred and suspicion and it may well be that dissatisfaction at the slow delivery of the Italian views from J. R. Cozens caused a severance of relations between patron and artist. Beckford was conspicuous by his absence from the list of those who contributed to Cozens's support after his breakdown from a nervous disorder in 1794. The story of Cozens's personal misfortune does, however, provide a link with another type of patron, exemplified in the figures of Dr Thomas Monro and Sir George Beaumont, who actively supported artists and endeavoured to aid and assist their artistic progress. Roget noted of Monro (1759–1833):

As a leader of connoisseurship, he was looked upon in his day much in the same light as Sir George Beaumont and Mr Payne Knight . . . none seems to have

taken more effectual means to promote the education of young artists than Dr Thomas Monro.

The son of a well-known doctor who was also interested in, and actively promoted, contemporary British art, holding 'conversaziones' at his house in Bedford Square, Thomas Monro succeeded his father James as Principal Physician at Bethlem Hospital in 1792, and in 1793 or 1794 he moved to 8 Adelphi Terrace where he remained until 1820. It was there that on winter evenings (usually Fridays) Monro invited young artists to come and study his collection of paintings and drawings by his friends, including those by Cozens, whom he was by that date treating for madness. Farington (*Diary*, 26 November 1794) wrote:

Steers says that Dr Monro's house is like an Academy in the evenings. He has young men employed in tracing outlines made by his friend Henderson [John Henderson, a neighbour who was also a patron of watercolours]. Hearne etc lend their outlines for this purpose.

Monro had double facing desks installed so the young artists could work facing each other, probably sharing an inkpot or water pot. Turner and Girtin told Farington of their visits there (*Diary*, 12 November 1798): 'They went at 6 and staid till 10. Girtin drew the outlines and Turner washed in the effects.' Monro paid Turner three shillings and sixpence each night, though it is not known how much Girtin received. Other artists who studied at this informal 'academy', or who visited Monro at Fetcham Cottage near Leatherhead, Surrey, which he rented 1795–1805, included Louis Francia, T. R. Underwood, Paul Sandby Munn and George Shepherd in the early days, J. S. Cotman in 1799, John and Cornelius Varley in 1800 and, later, Peter De Wint, Linnell and W. H. Hunt. Apart from aiding artists in this manner and providing, in effect, a facility for young watercolour artists denied them by the Royal Academy, Monro was also a very considerable collector. He told Farington in 1810 that he had spent three thousand pounds on his drawings collection (including eight hundred pounds on works by Hearne) and Farington, a close personal friend of the doctor, also noted that 'Dr Monro's collection of drawings by modern artists is larger than any I have seen before' and later: 'Dr Monro's house is full of drawings. In the dining parlour 90 drawings framed and glazed are hung up and in the drawing room 120. They consist of drawings of Hearne, Barret, Smith, Laporte, Turner, Wheatley, Girtin.' After Monro's death his collection was sold at Christie's; the sale, starting on 26 June 1833, lasted five days, though the total realised was only £2,723. In addition to the artists already mentioned, the collection included examples by Wilson, Gainsborough (as well as that artist's camera obscura), De Loutherbourg, Marlow, Edridge, Webber, Rooker, Sandby, Alexander, Neale, Havell, Bonington, Reinagle and Barret.

Whereas the introduction effected by Monro of the young Turner and Girtin to the sublime grandeur of Cozens's landscapes was to have a profound effect on the stylistic evolution of English watercolours, a prominent, if lesser, rôle was also played by Sir George Beaumont (1753–1827). Although his antagonism to the watercolour societies has already been mentioned, he did collect watercolours and owned examples by Hearne, J. R. Cozens and Girtin amongst others; he also showed considerable kindness towards Girtin, writing to the dying artist in October 1802: 'You must take care of yourself, and I hope you will be enabled to settle your concerns that you may pass the winter

89 William Alexander (1767–1816) *The Fetcham Cottage of Dr Monro.* Watercolour.

in Madeira . . . if you will send me a line to let me know you receive this, I will return you a note for the money.'

Beaumont belonged, however, to a generation primarily devoted to oil-paintings and, despite his own interest in landscape, would concede only a secondary importance to watercolours. He played a prominent part in the art politics of his time being one of the prime movers in the foundation in 1806 of the British Institution, where contemporary English oil-paintings were exhibited. His fine collection of Old Master paintings was presented by him to the newly founded National Gallery in 1824 and included the small painting by Claude of *Hagar and the angel* which he used to take with him on his travels in his coach. In similar fashion Dr Monro had netting specially installed under the roof of his brougham to carry a selection from his watercolour collection.

Like so many patrons and collectors of watercolours Monro and Beaumont were enthusiastic amateurs, though neither drew in styles that could be classed as advanced. Similarly, William Roberts, John Hornby Maw and the Rev. James Bulwer, who were all important patrons of Cotman in the 1820s and 1830s, were also amateur artists. Of the three Bulwer, whose family home was Heydon Hall near Aylsham, Cambridgeshire, was the most significant figure, purchasing more works by Cotman than anyone else during the artist's lifetime. This was mainly due to his buying in bulk of Cotman's preparatory sepia drawings for his series of etchings of the churches and ruins of Norfolk. The friendship between cleric and artist flourished especially in the late 1820s when both men had recently moved to London, Bulwer to

become minister of St James's, Piccadilly. Most of Bulwer's extensive collection of contemporary watercolours was auctioned at Christie's in the spring of 1836 and included examples by John Varley, Cox, Copley Fielding, Müller, Prout, Pyne and many others. Cotman himself bought back one of his own watercolours, the *Dismasted Brig* for only seventeen shillings (90). William Roberts was a successful manufacturer from Birmingham whose commercial interests often took him to Norwich, where he got to know most of the leading artists, and Cotman particularly well. John Hornby Maw was a manufacturer of surgical instruments who lived in Guildford and patronised Cotman during the 1830s. His own collection included works by Turner, Bonington, Prout, Cox, De Wint and a large group of Cotmans, forty of which were sold at Maw's sale at Christie's in 1842. These three patrons were typical of the shift in patronage away from that of the nobility and landed gentry who had patronised artists such as Girtin; his patrons had included Lord Hardwicke, the Earl of Mulgrave, General Phipps, the Earl of Buchan and the Earl of Harewood. Cotman's relations with his patrons were untypical and slightly old-fashioned, however, in that he did not, unlike Prout, Copley Fielding and other of his contemporaries, work for the trade or sell to unknown customers. He worked mainly for personal friends and patrons and would often insert a patron's coat of arms into a drawing and, if they were amateur artists, ask for a sketch from them.

There was also, both in the eighteenth and nineteenth centuries, another distinct type of patron whose acquisition of drawings and watercolours

90 John Sell Cotman (1782–1842) *The Dismasted Brig, c.* 1807. Watercolour.

followed on as a natural result of his antiquarian interests. Such a man was James Moore FSA (1762–99), a wealthy wholesale linen-draper with premises in Cheapside, who appears to have neglected his business for the sake of his artistic and antiquarian interests. An inveterate traveller round Great Britain, he was an indifferent draughtsman and frequently employed other artists such as Dayes, Girtin and Turner to execute drawings for his collection and to illustrate his various topographical publications.

Another collector with antiquarian interests (the history and topography of Norfolk) was the Yarmouth banker Dawson Turner (1775–1858), who has, until recently, wrongly been accused of forcing Cotman to concentrate on relatively dry architectural etchings at the expense of the marvellous lyricism he achieved in his 'Greta Bridge' period watercolours. The truth of the matter is that Cotman, who had probably made Dawson Turner's acquaintance at Norwich as early as 1804, warmly welcomed the expected income from printmaking and wrote to his friend and patron Francis Cholmeley (5 June 1811): 'I bless my stars at having now another [means] to support my family – save painting & Drawing'. In fact, a number of the most prominent water-colourists began their careers in the print trade, employed in the relatively mundane task of colouring in prints. Hand-coloured sets of prints, mounted and sold in portfolios, usually cost about double the price of uncoloured versions. By the early nineteenth century there were a considerable number of children trained in the art of hand-colouring prints, as the landscape gardener Humphry Repton acknowledged in his *Observations on Landscape Gardening* (1803): 'The art of colouring plates in imitation of drawings has been so far improved of late that I have pleasure in recording obligations to Mr Clarke, under whose direction a number of children have been employed to enrich this volume.' Girtin and Turner are supposed to have first met when employed as colourers of prints in the workshop of John Raphael Smith in the early 1790s when both would have been in their mid-teens.

Dawson Turner also engaged Cotman to teach drawing to his wife and daughters and recommended the artist to a number of Norfolk patrons just as, slightly earlier, the Cholmeleys in Yorkshire had engaged him as a drawing-master and secured work for him amongst the landed gentry of Yorkshire. While Dawson Turner provided good advice and acted as a sympathetic ear for much of Cotman's career, he purchased relatively few of the artist's watercolours (mainly early works), though on the artist's death in 1842 he provided a pension for Cotman's widow and advised her in the investment of the proceeds from the artist's modest life insurance.

Cotman was an infrequent contributor to the London exhibitions but it was in the capital at the watercolour societies' exhibitions that a ready market and appreciation of watercolours was built up. Additional attention was drawn to the medium by an exhibition of the private collection of Turner's major Yorkshire patron, Walter Fawkes (1769–1825) of Farnley Hall, who displayed his collection of drawings at his town house, 45 Grosvenor Place in 1819 and 1820. At his death in 1825 Fawkes owned some two hundred and fifty watercolours by Turner. In the 1819 exhibition sixty pictures by Turner were hung together in one room, while another two rooms contained about forty watercolours, including, apart from examples by Turner, drawings by Nicholson, Smith, De Wint, Hills, Fielding, Cristall, Cox, Gilpin, Prout, Robson, Varley, Atkinson, Glover, Ibbetson, Garrard and Heaphy. The catalogue to the exhibition proclaimed that it constituted 'a delightful repast

91 George Fennel
Robson (1788–1833)
*Gap of Dunloe, near
Killarney, County
Kerry, Ireland.*
Watercolour. This
watercolour was
probably in the
collection of Dr John
Percy (see p. 147).

92 Anne Frances
Byrne (1775–1837)
*Study of Blackberries
and Deadly Nightshade
on the Ground.*
Watercolour with
white heightening.

both for the Patriot and the Amateur'. Ackermann's *Repository of Arts . . .* estimated the undoubted importance of the exhibition in the following terms: 'Mr Walter Fawkes's fine collection of drawings did more to stamp the character of water-colour upon general attention than any other effort within our recollection.'

Commenting on the general improvement in watercolour technique the *Magazine of the Fine Arts* (vol. 1) remarked in 1821:

This may be seen in the splendid collection of Mr Fawkes. As drawings are generally confined to the size of a sheet of paper, and require a glass for their preservation, a limit is thus set to their magnitude, which keeps them within the size convenient for the decoration of English rooms; and when duly protected by their frames and glasses, they are safer from the effects of smoke and dust than even oil paintings, which, in private rooms, are often much injured by the continual operation of those nuisances.

Such reactions to the Fawkes exhibitions can hardly have failed to stimulate the market in watercolours.

As the late Basil Taylor noted in the catalogue to an exhibition held at Spink's, *The Old Watercolour Society and its founder members* (1973), there are few surviving contemporary accounts with which to illustrate the building up and arrangement of watercolour collections in the early nineteenth century. However, one description, quoted by Taylor, of the modest drawing-room of a house in Oxford Street where the musician Vincent Novello and his wife had for many years entertained a circle of friends that included Shelley, Keats, Leigh Hunt and the Lambs, conveys something of the re-strained, yet tasteful, décor to which watercolours could contribute:

The walls, were simply coloured, of a delicate rose tint and hung with a few watercolour drawings by Varley, Copley Fielding, Havell and Cristall (who were also personally known to Vincent Novello); the floor covered with a plain grey drugget bordered with a tastefully-designed garland of vine leaves and embroidered by Mrs Novello; towards the centre of the room a sofa-table strewed with books and prints; and at one end a fine-toned chamber-organ on which the host preluded and played to his listening friends, when they would have him give them 'such delights, and spare to interpose them oft' between the pauses of their animated conversation.

An exceptionally interesting collection of watercolours (dispersed at Christie's, 18 March 1980) was that formed by the Durham-born watercolourist George Fennel Robson (1788–1833) between 1826 and 1828 for Mrs George Haldimand, who was married to a London financier and was the daughter of a London alderman, John Prinsep. Robson's commission was to provide a collection which would represent an accurate cross-section of the best contemporary watercolours. There were, in total, one hundred drawings (measuring on average 7×10 in.) divided into three albums and in 1827 twenty-seven of them were placed on a screen and exhibited at the annual exhibition of the Old Water-Colour Society. Amongst the drawings included in the exhibition were a fruit-piece by Anne Frances Byrne (92), a marine by Sir Augustus Wall Callcott, George Cattermole's *Funeral of Henry V*, William Daniell's *On the Ganges*, Joseph Michael Gandy's visionary architectural caprice *The Temple of Apollo at Delphi*, William Henry Hunt's *A Boy hanging dead Game* and Turner's *Oyster Beds at Whitstable* (engraved for W. B. Cooke's *Views in the Southern Coast of England 1814–26*). Reading through the list of specialist artists one is tempted to draw a parallel between the mercantile societies of

nineteenth-century England and seventeenth-century Holland whose art market was equally diverse and specialised.

At least one of the contributing artists to the Haldimand collection had one eye on posterity, for Thomas Uwins, whose eventual contribution was a drawing entitled *Going to school*, gave details in a letter of 5 June 1827 of his first unsuccessful attempt at a drawing for the album: 'In Mrs Haldimand's book it would have been the weakest of the set', so he allowed Baroness Rothschild to buy it for her album (an interesting indication of the taste of the time for creating such watercolour albums) where it shone out 'amongst the bald and meagre attempts of the French, Italian and German artists'.

Perhaps the most intriguing of the Haldimand drawings was that produced by an amateur (James Prinsep, probably a relation) entitled *A Monument to Perpetuate the Fame of British Artists of 1828* (94) executed in 1830. In a delightfully decorative setting a column rises up from flowers and vegetation and is inscribed with the names of all those considered to be the principal watercolourists of the day. The most prominent position, and surely indicative of some sections of contemporary taste, is given to John Glover who, nine years previously, had mounted an exhibition of his own work which had been reviewed by the *Magazine of Art* (vol. I) in connection with the annual watercolour exhibition:

But few of them would have attempted the bold experiment, which Mr Glover has now ventured to make, of bringing his works directly into competition with those of celebrated masters, by exhibiting them together. He has, therefore, hung up a fine picture by Claude, – another by Wilson, – and a fine copy executed by himself, on a large scale, in water colours, from a masterpiece of Gaspar Poussin, – amongst his own works.

The gesture was worthy of Turner but by the middle of the century, when watercolours by Turner and Cox were fetching, on occasion, thousands of pounds, works by Glover, who had emigrated to Australia in 1830, very rarely commanded more than fifty pounds.

Although he was somewhat removed from the mainstream of watercolour activity, Turner's drawings were attracting increasing attention from artists and patrons in the 1820s to the extent that the critic of the *Athenaeum* (6 May 1829), reviewing the Old Water-Colour Society's exhibition, detected 'sunny effects, à la Turner' which would soon lead to nausea and 'even to the loathing of the prototype himself, unless he breaks the necks of some of his followers'. Stimulated by Turner's example many artists heightened the colour contrast in their drawings, as was noticed by the critic writing in the *Library of the Fine Arts* (July 1831):

. . . every year screws colouring up to a higher scale according to Exhibition pitch, until the very shadow of a cloud is rendered more intensely blue than Byron's classic sea . . . Yet as the ear of fashion accommodates itself to notes sharper and sharper still, so does the prejudiced eye see harmony in this graphic hyperbole – for all is compatible with the Exhibition key.

A selection of Turner's drawings for the series of engravings *Picturesque Views of England and Wales* was exhibited in 1829 by the publisher Charles Heath in the Large Gallery in the Egyptian Hall, Piccadilly, in an effort to boost sales for the engravings, the first of which had been published in 1827. By no means all of the critics were averse to the high-pitched colour of Turner's drawings which may have been determined, in part, by Turner's

95 John Glover
(1767–1849) *Landscape
with Waterfall*. Pencil and
watercolour. Formerly in
the collection of Dr John
Percy, this watercolour is
typical of Glover's work
in showing a marked
Claudean influence. Dr
Percy noted the opinion
of the picture dealer
Hogarth that the figures
in the drawing were
drawn by Joshua Cristall.

94 James Prinsep
(fl. 1830) *A Monument to
Perpetuate the Fame of
British Artists of 1828*,
1830. Watercolour.

wish to provide sufficient contrast for the engravers of his drawings to work
from. The *Athenaeum and Literary Chronicle* (10 June), for example, wrote of
the *Stonehenge* drawing: 'Surely there is nothing unnatural in this drawing! no
extravagent tints, no gold, no gorgeousness! and what a subject too! yet what
a picture.' In 1831 the publication of the *Picturesque Views* was taken over by
the Moon, Boys and Graves Gallery, who exhibited sixty-six of the original
watercolours at their own gallery in June and July 1833.

Turner's watercolours were frequently the main subject of discussion at a
number of artists' conversaziones which sprang up in London in the 1820s and
1830s where artists, amateurs, collectors, critics and dealers could meet
informally and discuss topics relevant to their professions and interests. Works
by Turner were generally lent to the conversaziones by private collectors such
as Maw and Tomkinson, the latter of whom brought twenty of his Turner
watercolours to a meeting of The Artists' and Amateurs' Conversazione,
which met at the Freemasons' Tavern in Great Queen Street, Lincoln's Inn
Fields. Commercial transactions at these meetings were banned under the
rules of the various societies, even to the extent of forbidding the asking of the
prices of the works under discussion. These rules were frequently overlooked,
however, and publishers such as Heath and Hullmandel, and dealers like
Thomas Griffith (Turner's agent) and R. H. Solly must have found it financially
advantageous to bring drawings from their stocks to these evenings. Heath, in
fact, displayed a selection of the engravings and drawings for the *Picturesque*

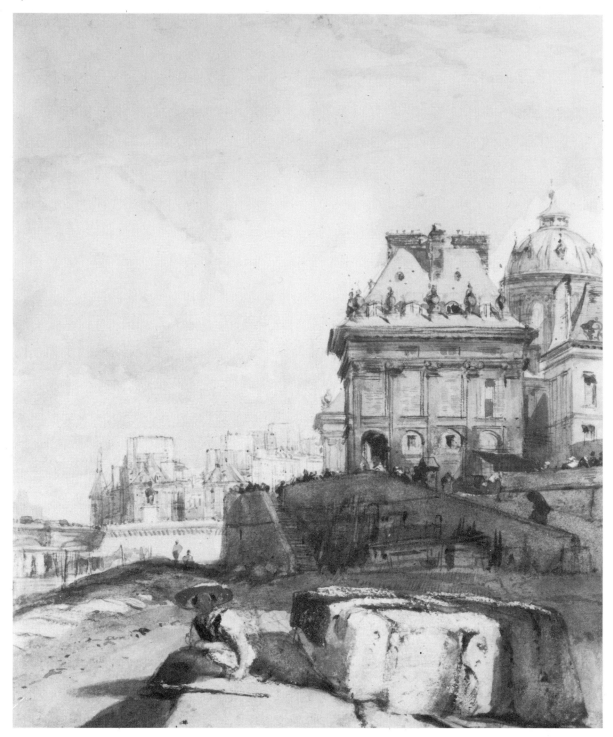

96 Richard Parkes Bonington (1802–28) *Paris, The Institute from the Quays, c.* 1827. Watercolour. Bonington had lived in France since his family moved there in 1817. His work was much admired by his friend, the French Romantic painter Delacroix, with whom he shared a studio 1826–7.

Views at one gathering in 1831. Meetings such as these constituted the 'wheels within wheels' of the trade in watercolours at the time. The London conversaziones helped to promote similar societies in the provinces and the minutes of the first meeting (held at the Norfolk Hotel) of a society organised in Norwich in 1830 loudly praised 'the entire circuit of the walls level with the line of vision hung with pictures, drawings and prints' while tables 'groaned under splendid publications upon art and portfolios'.

As the art world became ever more susceptible to rapid changes in fashion (Bonington's watercolours, for example, were very popular for a time after his early death in 1828) and artists and prospective patrons gained more points of social contact, so the rôle of the dealer assumed increasing importance. Given the tremendous increase in the trade in watercolours the rise of the middlemen was inevitable, though in some ways it was detrimental to artists and collectors alike. The new breed of dealers who catered for bourgeois taste and specialised in watercolours and small works in oils came in for criticism in the September issue of Arnold's *Magazine of the Fine Arts* in 1833:

The influence of dealers has, at times, been most unwarrantably directed to the exhibitions of the old Society of Painters in Water Colours. It is not an uncommon circumstance, that the greater number of works marked as sold . . . are already the property of dealers, even before they have left the portfolio.

One of the main reasons for David Cox leaving London in 1841 was to escape the constant demands of dealers for small, readily saleable drawings. Cox had on occasion benefited from dealers, however, as Roget noted:

His drawings at Palser's caught the eye of the Hon. H. Windsor, colonel and amateur, and afterwards the Earl of Plymouth, who sought him out and not only took some lessons from him, but got him aristocratic pupils at the West-end of town . . . Every year, from that after his marriage, when David junior, his only child, was born, he went to see his parents, and sketch near his old home. There was a dealer there, a Mr Everitt, who bought his drawings, and to whose son he gave some lessons.

Edward Everitt was a Birmingham artist and dealer to whom Cox used to sell his drawings (for example, four in 1811 for fourteen guineas). London-based artists generally sold their lesser works to provincial dealers, reserving their best for London exhibitions. Thomas Uwins, in 1838, described William Havell as 'selling his pictures at country exhibitions, at five, ten and fifteen guineas a piece', his principle being 'to meet and not to force the market'. The less sophisticated demands of the provincial market were noted by Ruskin in his *Notes* on Prout:

In his early days he had established a useful and steady connection with the country dealers – that is to say, with the leading printsellers in the country towns and principal watering-places. He supplied them with pretty drawings of understood size and price, which were nearly always in demand by the better class of customer. The understood size was about 10 inches by 14 or 15, and the fixed price six guineas. The dealer charged from seven to Ten, according to the pleasantness of the drawing. I bought the 'Venice', for instance, No. 55, from Mr Hewitt of Leamington, for eight guineas.

Watercolours were often sold in the provinces by booksellers and printsellers and the Leamington dealer would have been John Hewett with whom Prout had business dealings throughout his career. It is interesting to trace how the prices fetched by Prout's drawings rose during his lifetime and after. Early

97 OVERLEAF Joseph Mallord William Turner (1775–1851) *The Splügen Pass*, 1842. Watercolour.

in his career he charged half a crown for small drawings, though the dealers Palser (who sold Prout's work as early as 1806) and Ackermann soon paid him five shillings per drawing. The prices he charged Hewett have already been quoted and can be supplemented by a memorandum (dated 1842) from the artist to the dealer quoting: '9 small £9 9/-; 4 large £12 12/-'. Prout charged more for drawings exhibited in London, as Ruskin observed: 'the drawings made for the Water-colour room were usually more elaborate, and, justly, a little higher in price; but my father bought the *Lisieux* off its walls, for eighteen guineas'. In 1868, less than twenty years after Prout's death, his watercolour of *Nuremberg* was sold at Christie's for £1,002 15s.!

In retrospect it seems ironic that Ruskin, who through his writings and lectures had done more than anyone to foster an enthusiasm for watercolours, should have been outraged by such prices. Yet in 1877 (*Fors Clavigera*) he gave vent to his wrath in typically idealistic fashion:

The existence of the modern picture dealer is impossible in any city or country where art is to prosper; but some day I hope to arrange a 'bottega' for the St George's Company, in which water-colour drawings shall be sold, none being received at higher price than fifty guineas, nor at less than six . . .

Ruskin's own activities as a collector were, of course, primarily centred on the watercolours of Turner of which he possessed, at one time or another, over three hundred examples. Ruskin's father was a prosperous sherry merchant and in October 1842 the family moved from Herne Hill to a larger and grander house at Denmark Hill. Ruskin's reminiscences (*Praeterita*, vol. II) of the interior of the house as it was in 1845 give some indication of the liberal sprinkling of watercolours on the walls there: 'The breakfast-room, opening on the lawn and farther field, was extremely pretty when its walls were mostly covered with lakes by Turner and doves by Hunt' while the dining and drawing rooms 'had decoration enough in our Northcote portraits, Turner's Slave-ship, and, in later years, his Rialto, with our John Lewis, two Copley Fieldings [the artist had been employed by the Ruskins as a drawing-master], and every now and then a new Turner drawing'. The first three Turners Ruskin acquired were bought for him by his father from Turner's regular agent Thomas Griffith of Norwood who, in June 1840, introduced Ruskin to the artist whom he later described in his diary as 'the greatest of the age'. Ruskin senior had himself begun collecting watercolours in a modest way in 1832–3 with the purchase of a Scottish scene and a 'sea piece' by Copley Fielding. When Griffith offered for sale, between 1842 and 1843, a total of fifteen Swiss views by Turner at eighty guineas each Ruskin found his father discouraged by the asking price:

Of more than one drawing I had no hope, for my father knew the worth of eighty guineas; we had never before paid more than from fifty to seventy, and my father said it was 'all Mr Griffith's fault they had got up to eighty'.

The drawing Ruskin most wanted, *The Splügen Pass* (97), was bought by the great Turner collector Hugh A. J. Munro of Novar but was later presented to Ruskin in 1878 by a group of his admirers; they had paid one thousand guineas for it, which gives some indication of how steeply prices for the best watercolours had risen in the intervening period. In the 1870s Ruskin sold another drawing from the same series, a view of Lucerne, to the dealer Vokins for one thousand pounds.

When the contents of Turner's studio and gallery were finally handed over to the nation in 1856, five years after the artist's death, Ruskin immediately offered to catalogue the drawings. He completed this enormous task (the Bequest totalled between nineteen and twenty thousand drawings) by May 1858, having sorted the drawings into categories such as 'Fine', 'Interesting' and 'Good for distribution', the last of which often meant that the drawing was included in one of the numerous Turner exhibitions organised by Ruskin at venues such as the South Kensington Museum and the National Gallery, thus keeping Turner's work frequently in the public eye. Some of the drawings fared less well, being classed as 'Bad', 'Rubbish' or 'Valueless' and Ruskin even burned some which, William Michael Rossetti reported, 'it seemed undesirable to preserve'.

There was not, however, universal agreement with what some considered to be Ruskin's excessive adulation of Turner. John Cassel's *Art Treasures Exhibition*, written to accompany the 1857 Manchester exhibition, protested:

That Turner was an artist of original genius, and that even his most carelessly executed pieces prove the fact, no one is now disposed to doubt; but that his *chefs-d'oeuvre* are either more true to nature, more artistic, or more pleasing than those of Claude Lorraine, Constable, or De Wint, Ruskin will find as difficult to prove as that Tennyson and Browning are greater poets than Pope, Byron, Campbell or Scott.

Nevertheless, there can be no doubt that throughout the period when Ruskin was writing and lecturing on English watercolours Turner was the most widely collected artist and his works fetched the highest prices. A number of extremely important watercolour sales in the period 1860–85 can be examined by reference to G. Redford's *Art Sales 1628–1887* (1888) and to the press-cuttings and author's comments contained in Dr John Percy's manuscript catalogue of his own collection (catalogue now in the Prints and Drawings Department of the British Museum). Percy (1817–89) was a distinguished metallurgist and his exceptionally broad and varied collection of watercolours was dispersed in 1890. The most notable absentees from his collection were three artists who specialised in Far Eastern scenery – Roberts, Lewis and Lear. Like so many collectors he was also a capable amateur artist. He bought frequently in the London salerooms and also from dealers such as Palser, Tomkins and David Hogarth (whose advice he especially valued). The fact that emerges on consulting Redford and Percy is, as to be expected, that Turner tops the list with the best price realised for a watercolour of £3,307 10s. for his *Bamborough Castle* at the Joseph Gillott sale at Christie's 4 May 1872. Born of poor parents in Sheffield, Gillott was the inventor of the modern steel pen, of which he became the world's largest manufacturer at his factory in Birmingham. He had collected contemporary British paintings and water-colours extensively over a period of fifty years and the sale of his collection realised a total of £25,423. While the results of the Gillott sale directed the attention of the saleroom critics towards British art in general, the most spectacular sale of watercolours of this period was undoubtedly that of William Quilter of Lower Norwood, who sold a large proportion of his collection at Christie's 9–12 April 1875. Examples by all the major water-colourists were included and *The Times* remarked (12 April 1875): 'In dismissing this remarkable sale it may be observed that the prices of most of the important drawings were higher than any as yet reached at a sale by auction for works of this kind.'

Quilter was one of a number of mid-nineteenth-century collectors whose enthusiasm for David Cox raised the prices fetched at auction for his works to only a little below those achieved by Turner. In the same review *The Times* observed:

When the first works of David Cox were sold in his lifetime, they were almost a drag in the market; he rarely received more than 50 guineas for his large works, and for his small drawings, which we have just seen sold for from £50 to £500 each, he had something very little indeed.

Quilter apparently realised a profit of about two hundred and sixty percent on his original outlay for his collection and one drawing, Cox's *The Hayfield* had been purchased by Quilter for £600 and was bought by Agnew's at his sale for £2,950. A letter of 1881 from William Agnew to Samuel Ashton concerning the latter's collection confirms the rapid acceleration of prices of watercolours:

I quite agree in your opinion that you could not get another lot of watercolours so good or so beautiful. I am very glad to give you some valuations, and must ask you to believe that if anything I underestimate, and do not exaggerate. If I put my savings thirty years ago in good Watercolours . . . I should be a rich man at this moment! (G. Agnew, *Agnew's 1817–1967*)

The sales of other collections at this period which fully bear out Agnew's statement include those of Thomas Greenwood of Hampstead (1875, Cox

98 George Cattermole (1800–68), *The Soldier and his host*. Watercolour and white heightening. Cattermole's drawings were consistently popular in the nineteenth century and he was dubbed the founder of the 'Historico-Romantic School of Watercolour Art'. He was awarded the 'grande médaille d'honneur' at the 1855 Paris International Exhibition. Thirty-two of his works were exhibited at the 1857 Manchester exhibition where he was described in the catalogue as the 'King of *chique*'.

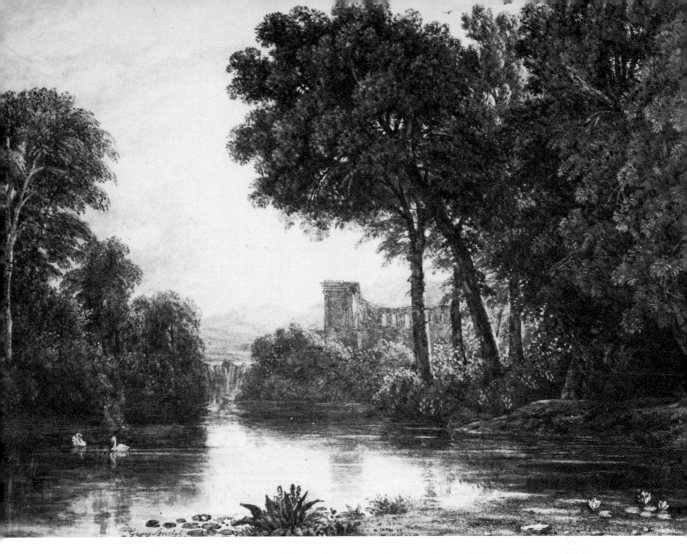

99 George Barret the Younger (1767?–1842) *Landscape with Lake and Ruins*, 1820. Pen, pencil and watercolour. Barret specialised in Claudean compositions of which, over the years, he exhibited hundreds at the annual exhibitions of the 'Old' Society. His works were especially popular with collectors in the second half of the nineteenth century.

and Turner especially) and Munro of Novar (1877, Turner vignettes: 'the race for all the great prizes was between Agnew, Mr Wallis, Mr Vokins and the agent of a lady of distinction, who proved a rather formidable competitor'). The artists, Turner and Cox apart, who fared best in these sales were generally those who had exhibited at the watercolour societies earlier in the century – familiar names such as Barret, Cattermole, De Wint, Copley Fielding, Hunt, Lewis, Prout and Roberts. Their success should be viewed in the context of a general enthusiasm for Victorian art as epitomised by collectors such as Gillott. Important precursors such as Sandby and Girtin or artists who, like Cotman, had not fared well in the London art world, did not command high prices.

The great London museums and galleries also reflected the growing interest in watercolours. Whereas the British Museum had acquired and been presented with important series of English drawings, its policy of acquisition had been, to some degree, undefined and accidental in this particular field. By contrast, the South Kensington Museum (now the Victoria and Albert Museum) had, since its opening in 1857, deliberately set out to form a representative collection of British watercolours under the guiding hand of the Art Referee at South Kensington, the art historian and Royal Academician

Richard Redgrave (1804–88), whose brother Samuel prepared an admirably thorough catalogue of the collection which was published in 1877. The National Gallery also possessed a good collection of watercolours many of which were later transferred to South Kensington. The varying conditions under which these collections were exhibited gave rise to a heated discussion in the press in the 1880s. J. C. Robinson (1824–1913), who had resigned his post as superintendent of the art collections at South Kensington in 1869, brought the matter to the public's attention in a letter to *The Times*, 11 March 1886. He expressed his concern at the damaging effects of daylight upon watercolours:

At the South Kensington Museum an important collection of English water-colour drawings has been continuously exhibited in the full daylight for 20 or 30 years past, and I have no hesitation in saying that by the mere fact of such exposure all these drawings have been more or less irrevocably injured and that in many cases the specimens are now as it were but the pale ghosts of their former selves. These treasures, then, have sufficed for the delectation of one generation only, and we ourselves have practically used them up.
At the British Museum, on the other hand, there is a noble – perhaps unrivalled – collection of drawings by the ancient masters. These drawings happily have been carefully stowed away in portfolios, and sedulously kept from the light. Practically they have suffered no deterioration in our own time. This mode of keeping them is safe and proper, but it has this great inconvenience, in that these treasures are invisible and remain practically unknown to the mass of mankind, and so long as they are kept in that way they must of necessity remain so.

Robinson's proposed solution was that watercolour drawings should be exhibited glazed and only for limited periods in the evenings under artificial lighting. His was not the first voice that had been raised from a concern on the subject. Roget noted an anonymous critic writing as early as 1824: 'landscape painters must be content to study for the portfolio . . . unless . . . they would forego the temptation of present applause for a more lasting though less brilliant fame, by confining themselves . . . to pigment less liable to change'.

Not unnaturally the Old Water-Colour Society (whose members' sales would have been adversely affected if such criticism had had a widespread effect) retaliated by stating in its exhibition catalogue for that year that '. . . no philosophical reasons ever were, or ever could be, adduced against the possiblity of producing by means of water-colours, pictures equal in . . . permanency . . . to those executed in oil'.

The conservation of Turner's drawings in the artist's bequest had been discussed by Ruskin in a letter to the *Daily Telegraph*, 5 July 1876. He described the careful storage in sliding racks in portable cabinets of the Turner drawings he had devised for the Ruskin Drawing School in Oxford and contrasted this with the disastrous deterioration of watercolours lent to the 1857 Art Treasures exhibition:

Thus taken care of, and thus shown, the drawings may be a quite priceless possession to the people of Oxford for the next five centuries; whereas those exhibited in the Manchester Exhibition were virtually destroyed in that single summer. There is not one of them that is not the mere wreck of what it was.

In the controversy of the 1880s Robinson and his supporters were opposed by two groups. A number of private collectors felt obliged to defend their own practices of exposing their framed watercolours to daylight by hanging them on the walls of their homes, though more responsible collectors would

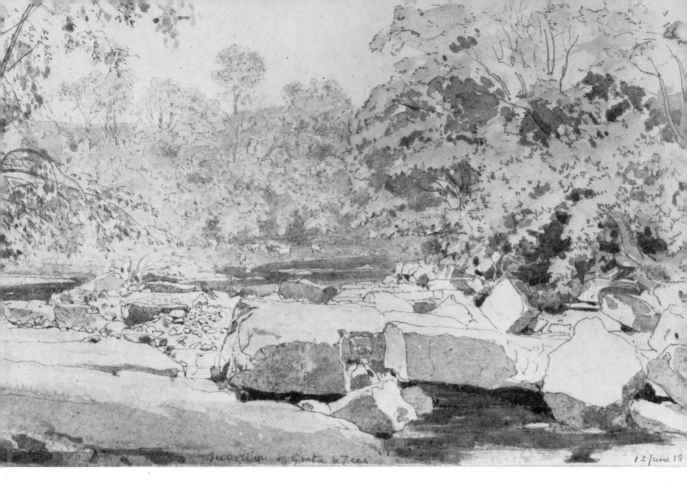

Junction of Greta & Tees 12 June 18

100 John Lewis Roget
(1828–1908) *The Junction
of the Rivers Greta and
Tees*, 1883. Pencil and
watercolour. Roget is best
known for his two-
volume *History of the Old
Water-Colour Society*
(1891), but this
watercolour shows him to
have been a competent
artist in his own right.

have been soothed by remarks made by Ruskin in a letter to *The Times*, April
1886:

Properly taken care of – as a well-educated man takes care of his books and
furniture – a water colour drawing is safe for centuries; out of direct sunlight it
will show no failing on your room-wall till you need it no more . . . is it for your
heir that you buy your horses or lay out your garden?

Thus beguiled by Ruskin the collectors were joined in their denial of Robinson's
assertions by Sir James D. Linton (1840–1916), President of the Royal
Institute of Painters in Water Colours who (incorrectly) claimed that 'it is not
too much to say, for instance, that the drawing of 'Warkworth', by Turner,
and those by Wm. Haxell [*sic*], instead of having been bleached by the action
of light, are absolutely richer and deeper than when they were first painted'.

 In July 1886 Linton and his society mounted a special exhibition of
watercolours by 'Deceased Masters of the British School'. The drawings lent
to the exhibition included examples by Cox, John Varley, De Wint and
Turner and one of the main purposes of the exhibition was to demonstrate
that drawings which had been hung for thirty years or so in direct daylight
had not deteriorated in condition. Debate on the subject continued in the
national press and the Lords of the Committee of Council on Education
appointed a special committee to investigate the whole subject, though
neither Robinson nor his supporters, who included the scientist Professor
A. H. Church and Dr Percy, were invited to contribute. The resulting report,
however, fully vindicated their claims. It was produced by Dr Walter J. Russell,

a chemist, and Captain William de W. Abney, a painter, and was published in 1888 with the title *Report . . . on the Action of Light on Water Colours*. It was rapidly acclaimed and its findings are still valid today. Russell and Abney concluded that light does damage some colour pigments causing them to fade and that too many artists were using 'fugitive' colours likely to be damaged by the action of light. Futhermore, they stated that varying amounts of oxygen and water could damage watercolours – an observation which has been well heeded by most museums and galleries in the twentieth century, many of which have had full air-conditioning systems installed.

The misgivings expressed during the controversy and the findings of Russell and Abney undoubtedly depressed the market in watercolours. Writing in 1891 Roget observed: 'the effect . . . of the scare was very distinctly felt, both by artists and dealers, in the increased difficulty with which they were able to dispose of water-colour drawings'. Only in the last twenty years or so have watercolours climbed back to occupy the high status in the overall art market that they enjoyed in the second half of the nineteenth century, though this is not by any means to say that they have not been avidly collected by enthusiasts in the intervening period. The number of books and exhibitions devoted to the subject of late bears eloquent testimony to recent interest – an interest that is more broadly based than that of the Victorians with their penchant for highly finished watercolours in heavy gold frames. Research today has focused attention on many hitherto neglected artists and has opened up new perspectives on the great names of watercolour, Turner especially. It is to be hoped that this book has allowed the reader time to draw breath amidst all this scholarly activity and to gain some realisation of the general background to the rise of watercolours in this country.

Bibliography

ACKERMANN, R. *The Microcosm of London or London in Miniature*, 2 vols. London, 1808–9.

ALEXANDER, BOYD *England's wealthiest son: a study of William Beckford*, London, 1962.

ARCHER, MILDRED *British Drawings in the India Office Library*, 2 vols. London, 1969.

ARCHER, MILDRED *Artist Adventurers in Eighteenth Century India: Thomas and William Daniell*. Exhibition catalogue, Spink & Son Ltd, London, 1974.

BARBIER, CARL PAUL *William Gilpin, His Drawings, Teaching and Theory of the Picturesque*. Oxford, 1963. (Gilpin's numerous publications, unpublished writings and letters are fully listed by Barbier.)

BOASE, T. S. R. *English Art 1800–1870*. Oxford, 1959.

CHANDLER, RICHARD *Travels in Asia Minor*. London, 1975. (Edited and abridged by Edith Clay with an appreciation of William Pars by Andrew Wilton.)

COHN, MARJORIE B. *Wash and Gouache A Study of the Development of the Materials of Watercolor* Exhibition catalogue, Fogg Art Museum, 1977. (Supplements the discussion of this subject in Hardie and contains a good summary of the conservation controversy of the 1880s.)

CROFT-MURRAY, EDWARD and PAUL HULTON *Catalogue of British Drawings [in the British Museum] Volume One: XVI & XVII Centuries*, 2 vols. London, 1960.

DAYES, EDWARD *The Works of the late Edward Dayes*. Originally published London, 1805, republished London, 1971, with an introduction by R. W. Lightbown.

EGERTON, JUDY *English Watercolour Painting*. Oxford, 1979.

EVELYN, JOHN *The Diary of John Evelyn*, 2 vols. Everymans Library edn, London, 1945.

FARINGTON, JOSEPH (ed. J. Greig) *The Farington Diary*, 8 vols. London, 1922–8. (A typescript copy of Farington's full diary, in the Royal Library at Windsor, is deposited in the Print Room of the British Museum. The original diary is currently being published for the Paul Mellon Centre for Studies in British Art by the Yale University Press, edited by Kenneth Garlick and Angus Macintyre.)

FAWCETT, TREVOR. W. *The Rise of English Provincial Art*. Oxford, 1974.

FAWCETT, TREVOR W. 'Eighteenth-century Art in Norwich', *The Walpole Society*, vol. XLVI (1976–78), pp. 71–90.

FORD, BRINSLEY (ed.) 'The Letters of Jonathan Skelton written from Rome and Tivoli in 1758', *The Walpole Society*, vol. XXXVI (1956–58), pp. 23–82.

FRIEDMAN, JOAN 'Every Lady Her Own Drawing Master', *Apollo*, April 1977, pp. 262–7.

FRIEDMAN, TERRY, *Engrav'd Cards of Trades-Men in the County of Yorkshire*. Exhibition catalogue, Leeds Art Galleries, 1976.

GILPIN, REV. WILLIAM *Three Essays on Picturesque Beauty; on Picturesque Travel; and on Sketching Landscape: to which is added a poem, on Landscape Painting*. London, 1792.

GIRTIN, THOMAS and DAVID LOSHAK *The Art of Thomas Girtin*. London, 1954.

GODFREY, RICHARD T. *Printmaking in Britain*. Oxford, 1978.

GREENACRE, FRANCIS *The Bristol School of Artists, Francis Danby and Painting in Bristol, 1810–1840*. Exhibition catalogue, City Art Gallery, Bristol, 1973.

GUITERMAN, HELEN *David Roberts R.A. 1796–1864*. London, 1978.

HAMILTON, JEAN *The Sketching Society 1799–1851*. Exhibition catalogue, Victoria and Albert Museum, London, 1971.

HARDIE, MARTIN (ed. Dudley Snelgrove, Jonathan Mayne and Basil Taylor) *Water-colour Painting in Britain*, 3 vols. London, 1966–8. (The standard work on the subject; vol. III contains a very complete bibliography up to 1968.)

HARLEY, ROSAMUND D. *Artist's pigments c. 1600–1835: a study of English documentary sources*. London, 1970.

HAWCROFT, FRANCIS W. 'Grand Tour Sketchbooks of John Robert Cozens 1782–1783', *Gazette des Beaux-Arts*, March 1978, pp. 99–106.

HAYES, JOHN *The Drawings of Thomas Gainsborough*, 2 vols. London, 1970.

HEAD, RAYMOND 'An endless source of amusement . . . Amateur artists in India', *The Connoisseur*, February 1980, pp. 93–101.

HERRMANN, LUKE *Ruskin and Turner*. London, 1968.

HERRMANN, LUKE *British Landscape Painting of the Eighteenth Century*. London, 1973.

HILL, DAVID *Turner in Yorkshire*. Exhibition catalogue, City Art Gallery, York, 1980.

HOLLOWAY, JAMES and LINDSAY ERRINGTON *The Discovery of Scotland*. Exhibition catalogue, National Gallery of Scotland, Edinburgh, 1978.

HONOUR, HUGH *The European Vision of America*. Exhibition catalogue, Cleveland Museum of Art, 1975.

HUGHES, PETER 'Paul Sandby and Sir Watkin Williams-Wynn', *The Burlington Magazine*, July 1972, pp. 459–66.

HUGHES, PETER 'Paul Sandby's Tour of Wales with Joseph Banks', *The Burlington Magazine*, July 1975, pp. 452–7.

HULTON, PAUL 'Drawings of England in the Seventeenth Century by Willem Schellinks, Jacob Esselens & Lambert Doomer', *The Walpole Society*, vol. XXXV (1954–56).

HUSSEY, CHRISTOPHER *The Picturesque*. London, 1927.

HUTCHISON, SIDNEY C. *The History of the Royal Academy 1768–1968*. London, 1968.

IRWIN, FRANCINA 'The Scots Discover Spain', *Apollo*, May 1974, pp. 353–7.

IRWIN, FRANCINA 'Lady Amateurs and their Masters in Scott's Edinburgh', *The Connoisseur*, December 1974, pp. 230–7.

JONES, THOMAS (ed. A. P. Oppé) 'Memoirs', *The Walpole Society*, vol. XXXII (1946–48).

KITSON, SYDNEY D. *The Life of John Sell Cotman*. London, 1937.

LEVY, F. J. 'Henry Peacham and the Art of Drawing', *Journal of the Warburg and Courtauld Institutes*, vol. XXXVII (1974), pp. 174–90.

LINDSAY, JACK *J. M. W. Turner, His Life and Work*. London, 1966.

LLEWELLYN, BRIONY 'Petra and the Middle East by artists in the collection of Rodney Searight Esq.', *The Connoisseur*, June 1980, pp. 122–9.

LUCAS, S. T. *Bibliography of Water Colour Painting and Painters*. London, 1976.

MAYNE, JONATHAN 'Taste in water-colour', *Apollo*, April 1963, pp. 289–94.

MAYNE, JONATHAN *Dr Thomas Monro (1759–1833) and the Monro Academy*. Exhibition catalogue, Victoria and Albert Museum, London, 1975.

MOIR, ESTHER *The Discovery of Britain*. London, 1964. (A lively and informative account of the growth of touring in Great Britain.)

NICOLSON, BENEDICT 'Thomas Gisborne and Joseph Wright of Derby', *The Burlington Magazine*, February 1965, pp. 58–62.

NORGATE, EDWARD *Miniatura; or the art of Limning* . . . (Edited from the manuscript in the Bodleian Library and collated with other manuscripts by Martin Hardie.) Oxford, 1919.

OGDEN, HENRY V. S. and MARGARET S. OGDEN *English Taste in Landscape in the Seventeenth Century*. Ann Arbor, Michigan, 1955.

OPPÉ, A. P. 'Francis Towne, Landscape Painter,' *The Walpole Society*, vol. VIII (1919–20), pp. 95–126.

OPPÉ, A. P. 'A Roman sketch-book by Alexander Cozens' *The Walpole Society*, vol. XVI (1927–28), pp. 81–93.

OPPÉ, A. P. *Alexander and John Robert Cozens*. London, 1952.

PARRIS, LESLIE *Landscape in Britain c. 1750–1850*. Exhibition catalogue, The Tate Gallery, London, 1973.

PERCY, DR JOHN *Manuscript catalogue of his collection of English drawings*. (Interleaved in a copy of the Burlington Fine Art Club 1871 catalogue, deposited in the British Museum Print Room.)

PEVSNER, NIKOLAUS 'Richard Payne Knight', *The Art Bulletin* (1949), pp. 293–320.

PIDGLEY, MICHAEL 'Cornelius Varley, Cotman and the Graphic Telescope', *The Burlington Magazine*, November 1972, pp. 781–6.

PIDGLEY, MICHAEL *John Sell Cotman's Patrons and the Romantic Subject Picture in the 1820s and 1830s.* Unpublished doctoral thesis, University of East Anglia, 1975.

PLUMB, J. H. *The Pursuit of Happiness, A View of Life in Georgian England*. Exhibition catalogue, Yale Center for British Art, New Haven, 1977.

PYNE, W. H. *Wine and walnuts*. London, 1824.

RAJNAI, MIKLÓS and MARJORIE ALLTHORPE-GUYTON *John Sell Cotman Drawings of Normandy in Norwich Castle Museum*. Norwich, 1975.

RAJNAI, MIKLÓS and MARJORIE ALLTHORPE-GUYTON *John Sell Cotman 1782–1842 Early Drawings (1798–1812) in Norwich Castle Museum*. Norwich, 1979.

REDFORD, G. *Art Sales 1628–1887*, 2 vols. London, 1888.

REYNOLDS, GRAHAM *A Concise History of Watercolours*. London, 1971.

ROGET, JOHN LEWIS *A History of the 'Old Water-Colour Society'*, 2 vols. London, 1891.

RUSKIN, JOHN *The Works of John Ruskin*, 39 vols. Library Edition, London, 1903–12.

RUSSELL, JOHN and ANDREW WILTON *Turner in Switzerland*. Zurich, 1976.

SHANES, ERIC *Turner's Picturesque Views in England and Wales 1825–1838*. London, 1979.

SIDEY, TESSA *Amelia Long, Lady Farnborough (1772–1837)*. Exhibition catalogue, Dundee Art Gallery, 1979.

SMITH, BERNARD *European Vision and the South Pacific 1768–1850*. Oxford, 1960.

Somerset House Gazette and Literary Museum, 2 vols. London, 1824.

STAINTON, LINDSAY *British Artists in Rome 1700–1800*. Exhibition catalogue, Kenwood, London, 1974.

TAYLOR, BASIL *The Old Watercolour Society and its founder-members*. Exhibition catalogue, Spink & Son Ltd, London, 1973.

TAYLOR, TOM *A Handbook to the Water Colours, Drawings and Engravings in the Art Treasures Exhibition*. Manchester, 1857.

The Repository of Arts, Literature, Commerce, Manufactures, Fashion and Politics, 50 vols. Published by R. Ackermann, London, 1809–29.

TYLER, RICHARD *Francis Place 1647–1728*. Exhibition catalogue, City Art Gallery, York, and Kenwood, London, 1971.

UWINS, MRS *A Memoir of Thomas Uwins R.A.*, 2 vols. London, 1851.

VICTORIA AND ALBERT MUSEUM *Press cuttings from English newspapers, 1685–1835*, London.

WALTON, PAUL *The Drawings of John Ruskin*. Oxford, 1972.

WARNER, OLIVER 'Miss Bowles visits Southey', *Country Life*, 2 May 1947, pp. 808–9.

WARNER, OLIVER 'The Sketch-book of a 19th-century country gentleman', *Country Life*, 27 February 1948, pp. 439–40.

WARNER, OLIVER 'Admiral Burrard's Red Book', *Country Life*, 19 June 1948, pp. 1239–40.

WHEELER, J. M. 'The Byrne Family and the 'Old Society'', *The Old Water-Colour Society's Club*, vol. XLVIII (1973), pp. 21–39.

WHITE, CHRISTOPHER *English Landscape 1630–1850 Drawings, Prints & Books from the Paul Mellon Collection*. Exhibition catalogue, Yale Center for British Art, New Haven, 1977.

WHITLEY, WILLIAM T. *Whitley Papers*. (Deposited in the Print Room, British Museum)

WILLIAMS, IOLO A. *Early English Watercolours*. London, 1952.

WILTON, ANDREW *Turner in the British Museum*. Exhibition catalogue, British Museum, London, 1975.

WILTON, ANDREW *British Watercolours 1750–1850*. Oxford, 1977.

WILTON, ANDREW *The Life and Work of J. M. W. Turner*. London, 1979.

WOODBRIDGE, KENNETH *Landscape and Antiquity, Aspects of English Culture at Stourhead, 1718–1838*. Oxford, 1970.

Index

Figures in italics refer to the black and white illustrations; those in bold type to the colour.

Acknowledgements

The author and publishers wish to thank the following for permission to reproduce the black and white illustrations: Thos. Agnew & Sons 24 (with Agnew's 1979), 97 (now in USA private collection); Ashmolean Museum, Oxford 33; Bristol City Art Gallery 53; British Library 26; Trustees of the British Museum 2–7, 12–17, 19, 21–3, 25, 27, 29, 34, 36, 38, 40–6, 48, 52, 56–9, 61–3, 69, 70, 73, 75, 76, 78, 82–4, 86, 89, 90, 96, 100; British Museum Publications (courtesy of the British Museum) 28, 32, 35, 79, 80, 98; Christies Fine Art 71, 92, 93, 94 (now in the British Museum); Michael Clarke 67; Derby Art Gallery 30, 66; Judy Egerton 68; Trustees of the Royal Society of Painters in Water-Colours 55; Science Museum, London (Crown Copyright) 9–11, 18; Victoria and Albert Museum, London 50, 51, 85; Trustees of the Wedgwood Museum, Barlaston, Staffs 8; Whitworth Art Gallery, Manchester University 1, 31, 37, 39, 47, 49, 54, 60, 64, 65, 72, 77, 81, 87, 88, 91, 95, 99; Yale Center for British Art (Paul Mellon Collection) 74, p. 6; York City Art Gallery 20.

All the colour illustrations are reproduced by courtesy of the Trustees of the British Museum.